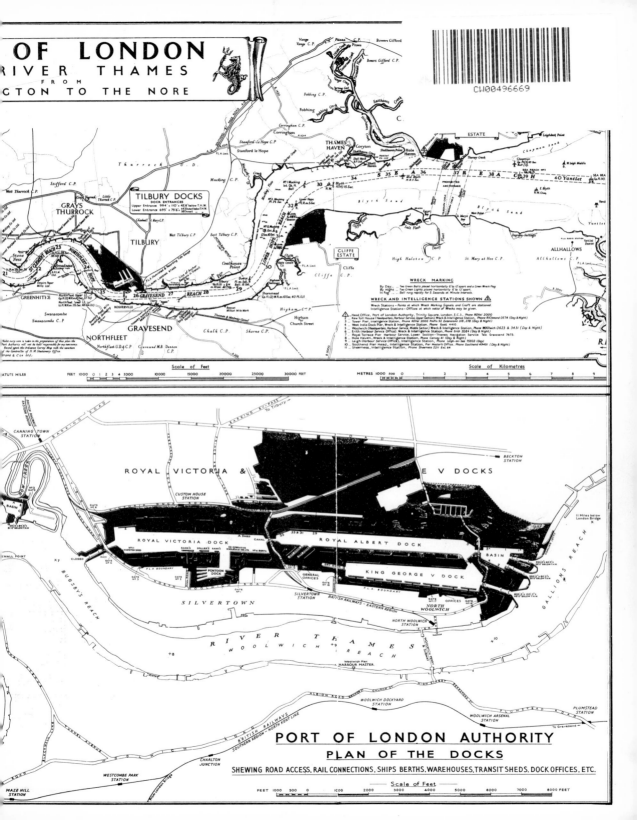

OF LONDON
RIVER THAMES
FROM
...GTON TO THE NORE

TILBURY DOCKS
DOCK ENTRANCES
Upper Entrance 994' x 110' x 45'8" below T.H.W.
Lower Entrance 695' x 79'6" ...

WRECK MARKING

By Day:— Two Green Balls placed horizontally 6 to 12 apart and a Green Wreck Flag
By Night:— Two Green Lights placed horizontally 6 to 12 apart
In Fog:— Bell rung rapidly for 5 Seconds at Minute Intervals

WRECK AND INTELLIGENCE STATIONS SHOWN

Wreck Stations — Points at which Wreck Marking Signals and Craft are stationed.
Intelligence Stations — Offices at which notice of Wrecks may be given.

1. Head Office, Port of London Authority, Trinity Square, London, E.C.3., Phone ROYal 2000
2. Kew Toll House (Headquarters, Harbour Service, Upper Section), Wreck & Intelligence Station, Phone RIChmond 0574 (Day & Night)
3. Tower Pier, Intelligence Station, Phone ROYal 2000 Prefix 92 Extensions 318, 378 (Day & Night)
4. West India Dock Pier, Wreck & Intelligence Station, Phone East. 4410
5. Woolwich (Headquarters, Harbour Service, Middle Section) Wreck & Intelligence Station, Phone WOOlwich 0623 & 3431 (Day & Night)
6. Erith (Harbour Service Office), Wreck & Intelligence Station, Phone Erith 2084 (Day & Night)
7. Royal Terrace Pier, Harbour Service, Lower Section - Thames Navigation Service Tele. Gravesend 7675.
8. Hole Haven, Wreck & Intelligence Station, Phone Canvey 41 (Day & Night)
9. Leigh (Harbour Service Office), Intelligence Station, Phone Leigh-on-Sea 75933 (Day)
10. Southend Pier Head, Intelligence Station, Pier Master's Office, Phone Southend 43451 (Day & Night)
11. Sheerness, Intelligence Station, Phone Sheerness 2311 Ext. 64

Scale of Feet

STATUTE MILES FEET 1000 0 1 2 3 4 5000 10000 15000 20000 25000 30000 FEET

Scale of Kilometres

METRES 1000 500 0 1 2 3 4 5 6 7 8 9

PORT OF LONDON AUTHORITY
PLAN OF THE DOCKS
SHEWING ROAD ACCESS, RAIL CONNECTIONS, SHIPS BERTHS, WAREHOUSES, TRANSIT SHEDS, DOCK OFFICES, ETC.

Scale of Feet

FEET 1000 500 0 1000 2000 3000 4000 5000 6000 7000 8000 FEET

ROYAL VICTORIA & ...E V DOCKS

ROYAL VICTORIA DOCK
ROYAL ALBERT DOCK
KING GEORGE V DOCK

RIVER THAMES
WOOLWICH REACH
BUGSBYS REACH
GALLIONS REACH

THE THAMES ON FIRE

BY THE SAME AUTHOR

The Merchant Service. Frederick Muller.
Tideway Tactics. (Short stories and wartime sketches.) Frederick Muller.
The Londoner's River. Frederick Muller.
The Royal River. Port of London Authority.
Open the Ports. The Story of Human Minesweepers. William Kimber.
(In collaboration with J. Grosvenor)
Somerset House: Four Hundred Years of History. Frederick Muller.
The Spirit of London River. Gresham Books.

THE THAMES ON FIRE

The Battle of London River 1939–1945

by

L. M. BATES

TERENCE DALTON LIMITED
LAVENHAM . SUFFOLK
1985

Published by
TERENCE DALTON LIMITED

ISBN 0 86138 037 1

Text photoset in 11/12 pt Baskerville

Printed in Great Britain at
The Lavenham Press Limited, Lavenham, Suffolk

Contents

Introduction vi

SECTION ONE: THE WAR IN OUTLINE

Chapter One The First Months 1

Chapter Two Dunkirk and the Months of Endurance ... 6

Chapter Three Marking Time 17

Chapter Four Preparing to Strike Back 22

Chapter Five D-Day Onwards 35

SECTION TWO: THE WAR IN CLOSE-UP

Chapter Six The Control Room 40

Chapter Seven The Docks (Part One) 50

Chapter Eight The Docks (Part Two) 68

Chapter Nine The Harbour and River Emergency Service 84

Chapter Ten The Lighterage Trade 90

Chapter Eleven The Royal Navy 101

Chapter Twelve Passive Defence 113

Chapter Thirteen Extended War in the Tideway 123

Chapter Fourteen The Towage Trade 143

Chapter Fifteen Salvage and Ship Repair 151

Chapter Sixteen On the Riverside 165

Chapter Seventeen The Army, Royal Air Force and Home Guard 173

Chapter Eighteen Aftermath 182

Selected bibliography 184

Index 185

Introduction

A BRIEF outline of the war in London's tidal river, as I was involved in it, has already been published*, so it is to be expected that in this longer and more detailed account there is some occasional overlapping. But what I saw and experienced were mere shadows of the greater story which for too long has remained untold. Again, some of the anecdotes have been repeated, because times when Cockney fortitude, humour and skill helped to repulse the enemy are very much a part of Thames lore and cannot be omitted from this more comprehensive version.

I undertook the original research in 1945 for a projected history of the Port of London at war. It was to embrace the Port of London Authority's contribution and that of the commercial firms and public utilities which are integral parts of the port. Also to be included was the story of the armed forces which operated afloat and ashore along the river during those momentous years. However, when the spadework was nearly complete, personal bomb stories had become two-a-penny and we were all anxious to forget the war. The history was laid aside.

Most Thamesmen who played a part in that epic, and who have survived the difficult post-war years, are now retired, but several of them have urged me to revive the plan for a detailed tidal Thames war history. They argue that generations who have never heard the sounds of bombs and crashing masonry or seen the glow of our burning cities and the leaping flash of gunfire are now deeply interested in what our generation had endured. Like most evil, war is fascinating—at a distance.

To those of us who went through the war and who will always have it fresh in our minds, it is a chastening thought that there are Britons of forty years, mothers and fathers of families, who have no first-hand memories of what this country, London and the Thames endured during those fateful years. For that reason, the more intimate stories of the tideway at war—the section entitled "The War in Close-up"—have been prefaced by five chapters—"The War in Outline"—which, while perhaps old hat to my generation of Thamesmen, may be necessary to set the scene for those latecomers.

The Port of London in 1939 was far more complex than it is today. Then it consisted of the whole of the tidal Thames, from Teddington to the sea, a distance of sixty-nine miles, five great enclosed dock groups owned and operated by the Port of London Authority (which was also River Conservator), and more than 150 independent riverside wharves.

*The Spirit of London's River, by L. M. Bates. Gresham Press, 1980.

vi

At that time, London was one of the world's three greatest ports, handling annually some sixty million tonnes of cargo and ninety million net registered tonnage of shipping. Docks and wharves were in keen competition for the berthing of vessels and the storage of cargo. Every port in the world was served, either directly or by transshipment, from London. In dock and wharf warehouses there was always a large and valuable concentration of imports awaiting delivery.

What a target for an airborne enemy! The estuary shoals and winding river reaches had protected London from most seaborne raiders through the centuries, but for an enemy plane the tideway was a flightpath straight to the heart of the port. Riverside wharves and enclosed docks were clearly visible, and German bombers made the most of them as landmarks.

The London and St Katharine Docks (Wapping) were this country's principal storage centre, with warehouses and vaults filled with many thousand tons of goods in almost every variety, nearly all barged up from the lower docks where larger ships discharged. At the India and Millwall Docks (Poplar) was stored much of the national supply of sugar, rum (more than a million gallons), grain and hardwood. The Royal Docks at North Woolwich had eleven miles of deep-water quay where the cream of British and foreign cargo liners regularly berthed. Warehouses at this group held tobacco while it matured (valued at £60 million, old money) and cold-air stores had a quarter-of-a-million carcases of frozen mutton; and ships with grain berthed alongside three large private flour mills. At the Surrey Commercial Docks (Rotherhithe) were centred London's provision trade and some half-a-million tonnes of softwood timber. At Tilbury Docks (Essex) the exotic products of India and the Far East, as well as London's then considerable passenger traffic, were handled.

The Port of London Authority's Board consisted of elected or appointed members representing all users of the port. But, although it had statutory powers, administration was fragmented, as, indeed, it remains. Towage in the docks was in the hands of the Authority, but towage in the river was contracted for by a number of private tug owners. Lighterage, an important pre-war feature of the port, was carried out by some two hundred companies, owning about 7,000 barges in daily use. Port health was administered by the City of London Corporation. The docks had their own police force, but the Metropolitan Police prevented and detected crime in the river. Pilotage, navigation marks and buoys were the responsibility of the Corporation of Trinity House. Different firms of stevedores loaded and discharged ships at the wharves and in some (but not all) P.L.A. docks. Gasworks, power stations and commercial industries, situated on the river banks, made full use of port facilities.

Port workers ranged from the most highly qualified professionals down to the man with a wheelbarrow.

At the outbreak of the war, these sometimes conflicting interests began to work together, and the following story is essentially about a degree of co-operation never before known in the Thames. Smearing our heroic past has become a popular theme for certain modern writers, and those who delight in pinpointing every wart, however tiny, may well complain that in this war story there are no villains; that "all the men were splendid". Certainly there were industrial strikes; there was pilfering (the worst of which concerned emergency rations taken from ships' life boats); there were planning failures; there were cases of human weakness in the face of mortal peril. But these murky ripples were submerged in the great tide of courage in adversity, inspired ingenuity, unstinting service and superb organisation by which the work and defence of the port were carried on.

There are not many great figures in the story, for it is mainly about ordinary men, men who turned out grumbling on Monday mornings, who went to work daily in uncomfortable, crowded and unreliable public transport, who often thought that "they" should do something about all manner of things; but who, when the enemy hammered at the gate, demonstrated—as they have demonstrated many times in the course of our national story—that we are a remarkable people.

Now that the port has fallen temporarily on hard times, I hope that this account of the most heartening period in the long story of the old river will help to revive any flagging belief in its future.

<p style="text-align:center">* * * *</p>

I am grateful to all those Thamesmen of long ago who, "bloody but unbowed" after nearly six years of total war, showed me their reports and files and told me their stories. I recorded their adventures but in those times, before the present personality cult came in, anonymity for all but the top echelon was the custom, and, alas, most of their names have gone beyond recall.

Among the few names in my tattered notes is that of Mr R.O. Tough, director of Tough Brothers of Teddington, and I am most grateful for his making available details of secret operations which have only recently been declassified. My warm thanks to Mr T.L. Mackie, M.B.E., a former officer of the Port of London Health Authority, who provided a valuable account of his experiences as a Gas Identification Officer at the Surrey Commercial Docks during the great blitz. I owe much to the late Charles Alexander, former managing director of W.H.J. Alexander, Ltd., who

lent me his Dunkirk evacuation log, one of his many spurs to my life-long interest in Thames tugs; and to the late Charles Braithwaite, former managing director of Braithwaite and Dean, for his account of the wartime lighterage school. Many thanks are due to friends and former P.L.A. colleagues for help and advice, Mr J.C. Jenkinson, M.V.O., Director of Administration, Mr G.E. Ennals, Secretary, the late Freddie Jones, who survived the Surrey Docks blitz, and Bram Evans, who typed most of the manuscript. Thanks are also due to the late Major W. J. Hodge, to Mr John Hockin and Mr Robert Rainie.

In the matter of wartime pictures, I am deeply indebted to Robert Aspinall, B.A., P.L.A. Librarian, and Alan Bazzone; without their sustained interest and help the illustrations in this work would have been very meagre. The kindness of the Port of London Authority, the Corporation of Trinity House, H.M. Customs and Excise, the Thames Water Authority, the Thames Division of the Metropolitan Police, the Royal Navy and Southend Corporation in supplying photographs is also much appreciated.

I gratefully acknowledge the kindness of the Port of London Authority in allowing me to use material compiled more than thirty years ago while I was in its service. Lastly, I record with gratitude the help of my talented wife who revived dormant editorial skills to pursue *non-sequiturs*, erase repetitions and deflate pomposities.

* * * *

Some of the Thames war story was told in my contributions to *Lloyd's List and Shipping Gazette* and *The P.L.A. Monthly* (now the quarterly *Port of London*).

Overleaf:
Members of the London Fire Brigade fighting a dockside blaze at the height of the "Blitz".

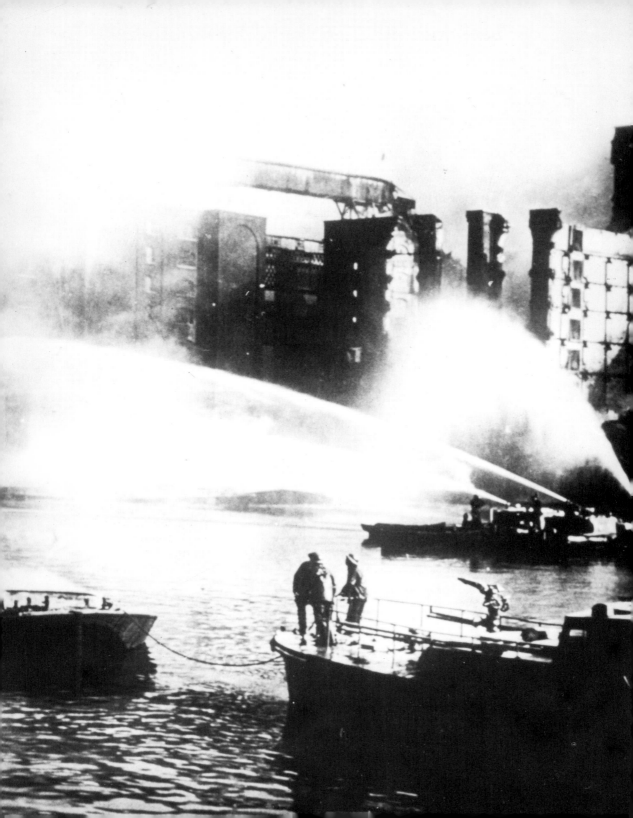

CHAPTER ONE

The First Months

CREWS of vessels entering the port on 2nd September, 1939—the eve of war—must have sensed that little hope remained of averting the conflict which had threatened Europe for so long. Outside the seaward limit of the port, the Navy was establishing guardships and the Naval Examination Service. Outward bound came most of the paddlers and other vessels of the London "Butterfly" fleet. The broad decks on which Cockney London had enjoyed day trips to the sea were crammed with frightened children, labelled like packages in transit. On both banks of the lower river, batteries were being manned and ammunitioned.

Along the middle river reaches, in dock and industrial areas, barrage balloon defences were being prepared. Within a short time, additional waterborne sites had been provided for this protection against dive bombers. Along the sixty-nine miles of tidal river*, other warlike measures were soon apparent. At their rallying points, men and craft of a recently formed River Emergency Service** were reporting for duty.

Passive defence organisations were being prepared throughout the port; fire, gas-cleaning and first-aid stations were already manned, blackout and stringent security measures were enforced by the P.L.A. Police at the docks, and by the Thames Division of the Metropolitan Police along the river. Strong detachments of Military Police were moving into dock premises, while men of the Royal Artillery were installing high-angle guns at locks and other vital positions. The Admiralty had already begun to use the docks for converting and arming many merchantmen and other craft requisitioned as auxiliary war vessels. Some of the dock sheds were crammed with pianos, panelling and other inflammable furnishings which had been hastily ripped out of the commandeered passenger liners.

To offset this influx of armed men, firefighters and other defence units, many port workers were reporting to the Services. In addition to the hundreds of reservists called up, others had enrolled after Munich in the special Dock Operating Companies of the Royal Engineers. These men were mobilised and took their experience to key ports in the many theatres to which the war ultimately spread.

In the Port Authority's monumental head offices on Tower Hill a

*The distance between the landward and the seaward port limits.
**Chapter nine.

reallocation of accommodation was taking place. In addition to staff leaving for the Services, many were preparing for evacuation to alternative offices and living quarters at Thames Ditton. An admiral and his staff and representatives of ancillary port undertakings had already moved into the P.L.A. Building, which became increasingly the headquarters of a co-ordinated port administration.

This, briefly, was the Port of London a few hours before the outbreak of war. The port knew that it would be attacked by a ruthless enemy; that to win the struggle, Hitler must—and undoubtedly

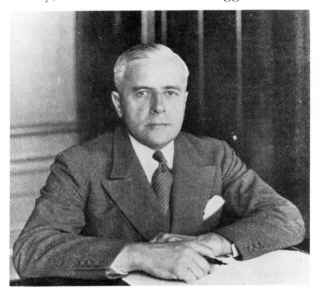

Mr J. D. Ritchie (later Sir Douglas), general manager of the Port of London Authority and chief executive of the wartime Port of London Emergency Committee.

P.L.A.

would—make every effort to destroy this nation's most important sea terminal.

Immediately war was declared, emergency administration plans came into operation. A scheme had already been evolved by the Port Authority at the Government's request to ensure continuity of its essential services in any national emergency. After Munich, this plan had been merged into the pattern of national policy for the wartime operation of all Britain's major ports. On 3rd September, 1939, all ports in the United Kingdom passed under the control of local Port Emergency Committees responsible to the Ministry of Transport. These committees were representative of the many and diverse interests comprising port services. In the case of London, the Port Emergency Committee's chief executive was Mr J.D. (later Sir Douglas) Ritchie, M.C.

In the early days, it was said to be a "phoney" war. The absence of

2

fighting on the Continent, the dropping of leaflets instead of bombs on enemy positions, German failure immediately to inflict on this country the anticipated air attack, and the general belief with the Prime Minister, Mr Neville Chamberlain, that Hitler had "missed the bus" encouraged the popular idea that "phoney" was an apt description.

But all those connected with the sea and ships knew that a relentless struggle had begun. There was nothing "phoney" about either the sinking of the s.s. *Athenia* a bare nine hours after the declaration of war or the other assaults which began on our sea communications.

London port workers had other reminders that war had begun in earnest, for within a few days the Thames scene had changed perceptibly. Many of the ships of famous lines which in some cases had berthed regularly in certain docks for more than half a century were diverted to other ports. Some were sunk. Ships which were almost placenames, so often had they used the same quays, were taken over by the Navy. Ships built and equipped for, and always associated with, special trades lost their individuality and arrived with general cargo. Strange ships, unfamiliar visitors to the Thames, occupied some of the berths vacated by the "regulars" and discharged strange cargoes not often seen in the tideway. Hardly ever before in the port's history had routine been so effectively routed.

At the dock and riverside quays and wharves, the normal methods of cargo dispersal were undergoing a similar transformation. Over many years each trade had established its own smooth-working methods in which the Authority and other port undertakings had co-operated. Food rationing, based upon supplies landed at the ports, diverted most of these normal channels of dispersal, and both importers and port workers had to familiarise themselves with a new routine. Their problems were not lessened by the increasing reserve supplies pouring into the country, but nowhere was the voice of the Luddite heard.

Further indications of active sea warfare were the large numbers of prize ships with contraband cargo sent in by the Navy. The Admiralty Marshal requested the Port Emergency Committee to handle these goods according to their destinations. Most of this cargo was lightered to transshipment berths and railheads, some was delivered direct by road or rail, and a proportion was stowed in dock and riverside warehouses.

At the same time, port transport was called upon for another duty. Before the war, it had been decided to disperse some of the stocks of foodstuffs warehoused at the docks and wharves immediately the emergency arose. Meat, dairy produce, grain, tea, sugar, rice, fats, oils etc., were normally held at the docks in huge quantities. A substantial proportion was now carried away by road, rail and inland water

transport. In a number of safe areas, "Buffer" Depots for foodstuffs and reserve storage depots for vulnerable raw materials were set up, many of them administered by skilled Port of London staff.

It was during this period that a steady demand arose for tugs and barges for the overside discharge of damaged ships seeking safety and repairs in London River, and this demand continued through most of the European war.

The salvage of ships sunk or damaged within the port limits is a normal commitment of the Port Authority and an efficient mooring and wreck raising service is maintained for this purpose. With the onset of war, the Admiralty had asked the Port Authority to extend its jurisdiction, so far as salvage was concerned, to areas then outside port limits, placing in return more salvage craft and gear at its disposal. The P.L.A. set up a new Salvage Department to cope with these extra duties; the story of its achievements is told in detail in a later chapter.*

With all these activities added to the burden, what remained of normal port routine was being carried on. London watermen, for instance, were still using the sweep of the tides for their vital work, but night navigation had become something of a nightmare. Many leading lights had been extinguished because of blackout regulations, others were dimmed, shaded or replaced by orange lighting. Arc lamps on wharves and quays, the glow from waterside taverns, factory chimneys silhouetted against shore lights and all those other familiar marks by which night river traffic had taken its bearings were now snuffed out.

An old and probably apocryphal story is told along the tideway about a tugmaster who brought his craft upriver through a thick fog by the use of his nose — by bearings obtained from familiar smells and stinks wafted from well-remembered gasworks, soap works, sewage works, chemical factories, and so on. Such a feat, even if basically true, was as nothing compared with the task of bringing down a tail of laden barges through the blackout on a winter's ebb tide, dodging bridges, piers, ships and craft, tiers and other obstructions which appeared either as mere patches of blacker darkness or which were so dimly lighted that nothing was visible a few yards away.

In November, 1939, Hitler produced the first of his secret weapons, the indiscriminately sown magnetic ground mines laid by aircraft. He chose for its testing ground the area which for him was the most important to immobilize, the Thames estuary. Thence onward, through-out the whole of the European war, German aircraft peppered the river and its approaches with this and other types of mine. Night after night, the guns of the estuary land defences and those of the patrol craft

*Chapter fifteen.

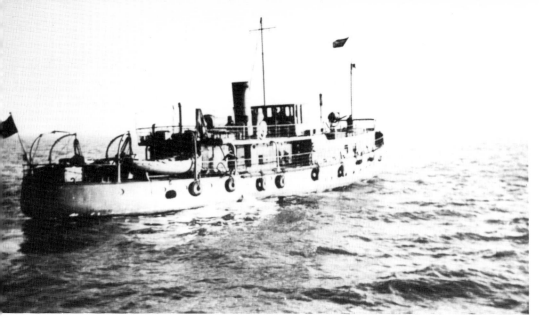

Armed with a six-pounder gun, the former P.L.A. survey vessel *St Katharine* served in the estuary as a unit of the Navy's Thames and Medway Examination Service. She is now among the historic ships preserved in the St Katharine Dock.

provided a reception committee for the aerial minelayers. The P.L.A. survey vessel *St Katharine*, then under the White Ensign, was one of the first, perhaps the very first, ship to open fire on these pests. Each dawn and, later in the war, each night saw a string of minesweepers leave Gravesend and Sheerness to clear the channels. For the first few months of this minelaying campaign these weapons were confined to the estuary and seaward approaches, but they were eventually sown in the very heart of the port.

Requests for craft by the British Expeditionary Force on the Continent and a vigorous drive to enlist Thames watermen in the Inland Water Transport Section of the Royal Engineers were handled by the Port Emergency Committee through its Lighterage Executive. The provision of old barges to block any breach made in the river walls was another duty of this body. Such a breach caused by the bombing of Teddington Weir was successfully stopped by this method. The attack may have inspired the immortal Dambusters of the R.A.F. who, at a later stage in the war, showed how this sort of situation could be exploited against Germany.

Up to the spring of 1940, the tideway endured on the whole a fairly quiet, irritating sort of war but one which could by no means be described as "phoney". Much worse was to come.

CHAPTER TWO

Dunkirk and the Months of Endurance

WHEN the dramatic signal "B.E.F. evacuated" was made, the Thames found that many of its ships and craft had achieved immortality, that some were battered wrecks on the dunes and shoals across the narrow sea, that some would never return. With these were coupled the names of Thamesmen who also failed to come back from the fateful beaches. Undoubtedly many feats of heroism and service in connection with "Operation Dynamo" have gone unrecorded, but some of the contributions made by the Thames will be remembered while the tides continue to serve London.

With the call to aid our hard-pressed army came a rare and invigorating sense of national unity. In the Port of London there was a resurgence akin to the Elizabethan spirit, and overnight came understanding of the nation's peril and a resolve to accept individual responsibility.

The broad outlines of the story of Dunkirk, the story of men old and young, professional and amateur seamen, those with no more sea experience than a trip to Margate, who at a moment's notice temporarily left civilian life to prove that "Rule Britannia" is something more than a patriotic jingle, are familiar to all. Not so familiar, perhaps, is the fact that the river provided most of the strange fleet of ships, yachts, tugs, barges and other craft which bore so many of our soldiers to safety.

The London Port Emergency Committee received the first warning of what might be required when the Admiralty took stock of the developing military situation across the Channel in the early summer of 1940. It was hoped, should the worst happen, that the Thames would be able to provide much help from among ships and craft always to be found in the port. Plans were immediately laid; few of those who worked with such a will during this preparatory period understood the purpose behind the activity. But when the evacuation was ordered, the Thames more than fulfilled the Admiralty's hopes and was one of the first areas to get into action.

Deep-sea ships, colliers and general coasters, private yachts, craft of all shapes and sizes, craft which had never before been out of the river, craft in which the embarkation of passengers had never before been contemplated, all got under way. A fleet of Thames sailing barges was assembled, their shallow draft and big holds being particularly suited to

the work. At least sixteen of them made the passage; at least eight failed to return. Keble Chatterton records in his *Epic of Dunkirk* that this was the first time since the Anglo-Dutch wars that spritsail-rigged vessels had gone to war.

The sixteen barges which actually made the passage were *Pudge, Lady Rosebery, Doris, Duchess, Thyra, H.A.C., Glenway, Lark, Spurgeon, Ethel Everard, Royalty, Tollesbury, Beatrice Maud, Barbara Jean, Ena,* and *Aidie.* Half of this gallant little flotilla was lost, *Lady Rosebery* sunk by a mine activated by her tug; *Doris, Lark, Barbara Jean, Duchess, Royalty* and *Aidie* beached and abandoned; *Ethel Everard* abandoned and set on fire. The adventures of their crews were fantastic and will for many years provide material for yarns in the creekside taverns where sailormen once foregathered.

Three other barges were abandoned but made miraculous reappearances. The strangest case was that of the Ipswich-owned *Ena*, anchored and abandoned in Dunkirk Roads; she must have taken a dislike to being left behind, for she sailed herself home and was found empty and comparatively undamaged on the Sandwich Flats. *Beatrice Maud,* also anchored and abandoned at Dunkirk, was boarded by some two hundred and fifty soldiers who, with no knowledge of the complications of spritsail rig, managed to sail her part way home, being picked up in the Channel and towed in some days after the evacuation had ended. Similarly, the *Glenway,* beached and also abandoned, was refloated and sailed to safety by nearly two hundred soldiers. Splintered and damaged to varying degrees, the remaining five barges returned safely, most of them bringing back a full load of troops.

An anti-climax to the loss of the *Ethel Everard* came after the collapse of the enemy when a German propaganda booklet came to light featuring a picture of her burnt-out hull and gear on Dunkirk beach, flanked by a claim that this was what happened to the British Navy when it tangled with the Nazis.

The famous fleet of Thames "Butterfly-ships" was there almost to the last vessel; the popular *Crested Eagle* was lost. The *Royal Daffodil* was bombed, machine-gunned and finally torpedoed, but brought back nearly 9,000 soldiers in the course of a number of trips; only grand seamanship saved her from foundering on her last run. The *Royal Sovereign* evacuated some 3,000 troops and an unrecorded number of stretcher cases.

Thames shrimping bawleys (the name of these craft is believed to derive from the boilers in which the shrimps are processed on the homeward passage), a sludge hopper, pleasure launches, an estuary R.N.L.I. lifeboat, a Thames fire float and motor barges went across.

Practically all the big ocean-going ship towage tugs were there; *Suns*, *Cocks* and other well-known craft worked unremittingly in Dunkirk Roads. Dunkirk is not an easy port to enter even in peacetime and it says much for the seamanship of these Thames watermen that they made passage undeterred by shoals, the absence of leading marks and lights, and under incessant attack from land and air. Even after all these years, one marvels at the tenacious courage displayed on such a grand scale.

Shipping companies, ship repairers, wharfingers, lighterage firms, railway companies, yacht yards and the Port Authority's staff, under the direction of the Navy, surmounted all obstructions. No fewer than 881 lifeboats from the shipping companies and other sources and some forty motor yachts from the upper river reaches were collected and towed to the fitting-out depots. Food, water, lifebuoys, fuel and arms were delivered by all possible means from the nearest sources. And the small craft tugs kept the vital ship traffic of the port moving in the absence of the larger ship-tugs.

Men from every section of the port's varied industries and organisations fitted out and manned the little ships. Many of these men assembled and were briefed in the P.L.A. head offices, some of them still wearing bowler hats and armed only with umbrellas. One enthusiastic body of workers at a Thames marine engineering company hired a coach and arrived at a coastal depot ready to sail at once. On the Sunday near the end of the operation there was a sudden demand for ships' engineers, and a fleet of taxis was used to scour London's dockland for men who could operate a marine engine.

In addition to all this coming and going of men, ships and craft, the abnormal wartime routine of the port continued. It was a picture of activity which the river had never before seen; a picture of a maritime nation rediscovering its soul.

With the evacuation of Dunkirk and the fall of the Continent came the conviction that the invasion of Britain was almost inevitable. London and its port have been the prime objectives of all would-be conquerors of this country. Soon our air reconnaissances of Continental harbours showed that another and formidable attempt was being prepared. At the beginning of June, 1940, the Port of London House Group of the Local Defence Volunteer Force was formed to help defend the port. In common with other groups of the L.D.V. the movement gathered strength and developed into the defensive arm of the Home Guard. A

The sailing barge *Will Everard*, whose sister ship *Ethel Everard* was abandoned on Dunkirk beach during the evacuation.

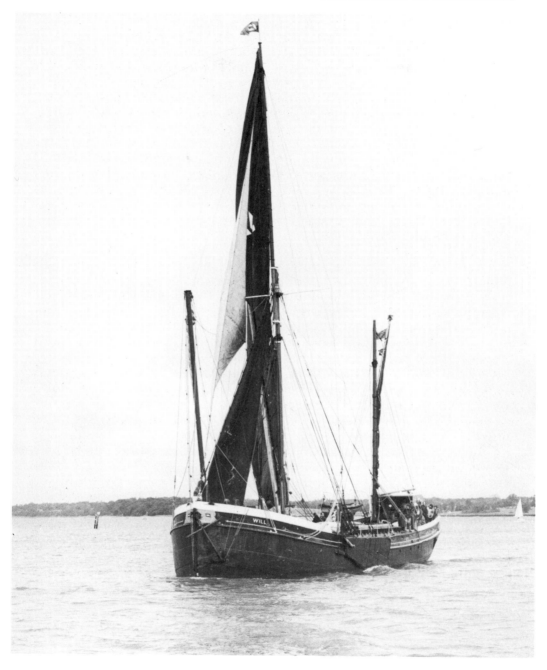

later chapter* describes the work of these Port of London volunteers; here it is sufficient to record that for nearly five years effort and comradeship were given unstintingly by a large number of port workers who, in addition to their daily work, devoted many hours and much energy to training and—the hardest duty of all—waiting.

For a short time after Dunkirk there was a lull while the enemy air force made new dispositions in the occupied countries. Then scattered raids began on out-ports and coastal areas, gradually penetrating inland, the Luftwaffe probing towards its main objective, the Port of London. Occasional minor night raids on the Thames gave London a foretaste of things to come. The London Port Emergency Committee used this period to tighten its A.R.P.** and security organisations. A pointer to forthcoming events was the burning of the Thameshaven oil tanks on 5th September, 1940; a spectacular conflagration seen far out at sea for several days and nights.

On 7th September, 1940, on a fine Saturday afternoon, the major attack on this country began when some thousand enemy aircraft struck at the Thames and docks of London. Goering told Germany on that day: "This is the historic hour when our air force for the first time delivered its stroke right into the enemy's heart."

The German airmen took the traditional road of London raiders and followed the river up from the sea. Woolwich Arsenal and Beckton Gasworks were two of the many targets. All the dock areas, particularly the Isle of Dogs and Rotherhithe, suffered. In the Surrey Commercial Docks there was an immense fire which spread despite the efforts of the fire service. In other docks were several fires, each one with its own peculiar problems according to the commodities involved. Even the sunlight faded beside the glare.†

The enemy came back again that night, guided by the smoke and flames along the riverside. He continued to hammer at London, particularly at dockland, in an attempt to achieve a knock-out blow.

During those weeks the scenes in dockland were fantastic. Bombs and gunfire echoed up and down the river, people were machine-gunned as they worked, children were said to have been attacked on their way to school. Army gun sites, Royal Navy vessels and merchantmen in the port fired at low-flying planes whenever opportunity offered. In the autumn sky writhed vapour trails, while under them were the descending parachutes of British and enemy airmen. The river between Lower Hope Point and the Mouse became something of a graveyard for enemy planes.

*Chapter seventeen
**Air Raid Precautions
†Chapter seven

10

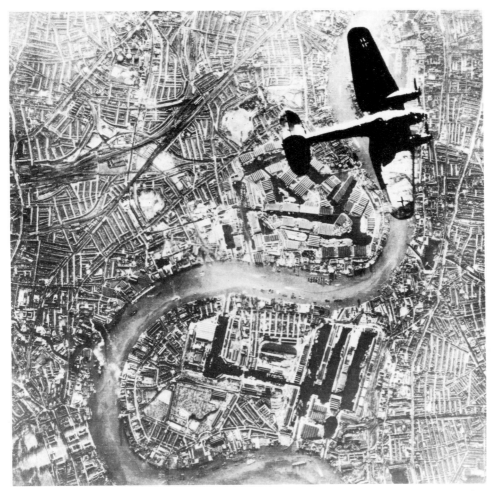

A Heinkel He.111 bomber over the Isle of Dogs, then the heart of the port, during a day-light raid. The great loop made by the tideway through Limehouse, Greenwich and Blackwall Reaches can be clearly seen. *Imperial War Museum*

From 7th September until 2nd November (fifty-seven nights) London, and principally the area served by the tideway, was under almost continuous aerial bombardment. This was the most searching test the Port of London had ever endured in its long history. Transport, communications, wharves and warehouses were destroyed or damaged.

Thousands of the dockland homes of port workers were demolished or rendered uninhabitable.

The broad outline principally pictures courage and endurance. On duty, port employees berthed ships, discharged cargo, operated tugs and barges and did their utmost to keep the port open. If their duty coincided with raids, they extinguished fires, saved valuable cargo and plant, rendered first-aid and performed other front-line services. Off duty, they assisted in digging their families and neighbours out of their ruined homes, took their turn as A.R.P. wardens or firefighters and then snatched what sleep they could. When the nightly glow over London paled before the dawn, they went, grey-faced and yawning, to their vital work. Who in Trinity Square will forget the gallant company of women office cleaners who, often while the raids were still in progress, travelled by devious emergency routes to their work?

The Surrey Commercial Docks ablaze during the sustained aerial attack launched by the Luftwaffe on 7th September, 1940. The stacks of timber blazed so fiercely that a "fire storm" was created, the flames being fanned by winds drawn in by the heated updraught resulting from the fires. *P.L.A. Collection, Museum of London*

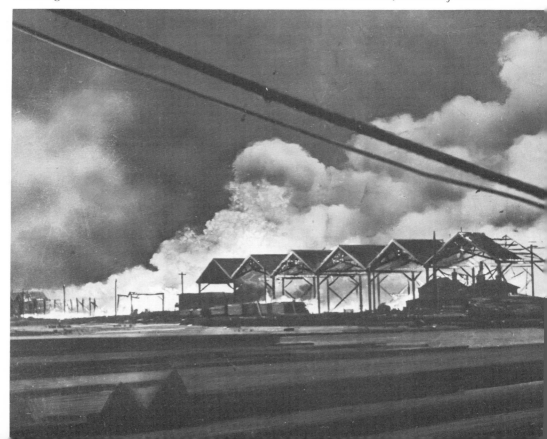

All Thames bore the heavy burden. Dock and river officers, police, clerks, tugmen, lightermen and stevedores grappled with the problems of being both soldier and civilian. Their hatred of the enemy spurred them to "take it" uncomplainingly, but their hatred was leavened by traditional London humour. One docker, piling sand in a strategic corner, announced that the Camel Corps would be landing soon and that he was creating a bit of desert to make them feel at home.

The women were equally resolute. When Mr Winston Churchill visited a devastated area on the borders of dockland, the homeless inhabitants cheered him until he wept with pride. "Give it 'em back" they cried.

No longer did watermen complain of the absence of navigation lights; night after night, their road was lit by the glare from burning buildings, by the flash of high explosive and incendiary bombs, punctuated by the fiery belch of guns. But here and there whole areas would be blotted out by immense banks of smoke and choking fumes, through which spurted jets from the hard-pressed firefloats.* To save the tide was ingrained in these watermen, and whenever possible they arrived at their destinations with their tows. Their determination, indeed that of all port workers, to carry on was not lessened by the anxiety with which they watched from their posts of duty great fires or explosions in those dockland quarters where they had their homes.

Although the Port of London suffered so heavily during this period, despite the destruction it was never within measurable distance of collapse. Indeed, many Londoners rediscovered the tideway as a main City highway, and one which was never obstructed by debris from blasted buildings, bomb craters or webs of fire hose. A river passenger service operated by tugs and launches was provided by the Port Emergency Committee through their Lighterage Executive on behalf of the London Passenger Transport Board. Conductors went along the decks clipping and issuing tickets as if modern commercial demands had imposed no break in the centuries-old continuity of the River Thames passenger traffic.

Early in 1941 the enemy began to shower parachute mines into the Metropolis. These weapons were so designed that if they fell upon factories, houses or land they became enormous (at least for those days) high explosive bombs. If they fell into the docks or the river they became magnetic mines which lay in the mud on the bottom until activated by ships or craft passing overhead. Hundreds of these pests floated down on dockland and several fell into the dock basins and into the river between Richmond and the Nore. Within a short time the Navy took efficient

*Chapter twelve

13

measures to counteract this menace.* But before then a number of ships and craft was lost in the tideway. Saddest of such losses was the s.s. *Lunula*, a fully laden tanker which set off a magnetic mine while shifting berth at Thameshaven. She had successfully eluded enemy aerial, underwater and surface raiders on her long voyage from the Gulf, only to come to grief at the end of her journey; ship, cargo, crew, jetty and tug went up in flames.

The many tugs in the Port of London are nearly all equipped with powerful salvage pumps. They had proved so valuable in fighting fires in ships and riverside premises that a River Fire Patrol was organised from among this fleet, operated by the Lighterage Executive in conjunction with the Harbour Service. Their duties were simply to patrol a section of the tideway during the night "alerts" and to assist in any way to keep the port open. They rendered invaluable service in keeping channels clear of burning craft.**

The lot of the port worker was lightened to some extent by the courage and unselfish work of the Women's Legion and other organisations which operated mobile canteens at the docks, several of them gifts from generous wellwishers in the Dominions and Colonies. The mobile canteens filled the place of those taverns and eating houses destroyed during raids on dockland and so helped to keep up the morale of port workers in the second winter of the war.

The strain caused by this long attack and the measures taken to minimise its effects drew the many organisations within the port to even closer working. The Home Guard included many men in Thamesside industry not necessarily engaged in direct port operation. Civil defence was intermeshed with the Home Guard, the National and Auxiliary Fire Services, the Navy, Army and police forces. Bridge lights for river navigation were controlled by the co-operation of the City of London Corporation and other authorities with jurisdiction over Thames bridges. Communications and the work of riverside public authorities were necessarily tied up with waterborne services. It was during this time that the London County Council (L.C.C.) laid the foundations of three temporary bridges designed to provide emergency communication between north and south banks at Westminster, Fulham and Chelsea in case any of the existing bridges were destroyed. Only one of these temporary bridges was put into use, and that only for pedestrians, but it was a wise provision, a public reminder to the citizens of London that we as well as the enemy could plan ahead.

With the increase of the air menace, ocean cargo carriers almost

*Chapter eleven
**Chapters ten and fourteen

ceased to use London. Ships from overseas discharged in other less vulnerable ports, and some foodstuffs and other necessities for the capital were brought into the river by small vessels which slipped past the front-line coasts at night. The main consignments arrived by road and rail, and large quantities of cargo were lightered from London railheads to the main distribution centre in the Royal Docks. Here was a complete reversal of peacetime procedure; rarely before had London watermen seen waterborne cargo being taken in quantity *from* instead of *to* the railhead.

In September, 1941, measures adopted to combat the incessant mining of the port approach channels culminated in the construction of the first "Maunsell" forts, launched at Gravesend. These towers of concrete and steel were designed by and took their name from a well-known civil engineer, Mr G. A. Maunsell. Four of them were built for the Admiralty, and they were towed to various strategic shoals in the outer estuary and sunk in carefully surveyed positions. The designer personally supervised the sinking of each fort; and several different port services contributed to the undertaking. The most northerly was on the

The most northerly of the forts built in the Thames Estuary to guard the approaches to the Port of London, the Roughs Tower, seen after it had been abandoned by the Admiralty.

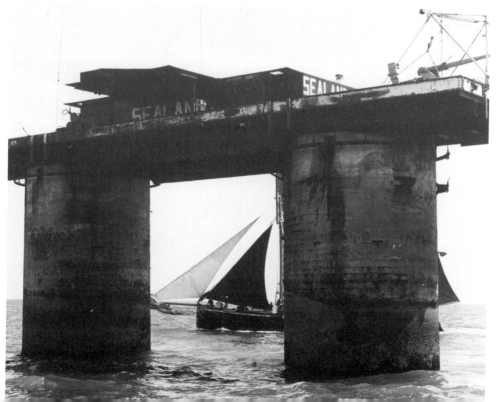

Roughs Sands off Harwich, the others being the Sunk Head Tower on the Sunk Sand, the Tongue Sand Tower and the Knock John Tower.

Each fort had a huge, flat-bottomed concrete base. In the case of the first four, two hollow concrete towers, each about 80 feet high and 20 feet in diameter, were built on each base. They incorporated an electric lift and accommodation for about 140 men, signallers, guns' crews and others. The two towers supported a steel platform weighing 650 tons well above the surface of the sea. Much the same routine as that of a warship was carried out.

Soon after these Admiralty forts had been installed, a passing destroyer was seen to hoist a flag signal which, when decoded by the

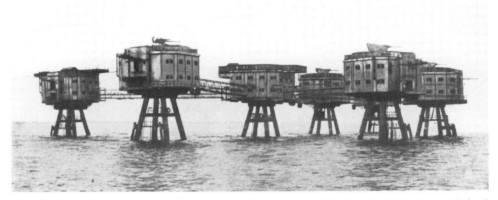

The Great Nore Tower, one of the estuary forts manned by the Army, was established approximately on the former site of the Nore lightship, first placed on station there in 1731. The fort was damaged by a vessel which struck it in thick fog after the war, and was eventually demolished. *P.L.A.*

Naval signallers in the nearest fort, read: "And how are the little princes in the tower this morning?"

Later three forts of a different design were constructed at the Nore and on the sands in the mouth of the Thames. Each fort consisted of seven circular towers, connected by flying bridges. These three forts, at the Nore and on the Shivering Sands and the Red Sand, were manned by the Army.

On all the forts, radar (then in its infancy), heavy and light anti-aircraft guns and other weapons and devices were used to detect and deter minelaying planes. Their efforts were highly successful for, in addition to destroying a substantial number of enemy aircraft, their presence led to a marked decline in estuary minelaying.

CHAPTER THREE

Marking Time

I N THE early summer of 1941 the Luftwaffe gave up the attack. What was at first thought to be merely a lull in the enemy's mass air offensive against the Thames was in fact the end of piloted raids in major strength. Although many of the main ports and towns of the British Isles had been battered throughout the winter of 1940/41, the greatest and most prolonged assault had been concentrated on the Thames tideway.

There was as yet, however, little relief in the Estuary and at the approaches to the port from the attentions of bombers, minelayers, E-boats, U-boats and long-range guns. Something like a state of siege prevailed with only a small proportion of the port's normal shipping arriving and departing. During the first year of the war, four and a half million tons of shipping had been lost, much of it normally berthing in London, where by the end of 1941 the traffic was reduced to one quarter of its normal figure.

The authorities were by no means convinced that the enemy had finished with attempts to destroy the port and so further dispersal of the still substantial contents of dock and riverside warehouses was ordered. But London's stock of flour could not be taken too far away, since accessibility was nearly as important as safety. The Port Emergency Committee therefore asked its Lighterage Executive to prepare a barge storage scheme. Hatched barges, loaded with large stocks of flour, were towed to moorings scattered between the Pool and Teddington. Regular attention to ventilation was, of course, important. The advantages of this scheme were that flour was no longer concentrated at one vulnerable point while, in a serious emergency, distribution to any particular area could be quickly arranged simply by beaching a flour barge at the nearest suitable place. It is worth noting that throughout the tip-and-run raids and the later attacks by robot and rocket bombs none of these barges was lost.

With the end of sustained raiding and with reduced shipping activity came an opportunity to clear up the battered docks. A rueful task was the sorting of debris from ruined dock and riverside warehouses and the salving of anything likely to be of use. This was one of the grimmest periods of the war when every ounce of foodstuffs and material counted.

During the great air attacks, the long ranges of sugar warehouses at the West India Docks suffered severely; some 75,000 tons of sugar was

involved. Most of it was buried in burnt and crumbled buildings. Working in gumboots and protected by overalls, men shovelled a syrupy mess of sugar, rubble and debris into casks which were shipped away to refineries. By skilful treatment approximately 61,000 tons of sugar, fit for human use, was recovered.

Tobacco was another commodity which yielded some useful salvage. Sixteen tobacco warehouses had been destroyed with a potential loss of 34 million pounds weight of leaf. A quantity suitable for manufacture into cigarettes and pipe mixture was recovered, and several thousand tons of tobacco too much damaged to be of use to the tobacco companies was sent north for the extraction of nicotine. The remainder, completely ruined, was treated with lime and sent away to be used as fertiliser.

An approximate total of 600,000 tons of foodstuffs in London's dockland warehouses was damaged by bombs. About 480,000 tons were recovered, fit either for human consumption or for other useful purposes.

The results of the drive for scrap metal to serve munitions factories became evident in London's docks. Some 250,000 tons were shipped from the London & St Katharine Group to the smelting towns in the North-east, steamrollers and baling presses being used to convert these unwieldy masses into suitable shapes for loading. More than three hundred coasters were engaged in this traffic from the Thames.

Large quantities of rubble that had once been London homes and factories passed through the port to further the Allied cause. During 1941/42 some 70,000 cubic yards of rubble were taken round the coast by Thames sailing barges to serve as hardcore for construction of vast new airfields in the Eastern Counties and elsewhere. Altogether about a million tons of rubble were handled by Thames craft during the course of the war.

An important event was the opening of a cross-country oil pipeline from west to east. To avoid the obvious dangers of bringing oil into the river by deep-sea tankers this pipeline had been constructed from Avonmouth, across the lap of England to a terminus at Walton-on-Thames. Tankers which had escaped the hazards of the North Atlantic were able to discharge their cargoes on the West Coast and the oil was pumped across country to Walton-on-Thames; it was from this point that the Port Emergency Committee was asked to co-operate. Through the agency of the Lighterage Executive, representatives of the four principal petrol lighterage companies formed the Walton Committee to operate the distribution and delivery organisation. It collected a fleet of tank barges, some from the London tideway, others coming with their crews from the Humber. With these craft a regular service was arranged, oil

loaded at Walton being taken downriver to be distributed to depots at the direction of the Petroleum Board.

The operation was not without its difficulties. Above Teddington Lock the river ceases to be tidal and during the winter certain reaches were then liable to extensive flooding, giving low clearance under some of the bridges. It was said in some quarters that the barges were bound to be held up for days at a time but, fully aware that the success of the scheme depended upon a regular and unfailing delivery by the barges, the Walton Committee persisted with its plans. The rains and the winter floods came but the ingenuity of the committee and the skill and tenacity of the watermen who handled the craft overcame all obstacles; London and the Southern Counties never failed to receive their allotted supply of oil. There was, too, the additional hazard of spasmodic air activity, while there was no guarantee that the tugs and petrol tank barges would not find a mine in their path. The enemy made a deliberate attempt to cut this supply in February, 1944, by bombing Richmond Lock, and the damage inflicted slowed down the supply of oil for a short time.

All through this difficult siege period much of the usual port traffic was diverted to the Clyde Anchorages Emergency Port. As its name implies, this was an emergency harbour for overside discharge; it was planned early in the war and began to operate when the heavy London raids increased the risks to shipping using the Thames. Although at the other end of Britain, it was almost an annexe to the Port of London since the management and executive staff, most of the stevedores and port operatives and much of the equipment, including some 300 barges and other craft, had been transferred from London.

The distribution of cargo involved careful planning, as there were no quays or sheds available for holding goods pending delivery instructions; it was therefore necessary to decide before each consignment rose from the ship's hold what route it was to take; whether coastwise, road or rail.

When the main air attack on this country ceased and ships again began to use the more vulnerable ports, the Clyde Anchorages became predominantly a terminal for large troopships. A regular ferry service was maintained between there and the U.S.A. by the *Queen Mary, Queen Elizabeth, Aquitania* and other well-known liners.

During five years of operation the Clyde Anchorages dealt with nearly two thousand ships, more than two million tons of cargo and more than six million packages of military supplies.

The steady drain of London port staff into the three services continued, with many more joining the Dock Operating and Inland Water Transport Companies of the Royal Engineers. Recruitment of

these companies from dock and harbour workers was an unqualified success. The Thamesmen quickly demonstrated their ability and adaptability, and many reached high rank. London dockers who were working in North Africa for the Alamein build-up were gratified to receive a typical Churchillian message from the War Premier during his visit to that front. It read: "Great work—you are unloading history."

In March, 1942, the National Dock Labour Corporation, a statutory body devised to provide greater mobility of port labour, came into operation. The Corporation took under its control all labour registered under the generic title of Port Transport Worker at most ports. It had, temporarily, powers to withdraw workers from ports not fully engaged and to draft them to other ports where ship discharge was held up by shortage of labour. In return the docker for the first time became decasualised and received a guaranteed minimum weekly wage.

It was during this period, in the spring of 1942, that the Port Emergency Committee received a request from the Admiralty to provide one thousand barges for an undisclosed purpose. By this time ocean

Two spritsail barges transferred from the Thames to work in the Clyde Anchorages Emergency Port lying on the south wall of Kingston Dock, Glasgow.

Dan MacDonald collection

traffic was beginning to return to the Thames and the lighterage trade was in need of some of the hundreds of craft already surrendered to the services and to other ports. But a hint that they were to be converted forthwith for beach work was enough; the lighterage trade selected the barges, levying on each operator according to the size of the fleet.

The conversion programme was begun at once, being carried out principally by the barge building and repair yards on the Thames banks. The craft were provided with concrete and plastic armour; they were engined; movable ramps were substituted for the after swim heads and budgets; and other necessary alterations were made. When the work was finished each craft in the flotilla was sheeted and quietly disappeared, bound for a South Coast rendezvous.

Afterwards it was reported that they had once or twice manoeuvred in the Channel and had so successfully bluffed the enemy that he had kept back many divisions on the Continental coast at the time his hard-pressed generals were pleading for reinforcements in Russia. It is not too much to claim that the bluff carried out with the aid of these Thames craft contributed to the turn of the tide on the Eastern Front. As will be seen in the next chapter, bluff was only one factor behind the conversion of this great fleet. The collection, fitting out and delivery of these barges, arranged by the Port Officer appointed for Admiralty liaison duty, involved more than 2,600 movements of craft.

Following the loss of so large a proportion of its fleet, the port awaited the almost inevitable request for men; inevitable because the handling of bluff-bowed barges is not normally included in the Navy's seamanship training programme. The request was made soon after the barges had been taken over by the Admiralty and a recruiting campaign was launched among the Thames watermen. No one was allowed to voice the general surmise that the recruits would be required to man invasion barges, and volunteers were called forward for special short-service work of a secret nature. Under this scheme about 750 men quitted the tideway for wider waters.

The long lull between the end of massed enemy raids and the build-up for the invasion of the Continent was a difficult period for the port. The spirit of Dunkirk and the comradeship engendered by the bombardment were hard to keep alive during a dull and rather monotonous time of waiting. Hope deferred is a hard trial, and there was as yet no foreseeable end to the world struggle. But time is a great equaliser and the port which had suffered most was to be permitted to contribute most to the downfall of the foe.

CHAPTER FOUR

Preparing to Strike Back

A NEW and singular phase of war began in the Port of London during the summer of 1942. The enemy had nearly won by concentrating on novel devices and ideas, audacity and surprise. His parachute divisions, air troop carriers, fifth columnists, dive bombers, etc., had disorganised Allied plans for defence aimed at meeting conventional strategy. But when it was realised that we too must modernise, that we must invent or perish, this nation surpassed all others in devising and constructing new forms of defence, new weapons and ingenious methods of supply. The Port of London, with its wealth of light and heavy industries, was at the centre of much of this work, and a number of strange machines and appliances were invented, manufactured and tested between Teddington and the Nore.

The first of these was "Pluto" (operational title of the Pipe Line Under The Ocean), which ultimately supplied 172 million gallons of oil, at the rate of a million gallons a day, to the liberation armies on the Continent. The first suggestion of the need of this pipeline came early in 1942 from the Chief of Combined Operations, Vice-Admiral Lord Louis Mountbatten; he knew both the part which would be played by oil during the assault and the efforts which the enemy would make to prevent cross-Channel tankers from delivering it to our armies.

The Petroleum Warfare Department of the Government secretly approached a well-known Thamesside firm of submarine cable manufacturers and asked for some hundreds of yards of pipeline which was to be waterproof, hollow, flexible and of great strength. Within a fortnight of the order being placed this trial length of pipeline, known as "Hais" cable, was being tested in the Thames by a Post Office cable ship. The new cable passed its tests with every success and was then put into full production. First, enough cable was produced to lay a pipeline across the Bristol Channel both for further testing and for training the storage and pumping personnel. No cable ship was large enough to accommodate the length of pipe required for this lay, so the well-known Thames steamer *London* was converted to become the first "Pluto" cable layer; loading was carried out at the Tilbury Docks and later at the Royal Docks.

In April, 1942, it was proved that lengths of steel pipe, three inches in diameter and 20 feet or more in length, could be welded into any required lengths and could be wound on to a drum and pulled off

relatively straight, provided that the drum was at least 30 feet in diameter. A special factory was established in the marshland held by the Port of London Authority for future development at Tilbury Docks; roads, rail tracks, etc., were installed. The steel piping, known as "Hamel", was manufactured in Scotland and Northamptonshire and delivered by rail to the new factory in lengths of 20 feet and 40 feet. Two lengths of the piping were welded together, the inside flashes of the weld being cut off and cleaned to prevent obstruction of the oil flow. Between four and five hundred hands, most of them beginning as unskilled labour, and specially designed machines and tools were provided for this work. The welded sections moved automatically out of the works, being halted to allow another pipe length to be welded to each of them. This process continued until 4,000 feet of continuous steel piping had been provided. Compressed air was then blown through to remove any dirt or other obstruction, and, as a last precaution, a projectile was fired by compressed air through the whole length of piping. Both ends were then sealed up, the length put into store until required and the process began again. About ten per cent of the steel tube supplied was tested by a specially designed bending machine.

Six steel drums, known as "Conums" (short for H.M.S. *Conundrum*), each weighing about 250 tons empty and about 1,700 tons with a full

A "Conundrum" in the Thames Estuary awaiting towage to European shores. Each of these carried some seventy miles of flexible pipe designed to carry oil to the Armies of Liberation. *Imperial War Museum*

load, were constructed and launched in the Tilbury Docks. Each drum (diameter thirty feet) had a capacity of seventy sea miles of steel piping. Two loading terminals were constructed in the Tilbury Docks where the drums could be turned by machinery, drawing a length of cable on to their axles as they revolved. A checking machine was installed to provide a light strain on the piping and to ensure tight winding. The piping was led on to the drum by a travelling gantry which moved from side to side to ensure even winding.

From this point the operation became a naval commitment, the drums being towed by Royal Navy tugs. It was originally intended that they would not tow in a wind of more than Force Three; owing to the urgency of the scheme they were sometimes towed in winds as hard as Force Six, and on one occasion during a blizzard. The dockmasters overcame the many difficulties of docking and undocking these huge bobbins, and they and other dock officers earned ungrudging praise for their contributions to the success of "Pluto".

Pumping and storage stations were installed on the South Coast and a few days after D-Day the first submarine supply of oil to the Continent began. Eleven "Hais" and six "Hamel" lines were laid, and there is no doubt that the liberation armies' superior liquid fuel supply system was an important contribution to the defeat of the enemy. "Pluto" was a true combined operation involving a large variety of commercial firms, Government departments, public authorities, institutions and the Services.

Shipbuilding, once an important feature of Thameside industry, moved to the north more than half a century ago, but craft building and ship repairing had remained and flourished in the port. During the spring of 1942 craft building began to increase, many new sites being established at the docks and at suitable places along the river. The vessels produced were diverse in size and type, but one feature was common to all; they were all designed for use in an offensive.

Wooden motor launches and wooden minesweepers were built by the score in Thameside yards; the wheel had indeed completed its circle when, mainly because of the danger posed by the magnetic mine, wooden vessels were again constructed on the Thames banks. Landing craft of different types were launched from what were normally repair yards and from emergency building sites at the impounded docks. New concrete and other types of barges began to gather in dock basins and at river buoys. In a well-known Teddington yacht yard, midget submarines were

The Army, the Merchant Navy and the civilian docker all co-operated to win the Battle of the Atlantic. *P.L.A.*

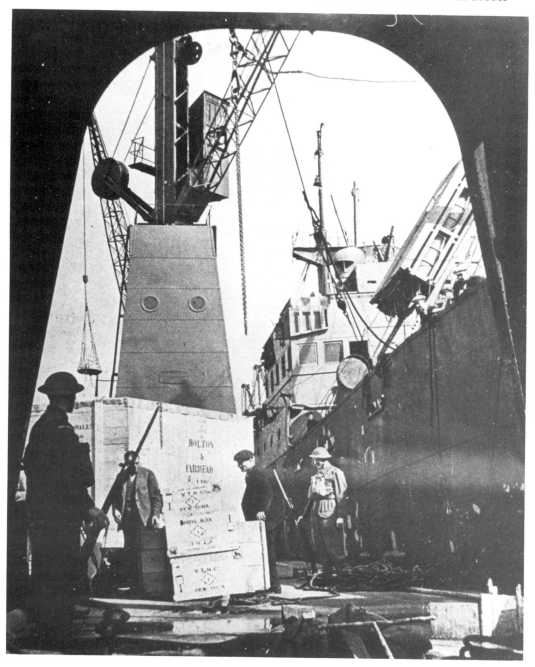

constructed; a wartime secret that only leaked out long after VE-Day*. Owing to a missing signal the trials of one of these craft were unheralded and so gave rise to a submarine scare in the tideway.

In the meantime, American ships had begun to appear in the port, most of them Liberty Ships fulfilling the Lease-Lend agreement. When D-Day loomed nearer they were followed by supply ships for the United States forces, and dockland's welcome to their crews was a substantial if unrecorded piece of Lease-Lend in reverse.

There were other signs in the port that we had drawn closer to the United States. American austerity locomotives were landed on to dock sidings, lorries bearing the legend "Left hand drive" crowded dockland roads, and the Cockney tongue was enriched with many western idioms. Reluctantly it must be admitted that another sign of the times was the rhythmical motion developed by young Cockney jaws.

At the beginning of 1943 the Port of London was busy with a series of training courses for Service personnel. The port's diverse facilities were admirable for this work and a number of technical schools developed at the docks and on the river; the practical lessons being given by port workers while engaged in their daily tasks.

By the summer of 1943 there were many signs that London was to be one of the principal springboards of the invasion of Europe. As the enemy became more and more enmeshed in the great Russian trap, it was felt that a full-scale invasion of Great Britain was less likely; road blocks and other defence measures in the port, likely to impede the great build-up of the Allied forces, disappeared.

Another indication that a climax was approaching came with a return to the tideway of most of the thousand craft which had bluffed the enemy so effectively. Some of them were handed back to the barge yards for reconversion into oil carriers, battery craft and, what were surely among the strangest vessels of the war, Landing Craft (Kitchen). These were beached with the assault troops whom they kept supplied with hot meals until more permanent cooking arrangements could be made. With a crew averaging twenty-six in number, ten of whom were cooks, these L.C.(K)s could provide more than a hundred hot meals at a time, sending food ashore in heated containers. Other ex-barges were held in the river by both the British and American forces for the transport of supplies. This flotilla went in with the second wave after the initial assault on D-Day.

Yet another indication of forthcoming events was a request to the port administration for representatives to attend a secret Government

*Chapter fifteen

26

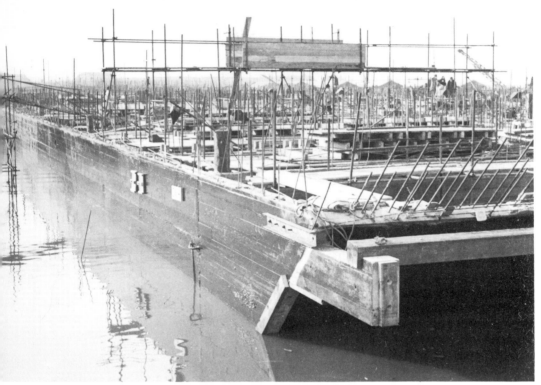

A Phoenix unit for the Mulberry harbour being constructed in a London dock. The construction of such items posed many problems for the men responsible.

Imperial War Museum

Committee, comprising all aspects of port operation, to advise on the working of certain Continental harbours after they had been recaptured.

Air raids on the Thames began again but they were mere nuisances compared with the devastating attacks of 1940/41, and were contemptuously referred to as "tip-and-run raids". They were, however, a timely reminder that the enemy knew of the preparations being made in the port and that he, too, was planning and preparing.

In the autumn of 1943 a new addition to the list of operational codewords began to be heard up and down the tideway; the word was "Phoenix", used in connection with the then equally mystifying term "Mulberry". Everyone now knows that these words shrouded the

planning of one of the greatest feats of unorthodox warfare since the days of Hannibal.

The following description of the design and construction of the "Phoenix" units came largely from the late Major W.J. Hodge, in peacetime a P.L.A. officer, who during wartime service at the War Office was in charge of the design of the caissons for the prefabricated harbour known as "Mulberry". He was created M.B.E. for his work. Another P.L.A. man, Staff Captain P.B. Steer, was also involved.

Many marine structures have been built in the past by means of reinforced concrete caissons—jetties, quays, dolphins and breakwaters—but never before had engineers designed and constructed six miles of them in six months for towing down the Channel for nearly two hundred miles. They were sunk on the sea bed off our own coast, then pumped out and refloated, towed across one hundred miles of open sea to the very foot of Hitler's western wall, and sunk again in predetermined positions to form breakwaters at the rate of nearly a third of a mile a day; all this in the middle of the most gigantic military operations ever undertaken.

In all, eight-and-a-quarter miles of caissons were built with a total weight of 1,014,000 tons. Of this huge task no less than five miles, weighing 668,000 tons, or two-thirds of the whole, were constructed in the Port of London. In addition many of the other concrete sections of the harbours were built in London. All told, the Thames was responsible for about seventy-five per cent of the concrete work.

The largest caissons had a water displacement of about 7,000 tons, equal to what was then a good-sized merchant ship. In fact, except that they were not fitted with engines but had to be towed, they were designed like orthodox ships. They had to withstand the same wave action and have the same stability in calm or storm: and they were shaped to give the lowest towing resistance and freedom from yawing under tow. Incidentally, it was found that swim ends, similar to those of the Thames lighter, were the most efficient for both these reasons.

The caissons had to suit two other conditions which do not usually concern ship design. They needed to be sunk under control without capsizing and without "planing" sideways and finishing up in the wrong place. They also had to remain stable on the sea bed and protect the harbour from the force of Channel storms. This, of course, was their principal function.

In early October, 1943, twenty-five civil engineering contractors were appointed by the Ministry of Supply for work on the breakwater caissons. Although even their design by the War Office had not been started until 1st October, this great work was so well organised that many

of these firms had actually started concreting the bottoms of their first units by the end of that month. Some of these contractors were working on as many as a dozen caissons at a time.

The ideal sites for construction were of course dry docks, and full use was made of all that were available. But these could not accommodate more than a fraction of the requirements and it fell to the Port of London to improvise facilities for constructing the balance, using dried-out wet docks and basins.

Two of the Port of London's wet docks, the East India (Import) Dock and South Dock, Surrey Commercial Docks, were dammed at their entrances and the dock water pumped out for the first time since these docks had been built over a hundred years earlier. Rubble from London's blitzed buildings was spread out over the bottom of the docks in strips sixty to seventy feet wide round the edges in reach of the quay cranes, and on these beds the caissons were built. Three-quarters of a mile of breakwater was constructed in this manner.

The contractors who undertook the work employed large numbers of Irish labourers. One harassed dock policeman at the Surrey Commercial Docks who had to check dock passes complained that all the Muldoons in the world were working there.

The "basin" method of construction was the most interesting and most complex of all from an engineer's point of view, but it proved a success and was the means of providing over three-and-a-half miles of breakwater. Shallow basins were excavated in open land on the banks of the Thames and in the Surrey Commercial Docks, and in these excavations the caissons were constructed. The earth dam between the basins and the river was then removed and the unfinished caisson floated out at high tide. These excavations could not be dug very deep before striking the ground-water at high tide, however, and they were so shallow that on breaking down the dam at high water spring tides there was only eight feet of water in which to float out.

The basins were used several times, and after each launching the entrance cuts were made good by steel piling which had to be withdrawn and redriven. The foreshore had, of course, to be deepened to the basin level. There was neither time nor plant to dredge, so the National Fire Service was brought in to clear the mud with their hoses under pressure. One basin provided five building berths, the inner one being 1,000 feet from the river bank.

The problems connected with floating out partially completed hulls from the basins (Stage One) were numerous. Those responsible were told that once a unit floated it must not be allowed to ground again as in its uncompleted condition it would break its back; consequently in basins

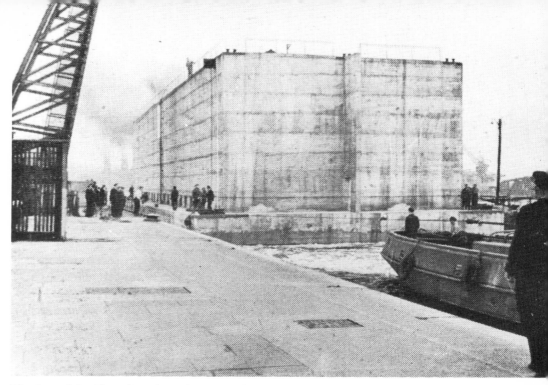

The last of the Phoenix units to leave London passing through the King George V Dock entrance lock. Handling these ungainly concrete units provided unusual difficulties for tugmen, dockmasters and others. *P.L.A.*

where two units were under construction at once, one was flooded to keep her steady while the other was floated out. The former was then drained during the following low water and, with flood valves closed, floated out on the next tide. After a little experience it was found possible to float both out together.

The floating out could not be done during neap tides. In practice, only on some five days during spring tides was it possible to do the work, and even then the closest watch had to be kept on each tide. Everything, of course, was based on prediction; a tidal curve was drawn up each time and if the tide was found to be early and falling short of prediction the work had to be hurried forward. Owing to the small depths of water in the basins and entrances only very shallow-drafted tugs could get close enough to make fast tow ropes. The problem was to find a powerful tug with a small draft capable of moving the basin-built units, which were about 1,500 tons deadweight; eventually one was found and did excellent work pulling many units in Stage One condition to the larger tugs standing by in the river to tow them to dock for completion. In some

cases this journey was full of difficulties for the pilots and tugmasters, and sometimes the trip took several hours, wintry weather making work even harder. The pilots—Thames watermen—who took them out deserve much credit. The entire operation was a matter of inches, minutes and prompt decisions.

The finished caisson drew about twenty feet and there could therefore be no question of completion in these basins; less than a quarter of the height could be built there so as to get out at eight feet draft. These partially completed units, little more than the "hulls" of the finished caissons and bristling with a network of projecting reinforcing bars, were then towed under the supervision of the P.L.A. River Department out into the river and into the wet docks, where construction was continued afloat.

One problem connected with this new method of shipbuilding was the need to add carefully calculated amounts of water ballast to the inside cells as the work proceeded, as much as 1,500 tons in the final stage. Without this the caissons would simply have broken in two and sunk in the docks.

As the caissons were completed they were fitted out with navigation lights, liferafts, crews' quarters, towing gear, emergency anchors (consisting of concrete sinker clumps), bilge pumps and all the equipment necessary for ships at sea. The lack of a bridge was a problem for the river pilot, who had to stand forward on a small platform and so received in his face all the smoke from the towing tug. The pilots of the Stage One units were at times better served; in some cases a tubular steel bridge was rigged with tarpaulin protection. The caissons had Bofors guns mounted on the top deck amidships to be ready to give effective A-A defence to the Normandy harbours.

They were towed away from the Thames by the Royal Navy, carrying a mixed company of sappers and seamen as well as the gun crews. The units were going down river from March, 1944, onwards, but there were no suitable moorings available near the D-Day assembly area. So these versatile "ships" were simply flooded and set down on the sea bed about a mile offshore to wait with the thousands of other craft for the great adventure.

Starting on the evening before D-Day, the flooding valves were closed and the Royal Navy salvage vessels came alongside. In a few hours the water was pumped out, the floating caissons were handed over to tugs and joined the traffic in "invasion alley" at the rate of about eight a day. The Port of London also played its part in this flooding and refloating work, for wreck-raising officers and salvage ships of the P.L.A. Marine Salvage Service were loaned to the Navy for these operations.

After VE-Day, surplus caissons were sent to the Netherlands to help plug gaps in war-damaged sea walls.

At the beginning of 1944 all Thames sensed that the supreme effort was at hand. War supplies in vast quantities were pouring into the port; warehouses and sheds were crammed, and higher and wider grew the dumps. Men-of-war, transports and supply ships were gathering in the three operational docks, Tilbury, Royals and West India, and at every river mooring. Great armed camps were being established in the vicinity of the port.

The naval and military planning for D-Day was a model of prevision and attention to detail. The landing of men and supplies on the Continent was by no means the only problem to be faced. The Port Emergency Committee was given a broad outline of the demands which would be made upon its services and was asked to submit plans to meet them. A vast and highly detailed scheme, involving a review of practically all port facilities, was drawn up.

Communications were overhauled and expanded. Special lighting at key points for night loading and embarkation was installed. Security measures were stringently tightened; no easy task considering the number of men employed at docks and wharves, the number of private tenants in dock premises, and the constant coming and going of ships, craft, road and rail vehicles. Advance information about drafts of some of the ships to be employed on D-Day helped berthing plans; dredging was carried out at certain points. Dock labour required for the emergency was a major problem; more skilled men were provided, a special "Western Front" agreement was made to ensure continuous loading of military supplies despite possible attack by enemy planes; meals and special transport for night workers were arranged. Anticipated demands for tugs and barges were reviewed and the towage and lighterage trades prepared for full co-operation.

Lockgates, cranes, conveyors and other equipment were overhauled; loading hards for mechanised and military transport, new bridges and new dock roads were constructed. Dock sheds were allocated to the Services and temporary huts erected for accommodating and feeding troops awaiting embarkation; washing and lavatory accommodation was provided for the vast numbers involved. Dock railway systems were warned to expect a daily maximum load of trucks; any hitch would have meant confusion and delay, for both before and after D-Day rail traffic flowed continuously. The fresh water supply at docks and certain riverside wharves was overhauled and special plans laid to increase delivery to the ships.

It was feared the enemy would make every effort to halt or delay the

project with a bombardment either by aircraft or by the long-range weapons which we knew had been installed on the Channel and North Sea Continental coasts. Passive defence measures in the port were tightened accordingly and the Services co-operated in protecting the numbers of men awaiting embarkation. The port engineers laid their plans for the repair of bridges, lockgates, dock roads and rail tracks in case this threat materialised.

The head offices of the Port of London Authority, housing the Port Emergency Committee, the Navy and other authorities, were a nerve

Lease-Lend cargo from the United States being discharged in a London dock.

P.L.A./Beckley

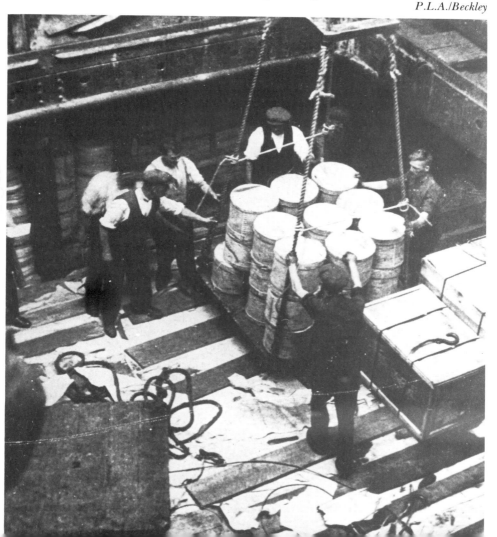

junction in this great effort and, to avoid the possibility of a knock-out blow which would have imperilled the whole invasion plan, alternative emergency headquarters were arranged, linked up with the existing communications network. The possibility of a desperate attempt by the enemy to land paratroops was foreseen and members of the Home Guard in the port, many of them key workers, were instructed as to when they should remain at their vital work and when they should assume the role of soldiers.

To avoid congestion of the shipping that gathered in the port for D-Day, and to make the fullest use of the accommodation, an organisation for the allocation of berths was created. Guarded warning was given to some of the private wharves on the riverside that they would be needed by the Services. The use of anchorage grounds and berths at river buoys together with facilities in docks and at riverside wharves and jetties were embodied in the preparations. Of great importance to the scheme was a pre-loading programme whereby ships would come alongside to load provisions, water, stores and fuel and then return to offshore berths to await the signal to sail. River pilots were briefed through the Trinity House Corporation. A temporary organisation was set up to control and utilise the services of dock pilots and boatmen.

The Port of London had by now given ample proof of both its powers of endurance and its capabilities. But no effort in its long history had been comparable to the task which it was about to undertake. It was decided to tell port workers generally just how high they ranked in the great plan. Through the agency of the G.P.O. all the docks and principal wharves were wired to a microphone in the Royal Victoria Dock and provided with loudspeakers. On 3rd March, 1944, General Montgomery went to the microphone and talked to more than 16,000 port workers. When he had finished the dockers dispersed to their work charged with a new belief in their role.

Marshalling for D-Day began on 27th May in London and 28th May at Tilbury; loading began in London on 30th May and at Tilbury on 29th May. Thence onwards the Port of London was stretched to the limit in dealing with military cargo in enormous quantities, with the embarkation problems of hundreds of thousands of men and their equipment, and with the unending needs of an armada. Coincidentally, the port kept London supplied with fuel, food and supplies necessary for the civilian population and Thamesside industries.

CHAPTER FIVE

D-Day Onwards

NEVER before in its recorded history had the Thames harboured such a fleet of warships and armed merchantmen as those preparing for D-Day.

An onlooker taking his stand on Minster Cliffs would have seen history in the making, not the subtle history of statesmanship and treaties but picturesque history with a meaning plain to all. From the docks and wharves upstream a steady flow of laden ships came down to gather at the rendezvous off Southend. There were deep-sea merchantmen, tugs, barges, oilers, landing craft of many types, joined in the anchorage by a flotilla of escort vessels. With them came a large fleet of coasters which had been waiting at anchor after taking in stores and ammunition at fifty-four dock berths well before D-Day.

Between Tilbury and the West India Docks the port absorbed men and vehicles in a continuous stream which flowed smoothly into the waiting ships. When "Overlord", the operational codeword of the day, was signalled the London suburbs and outlying villages awakened; many of them had long been army parks for the enormous number of vehicles to be embarked. From all directions the men and the vehicles now converged on these few miles of river, a seemingly endless procession of turning wheels and camouflaged bodies. Supply trains loaded to capacity almost completely monopolised dock and riverside tracks. Transports, landing craft and supply ships virtually queued up for a berth and when loaded withdrew to make way for the next vessel.

In a river where for centuries traffic had shuttled inward and outward according to tide, it was uncanny only to see ships departing. Most port workers were conscious of the drama of it all and co-operated with a cheer on their lips and a lump in their throats. Men too old to fight bought refreshments for the troops at dock canteens, and buckets of tea on the end of a line were hauled aboard departing ships. Not only was it one of the most impressive and picturesque occasions in all Thames's story, it was technically one of the most perfect undertakings in the history of the port; a triumph of organisation never achieved by the enemy in the heyday of his successes, especially when one considers the planning involved, the co-operation necessary between a score or more of widely different services and authorities, and the vast area covered.

On the evening of 5th June, 1944, all was ready. The great tide of

men and machines had subsided; the fleet had gathered at Southend. On the next day, 6th June, this twentieth-century armada sailed. There is no need to record here the success of the greatest military operation in our history. The Port of London played a major part worthy of its status as the principal port of the Commonwealth. Three hundred and seven ships sailed from London, carrying some 50,000 men, nearly 80,000 tons of military stores of all kinds, and about 9,000 vehicles. In spite of this magnificent effort, the port never flagged in its common round of keeping London supplied with food, oil and other necessities. The Thames soon discovered that it was not yet time to relax. To London fell the honour of becoming the principal base supply port of the British Army of Liberation as it fought northward. This period of sustained movement began in London and Tilbury on 6th June and proceeded

Preparing for D-Day: tank landing ships passing through a dock entrance in the Port of London. *P.L.A./Beckley*

according to plan for the first few days, but bad weather intervened and by the end of that week the aftermath of the great Channel gale became evident and ships returning for fresh loads were few. This tended to cause congestion in the port rail system, but the use of dock transit sheds and close co-operation on the far shore prevented serious confusion and helped to restore the schedule. In most cases ships loaded more quickly than the most optimistic anticipated and stowage was entirely satisfactory.

Of all the port's facilities, none contributed more to the success of the scheme than the P.L.A. Railway Department; details of its operations will be found in the chapter on the work of the docks*.

One of the most interesting and successful experiments was the Thames Turco organisation. This committee consisted of representatives of the four principal authorities interested—the Admiralty, the War Office, the Ministry of War Transport and the London Port Emergency Committee—whose duty was to implement planning for the "Turn round, combined operations." Primarily due to the work of this body, only one ship failed to catch her convoy out of the first five hundred sailings. It is on record that the five telephones in the Turco offices in the P.L.A. Building were rarely silent during sixteen out of every twenty-four hours, and that a daily average of two hundred signals entered or left this department. Co-operation from the fighting forces was not always easily obtained, for the eyes of commanding officers were on the far shore and the movement planning on this side sometimes appeared to them to be so much red tape.

Among the many other schemes put into effect was a fluid bunkering organisation to assist the quick turnround of supply ships. Some three hundred barges, contributed by the London lighterage trade, were loaded with 30,000 tons of fuel and held in readiness to be placed alongside any vessel at the shortest notice.

Between D-Day and 31st August, 1944, no fewer than 311,344 Service personnel and 123,443 military vehicles, and no less than 590,531 tons of stores left the port for the Continent. Just as the Port of London had been the hub of commerce in days of peace, it became the hub of total war in the triumphant stages of the struggle. The build-up of men and material during the long lull after the fall of Antwerp gave further impetus to this traffic.

Soon after D-Day the enemy introduced his long-range weapons, the pilotless plane and, later in the year, the rocket bomb. Once again the Port of London bore the brunt of this indiscriminate warfare. Offices, wharves, warehouses and dockland homes were again the principal

*Chapter eight

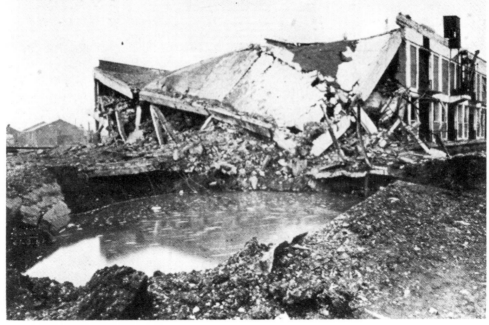

The result of a direct hit by a bomb on a reinforced concrete warehouse at the Millwall
Dock. *P.L.A.*

targets. Until the defences got the measure of this bombardment,
casualties and damage began to assume alarming proportions.

The enemy experienced much bad luck in these attacks on London's
dockland. One flying bomb destroyed No.10 shed Royal Albert Dock
just before a special train of thirty wagons containing high-octane petrol
was due to be placed alongside. Another destroyed No.4 shed King
George V Dock just after a coaster had left the berth with three thousand
tons of ammunition. Two direct hits were made on the Exchange Sidings,
Royal Victoria Dock, the heart of the port railway system, but the efforts
of railway workers, Army authorities and port engineers minimised the
interruption of traffic.

During the opening phase of the attacks by the V.1 pilotless planes it
was rare for port workers to hear or see less than half a dozen of these
weapons while they worked a shift. Generally speaking, they bore this
further trial with even more stoicism than had been shown during the
piloted raids and fewer man hours were lost to industry. But these
pilotless planes and the long-range rocket bombs appeared to unnerve
womenfolk more than the earlier form of attack and it did not help port

workers to be patient when across the Thames banks and warehouse roofs they saw these uncanny weapons fling up smoke and debris in the vicinity of their homes. They knew that, even if their families and houses had escaped death and destruction, terrified women and children would be anxiously awaiting the return of their menfolk.

On 22nd April, 1945, Tilbury was *en fete* when the first ship to reach London carrying former prisoners-of-war berthed at the Landing Stage. The men were met by an official reception committee and a military band, and by an unofficial committee of civilians outside the railway station barrier. After being given a hot meal, the men left Tilbury by a special train. It was a dramatic moment when the military reception party saluted and the band played "Auld Lang Syne" as the train pulled out of the Riverside Station.

The ordeal of long-range bombardment was practically the last of the tideway's trials. On 8th May, 1945, the enemy capitulated and the Battle of the Thames was won. London received the news soberly and gratefully and with little outward show. The port permitted itself a return to the old custom of celebrating a great event by the massed blowing of ships' whistles. Between D-Day and VE-Day 2,760,000 tons of military stores, ammunition, etc., including 202,000 tanks and vehicles, had been despatched from the port to the Continent. From September, 1939, to May, 1945, the Port of London accommodated more than 106 million tons of shipping.

Soon after the collapse of the enemy a tangible token of victory was sent to London in the form of *U.776*, one of the fleet of submarines taken from the enemy. It berthed at Westminster Pier, but the depth of water and the facilities for handling large crowds of visitors proved to be unsuitable. On 24th May it was transferred to a berth at the North Quay, London Docks, and was there thrown open to the public. Visitors included the Lord Mayor of London, admirals, and other distinguished spectators; but in greater numbers were the dwellers in London's dockland, the people associated with ships and the sea to whom the menace of the submarine had meant more than to many other civilians. Bad weather and long queues failed to deter them and more than 39,000 people boarded the craft and more than 147,000 viewed it from the quay.

For nearly six years the port had endured bombardment and the strain of being a front-line salient during one of the most ferocious wars in history. Future generations may assess the resistance and exertions of the Port of London, and the city and nation it serves, as not inconsiderable factors among many others in the final victory.

CHAPTER SIX

The Control Room

HOW THE port was operated and defended during its long ordeal can, perhaps, be best understood by joining duty staff in the Control Room of the Port Emergency Committee.

This room, in the P.L.A. head offices, was reasonably safe from all but a direct hit. The building was virtually a massive cube, occupying the whole of a City square, surmounted by an impressive tower. The central feature of the building was a rotunda claimed then to be the largest unsupported concrete dome in the world. The edifice was immensely strong but ornate to the point of being described by an irreverent journal as "Directors' Grecian".

There was a number of control rooms, manned by various organisations, situated in basement corridors, all specially strengthened by steel girders, protected from blast and splinters, and equipped with emergency lighting and other aids. The main junction of the port's communications links, the Control Room of the Port Emergency Committee had many telephone lines dispersed through different exchanges, some direct to dock and river headquarters, while others to the nearest gun sites were linked to the usual type of plotting table; these were particularly useful during the flying bomb phase. On the walls were large-scale sectional charts of the Port of London. In a corner was a portable emergency switchboard, part of the alternative network, ready to be brought into operation if the main installations were damaged. There were the usual camp beds, emergency foodstuffs, etc., but the piece of equipment most appreciated was the radio set.

In the vicinity of the general Control Room was the Supervisory Control manned by two senior officers responsible to the Chief Administrative Officer on duty. This room had a direct line to Regional Headquarters. Raid warnings and "all clears" were given by the standard colour system received over the public telephone circuit.

About a score of P.L.A. officers volunteered before the war to train as switchboard operators with a view to replacing women at night in the event of serious raids. A rota of these men was compiled for duty at the switchboard, their main tasks being to ensure the quick transmission of messages and the broadcasting of raid intelligence over the whole of the Port of London communications system.

What better date to choose for our vigil with the control staff than

7th September, 1940, the day which marked the end of the "phoney" war in this country with the first great air bombardment of the port?

It is a fine autumn Saturday afternoon, and the duty staff are rather wistfully regarding the sunshine from their office window and from the roof.

In the Dock and Traffic Department, men are engaged in various occupations; one is calculating piecework rates; another is compiling statistics of food stocks; a third, in the Shipping Section, is putting the final touches, with obvious relief, to the return for the Ministry of War Transport, compiled from the shipping lists. Another member of the duty staff comes in and sits on a camp bed under the window. It wants but a few minutes to 5 p.m.

A telephone beside the idler rings; he listens for a moment and then chants back to the operator, "Air raid message purple." Nobody is perturbed; similar messages have sent them fruitlessly down to the Control Room before and the novelty has worn off. But the leader quietly details two men to go below and take up their stations. As the two men unlock the door, a distant siren wails its warning and the telephone gives them: "Air raid warning red." Then a quiet "burr" and the flashing lamp calls the other man to the end of the room. "Hello, Tilbury. Planes passing over you? Anything dropped? Good!" Then follows: "Hello, India. Gunfire? I can hear it now in the Control Room."

The rest of the team are already at their stations, armed with shipping information and emergency instructions. In other parts of the building, the Engineer and his assistant, the Medical Officer and his orderly, staff of the Salvage and River Departments, the police officer and others are standing by their telephone extensions; they realise that this time the enemy will probably press home the attack. Already all five lamps of the dock lines are flashing as reports from Tilbury to Tower Bridge come in. At one corner of the Control Room, the Naval Flag Officer and his Chief of Staff are conferring with the Chief Executive— obviously pooling the news coming through their separate channels of intelligence.

The leader urges on his team manning dock lines and they scribble faster as the information comes through. Coloured pins marking the fall of bombs and the position of major incidents begin to spread across the large-scale charts. There is a sense of alertness and continual movement, but the movement is calm and there are no signs of confusion.

At this stage in the attack the worst "incident" had occurred at 5.10 p.m. when several bombs had fallen on ship repair workshops just outside the King George V Dock. The report had added with grim brevity: "Have requested ambulances."

By 5.35 p.m. more gunfire at the West India Docks and twenty-five enemy planes flying in a westerly direction, followed by British fighters, are reported. Five minutes later fires in the vicinity of the West India Docks are also reported by the dock staff. Four minutes later comes the news of more enemy planes flying west. Another message comes through at the same time stating that the Royal Albert Dock telephone system has broken down and that emergency lines are now in operation.

The next twelve minutes are almost entirely devoted to evil tidings. At 5.47 p.m. the Royal Docks report that the Upper Outer Lock Gate of

The former P.L.A. head offices on Tower Hill, which served as the wartime headquarters of the Port of London Emergency Committee and of the Flag Officer in Charge, London.
P.L.A.

King George V Dock entrance has dropped two feet owing to bomb blast; the lock wall has been badly shaken. At the time the s.s. *Glenstrae* was moving into the dock from the lock but is apparently undamaged. At 5.55 p.m. comes the news of bombs falling around the East and West India Docks system. A preliminary report of high explosive bombs falling on "E" Shed is followed by the account of a fire south of the shed. One minute later, the Empire and Millenium Mills, great dockside flour mills at the Royal Victoria Docks, are said to be on fire. Only one more minute passes before more H.E. bombs on the East and West India Docks and the failure of the lighting system there are reported.

At 6 p.m. Tilbury informs via Tower Pier that thirty planes have passed westwards and are believed to have hit Purfleet Oil Wharf. Simultaneously the West India Docks report a large fire in that dock system, exact position not as yet fixed, but believed to be due to a fallen plane. Next a fire report at the London Docks is followed by "Water main burst!" and a statement that a dock first-aid party is being sent to assist casualties aboard the s.s. *Bennevis* in the West India Docks. At the same time the staff at the East India Docks cheerfully proclaim that they are successfully tackling incendiary bombs with their own equipment.

A preliminary message from Surrey Commercial Docks about a large and unspecified number of fires engaging the attention of the local fire brigade and A.R.P. services causes apprehension in the Control Room; there are approximately half-a-million tons of softwood timber concentrated in these docks.

At 6.10 p.m. the West India Docks control thankfully telephones news of the arrival of reinforcements in the form of firemen with twenty-five fire engines and states that superficial damage has been done to the Superintendent's offices. The lighting system there is still out of action. Immediately afterwards the control comes through again with the news of fires at No.14 Shed East India Docks, and at the premises of a dock tenant. River intelligence then reports four burning coal barges drifting towards Woolwich Ferry.

For the next hour bad news continues to flow steadily into the Control Room and none of the telephones is silent for more than a few seconds. There are further bombs at the West India Docks and damage to one of the main roads in the Royal Albert Dock. The situation at the Surrey Commercial Docks appears to be getting out of hand and flames are spreading almost with the speed of a prairie fire, the efforts of the handful of firefighters having practically no effect. The Supervisory Control Room is in constant communication with Regional Headquarters, and fire brigades from near and far are on their way. The Harbour Service is asked to deal with more blazing, drifting barges which are

imperilling a riverside wharf. What proved afterwards to be a false gas-alarm jostles for place on the telephone line with a message regarding a timber fire at the East India Docks near a trawler laden with high explosive.

Dock A.R.P. staffs are now finding time to assist some of the ships which have been hit. Several serious casualties have already been taken off the s.s. *Bennevis* in the West India Docks. Assistance is being given to the s.s. *Inkosi* on fire in the Royal Victoria Dock and, in the same dock, to the s.s. *William Cash* which has been bombed and is sinking. A report from s.s. *Gothland* that she is cradling an unexploded bomb is promptly passed to the Naval Duty Officer.

Down in the bowels of the huge building, shaken from time to time by muffled reverberations, the duty staff stick grimly to their work. The atmosphere is stifling; they have no time to seek a breath of fresh air, no time to watch the smoke and glow in the eastern sky which pales the afternoon sun. All sections of the port are in action; Woolwich, Millwall, Greenwich, Shadwell, Limehouse, Rotherhithe, Blackwall, Silvertown and, in fact, areas all the way down the river as far as Tilbury and beyond. Fire forces are directed to major conflagrations; the lesser fires are left to luck and what attention can be spared by the hard-pressed duty staff at the docks.

Appeals to the Harbour Service for tugs and launches are made on behalf of riverside premises and ships and craft in trouble along the river. Reports of the mounting damage to dock and riverside installations are piling up on the desk of the Duty Engineer; at this stage he is interested only in vital damage to key points, and his staff is planning first-aid to lock gates, dock walls, bridges and other equipment, the destruction of which could cause a major disaster. Ambulances and medical help are moved about dockland as the telephone dictates. All night long the great fires rage in the Surrey Commercial, West India and Royal Victoria Docks. These fires were among the most spectacular disasters in the long Battle of London*.

* * * *

So it went on throughout the night. There was a lull between the afternoon and the night raid, but there was no lull in the stream of reports pouring into the Control Room. When the enemy airmen ceased their night's work, reports came in as fast as ever—delayed action bombs here, lock gates requiring repair there, damaged warehouses everywhere, enormous fires still raging, port workers killed or injured, communications and lighting still out of order. Hundreds of cases of

*Chapter seven

minor damage were not reported until late the next day, but between 5 p.m. when the raid began and 6.15 a.m. the following day some 120 serious "incidents" were reported to the Control Room. The outgoing calls demanding assistance and ordering improvisations were nearly as heavy. More than sixty major "incidents" occurred along the river banks within the purview of the Port Emergency Committee; over sixty craft were sunk or destroyed in the river.

That night's work was repeated to a greater or lesser degree on nearly every night for the next two months and at scattered intervals for the next five years. The heaviest night in the Control Room was on the 19th/20th March, 1941, when 120 separate messages, many of them collectively reporting a number of "incidents", were received. On that night the enemy showered thousands of incendiary bombs intermixed with high explosive bombs and parachute mines upon all parts of the port. The duty officers had by then gained much experience and as the messages poured in, instructions poured out. Sunken ships or craft were reported to the night staff of the Harbour Service and the Salvage Department. Information about unexploded bombs and mines was quickly passed to the Naval Duty Officer. Damage to roads, rail tracks, bridges, lock gates, etc., was brought to the notice of the Duty Engineer; by daylight his men were patching, clearing, improvising to ensure that the port was kept working. Obstructions to navigation were recorded for action by the Harbour Service and the Salvage Department.

It must not be assumed that the Control Staff was only employed in this defensive work. Equally important were their night duties relating to port operation. A review of the messages received in this connection reveals a wide range of subjects, showing that the duty officer had no book of rules to which he could turn, but that a broad and general knowledge of all port procedure was necessary.

As an example, on the night of 9th/10th January, 1943, the West India Docks police informed the Control Room at 8.35 p.m. that a Norwegian cook aboard one of the ships had committed suicide. This was not the sort of problem likely to come the way of a port officer more than once in a lifetime, but the action taken was faultless. Twenty-five minutes later the Surrey Docks reported that the dock tug had broken down. A spare tug from King George V Dock was ordered up as a substitute. At 9.40 p.m. Tilbury Docks told Control that a barrage balloon had broken loose and drifted over the dock causing slight damage to No.7 Shed. The Duty Engineer, the Navy and Balloon Barrage headquarters were informed.

Many messages were received from various police stations reporting the presence of seamen who had missed their ships and asking for the

destination to which they were to be sent to rejoin. The postal authorities continually asked for urgent telegrams to be passed to seamen aboard merchant ships. Such inquiries meant that the duty officer concerned had to take all security precautions about revealing the ships' destinations and at the same time to ensure that men or messages reached the vessels before they sailed. The Control kept in touch with the discharge of explosives from ships in the docks, and trains similarly loaded were watched throughout the night and their final departure from the dock sidings recorded with relief.

The arrival of vessels, naval or commercial, which by reason of damage or other causes sought harbourage in the port without due notice involved the Shipping Control Officer in complicated matters of tidal hours at entrance locks, draft, length of ship, nature of cargo, whether rail facilities were required for cargo, etc., before a berth could be allocated. Both the Navy and the Ministry of War Transport had to be kept informed of these emergency arrangements. A request might be received in the early hours of the morning for a floating derrick, for oil barges to lighten a tanker ashore in the outer estuary or for other port equipment. All these matters had to be dealt with as quickly as possible.

One of the most amusing inquiries to reach the Control Room was when two ships collided in the river at Woolwich. No lives were lost, and after reporting to the Salvage Department and Harbour Service that one of the vessels was in a sinking condition the Control Room assumed the matter was closed. Presently, however, questions came through regarding a cow which, it was alleged, had swum ashore from the ship and was in the care of the Royal Arsenal Fire Brigade. It was also said that a calf had likewise escaped and was missing. The regulations of the Ministry of Agriculture regarding the unauthorised landing of foreign cattle occupied the attention of the Control Room for quite some time.

In a nearby basement corridor, the Flag Officer maintained an equally busy Control Room manned by Navy personnel. Here the teleprinters and typewriters chattered night and day, passing and receiving signals about the arrival and departure of convoys, routing orders, navigational warnings, defence measures, etc.

So far the picture painted depicts only endurance and initiative on the part of the Control Room, a sort of periscopic view of the battle raging downstream in the docks. Details of the events behind these terse factual reports pouring into the ears of the duty officers are recorded in the appropriate chapters. But these men in the depths of the great building on Tower Hill also had first-hand experience of what an "incident" in the air attack meant. At 9.42 p.m. on Sunday, 8th September, 1940, a high explosive bomb weighing about a ton struck the

Rotunda, the central and most striking feature of the P.L.A. head offices. The Rotunda was completely demolished and extensive damage was also caused to blocks of offices on the ground and first floors and lesser damage to windows, doors, partitions, walls and ceilings throughout the rest of the building. A fire broke out in the Rotunda and on the ground floor, and there was some flooding in the basement from water played on the outbreak by the fire service. Luckily, the bomb penetrated only the roof of the Rotunda and burst at ground floor level.

To those who escaped the experience of being uncomfortably close to an exploding bomb it may seem strange to record that the sound of the actual explosion was not heard by any of the people in the building. As well as the port duty staff, Naval watchkeepers were on duty and most of the staff of the neighbouring Toc H headquarters were sheltering in the basement, yet only a small number of light casualties resulted. A survey of the building after the raid and the queer path left and impish tricks played by blast give rise to a belief in miracles. The control staff continued its duty undismayed, but with a much clearer insight into the background to the nightly reports from the docks.

On the night of 10th/11th May, 1941, when the enemy made one of its major fire-raising attacks on the City, the P.L.A. head offices were again hit by a high explosive bomb. The top of the building was struck a glancing blow, the damage being confined almost entirely to the top floors of one wing. A number of incendiary bombs fell on the flat roof and the resulting fires were promptly extinguished by the watchers

Air raid damage to the P.L.A. head offices on Tower Hill, the centre of the port's naval and civilian administration during the Second World War. *P.L.A.*

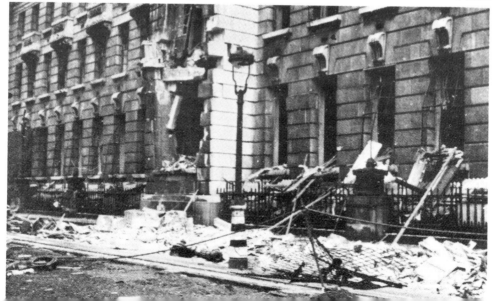

stationed there. On that night the P.L.A. head offices became an island in an ocean of flame; the building was separated only by the width of a narrow street from a number of major fires which included a warehouse full of fats, oils and other highly inflammable material. For some days afterwards the head offices staff, conscious of their meagre food rations, entered or left the building via a rink of butter and lard and worked in a dismal and greasy smoke-laden atmosphere.

The head offices had many other narrow escapes. Once the roof watchers were horrified to see a low-flying V.1 roaring straight for the main tower, which is the principal external architectural feature of the building. The bomb missed the tower by a few feet and continued westwards. The watchers had barely time to express relief before they saw the bomb make a U-turn and roar back at them. It came at an even lower altitude, almost grazing the roof and passed even more closely on the other side of the tower before crashing upon a riverside wharf.

An amusing incident happened in the Control Room during this era of flying bomb attacks. One of the duty officers with headphones

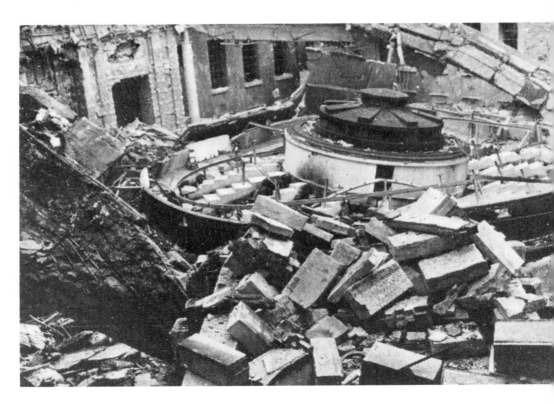

clamped tightly to his ears was plotting the track of one of these missiles. The rest of the duty staff were silently watching the plotting table. When the plot showed the arrival of the bomb in the vicinity of Charlton the onlookers heard the unmistakable note of its engine. It grew louder until it seemed only a few yards away. Then the engine abruptly cut out—as it usually did just before the bomb dived to earth and exploded—and the staff held their breath. At that moment the plotter took off his headphones and remarked brightly: "Passed Charlton; we ought to hear the engine..." The rest of the sentence was drowned by the noise of a nearby explosion.

On duty the night staff had little more than occasional "catnaps", eating and living in the depths of the building at the heart of the target area. Off-duty they travelled in crowded suburban trains through the blackout, and the misery of total war and forebodings at the sight of the nightly toll taken by the enemy, all added to the strain. They did vital work keeping the port moving—but it was unspectacular. Theirs was not among the easiest tasks of the war over the Thames.

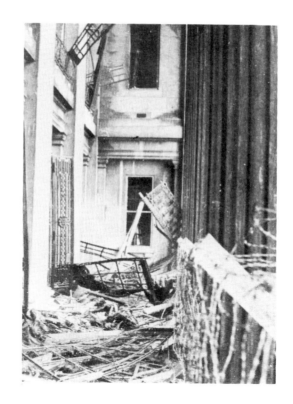

Opposite: The demolished Rotunda of the P.L.A. building after the attack of 8th September, 1940. *P.L.A.*

Right: Another view of damage to the P.L.A. building after it had been struck by a large bomb which burst at ground floor level.
 P.L.A.

CHAPTER SEVEN

The Docks of London (Part One)

IN THE broad outline of this story, the many services and areas constituting the port were frequently described collectively as "The Thames" or "the tideway". Little geographical distinction was made in the preceding chapters, for nearly all sections of the port suffered and fought with equal patience and tenacity. An attempt will now be made to localise some of the activities which contributed in a special way to the success of the whole. This chapter is devoted to the diverse operations carried on within the Port Authority's five great dock systems during the war.

The total area within Customs' fences of these dock systems was more than 4,000 acres. They were the very heart of the Port of London. Without them, London's growth as a port and a city would have been checked more than a century ago. To an industrial nation fighting for its life, and one, moreover, greatly dependent upon seaborne supplies, these docks were worth many fleets and army corps.

So many of the special war contributions made by the docks were shared by all five systems that it will avoid repetition if their story is told in the main collectively, recording nevertheless the outstanding incidents peculiar to any particular group.

Together with the comprehensive passive defence scheme, blackout and security were the first wartime measures to be introduced. The principal executive medium was the P.L.A. Docks Police Force. During the pre-war years, its standard of efficiency had been progressively raised, and by 1939 it was well equipped and prepared to bear the many burdens which the war laid in particular upon the force.

"Blackout" was the first sharp reminder that we lived under the constant threat of attack, and it created difficult problems at the docks. Apart from keeping an effective blanket over lights in ships, warehouses, power houses, etc., the police were concerned with the danger of drowning to seamen, military sentries and others unfamiliar with the topography of dockland after dark. To offset this danger they produced a specially-designed portable lamp, mounted in a heavy concrete base to ensure stability, which could be placed at strategic points to warn unwary night walkers and to plot safe routes to ships and dock entrances. At a later stage, distinctive slides were made available whereby the lamps

could be instantly adapted to give specific warning of unexploded bombs, craters and other dangers.

The principal sufferers from blackout in dock operation were the dockmasters who, daylight or darkness, were still servants of the tides. To the unenlightened onlooker, the introduction of a large liner into an entrance lock resembles an attempt to put the proverbial quart into a pint pot. In effect there are feet to spare when the ship is safely between the two sets of lock gates. But a matter of only feet is not too large a margin when the dockmaster is controlling from the lockside a moving mass of thousands of tons of steel. It is his practice to walk backwards along the lockside, whistle in hand, carefully watching the fore-and-aft line of the incoming ship. Any narrowing or widening of the gap between the ship and the lockside warns him to take action through the ship's main engines, his tugs, or his lockmen handling the check ropes. At night the operation is normally carried out under powerful electric lights. Imagine, then, his difficulties during the blackout when the ship appeared merely as a shadow in the darkness. It is a tribute to the skill of these officers that docking accidents during the war were rare.

In the matter of security, the P.L.A. Police Force was assisted by the Military Field Security Police, the commanding officer of which for some time was the Authority's Chief Police Officer. Vital points such as

Members of the Port of London Authority Police who received gallantry awards for their heroic work during the air raids on the port. In the middle of the front row is Acting Chief Police Officer W. H. Simmons, M.B.E. *P.L.A.*

entrance locks and power houses were guarded at the outset by a Territorial Army battalion, later relieved by units of the Corps of Military Police.

The P.L.A. Police at the West India Docks defeated what was probably the first attempt at wartime sabotage in this country, for when they arrested the German crew of the s.s. *Pomona* fifteen minutes after the declaration of hostilities they found scuttling arrangements to be well forward. The dockmaster was called in and he, with the aid of two engineers, managed to prevent the vessel sinking and so becoming of nuisance value to the enemy.

A round-up of aliens on dock premises followed immediately and suspects were held and reported to the appropriate Government Departments. The docks were declared a "protected" area and a permit system to control entry was instituted. Distinctive types of passes were issued to different classes of workers. When one visualises the not inconsiderable daily movement into and out of dock premises, it underlines the vigilance of the P.L.A. Police that few unauthorised persons gained admittance and certainly none caused any serious consequences. Further to illustrate the fine mesh of their net, at one dock group in one year particulars of more than 200,000 persons on the premises after working hours were recorded.

At the beginning of September, 1939, heavy and light high-angle guns were mounted on pre-selected sites within and around the docks. As the gunners manned their weapons, many barrage balloons rose from sites also prepared in advance. Guns and balloons were installed principally to deter dive bombers from pin-pointing locks, bridges and other vital targets.

When war came the anxiety of merchants to get their goods away before the sea lanes were closed to normal cargo resulted in an unprecedented tonnage of exports being loaded at the docks. As already recorded, the war ended many long and traditional associations between certain trades and ships and particular docks and berths.

At the Surrey Commercial Docks imports of Baltic timber ceased abruptly and the main occupation there became delivery from the vast stocks of softwood held for the timber trade. "A" Class Cunarders, one of the two principal lines supporting the dairy produce trade at the Greenland Dock in this group, were requisitioned by the Admiralty. Ships of the other line regularly using that dock, the well-known "Beavers" of the Canadian Pacific fleet, were all sunk during the course of the war.

In the West India Docks, famous Union-Castle and other liners disappeared to become troopers and hospital ships. As an example of the

disruption of normal routine, the staff at this system dealt with a strange tanker laden with—of all things—bales of cork.

The Royal Docks contributed the largest number of ships to Government service and the list of companies concerned, beginning with the P & O, Cunard White Star, Royal Mail, New Zealand Shipping, Shaw Savill & Albion, Aberdeen & Commonwealth, British India, City, Clan, Federal, Prince Line, was like a roll-call of the British Merchant Service. From Tilbury came vessels of the P & O, Orient, Bibby and other lines. The London Docks temporarily parted with General Steam, Coast Lines and vessels of other companies which had regularly berthed there.

The docks provided invaluable facilities for fitting-out and converting ships requisitioned by the Admiralty. Derricks which had done similar work during the First World War and more modern plant which had hitherto dangled heavy commercial lifts now hoisted guns, armour

King George VI making a wartime tour of the London Docks. On the left can be seen a London taxi equipped as an emergency rescue vehicle. *P.L.A.*

plate and other warlike gear. Panelling, carpets, furnishings and other peacetime refinements were taken out of ships to join unwanted deck gear and equipment in various dock sheds; painters drew the standard coat of grey paint over the distinctive hull and funnel colours of the various lines.

Most famous of the ships converted to auxiliary men-of-war in the docks of London was the *Rawalpindi*. While in the service of the P & O

Mrs Winston Churchill, wife of the wartime Premier, presenting a gallantry certificate to a member of the Port of London staff. *P.L.A.*

Line she made the Royal Docks her regular terminus at the end of each round voyage and it was fitting that she was there converted to an armed merchant cruiser. She carried on the traditions of her forebears in the London River, East Indiamen and Blackwall frigates, when she fought two great German battleships, going down at the end with her colours still flying. For some years after the war, her peacetime accommodation ladders, removed when she fitted out as an armed merchant cruiser, provided a way down to the Children's Beach fronting the Tower of London. They were eventually scrapped as beyond repair.

Another famous liner regularly berthing in the Royal Docks before passing under the White Ensign was the Aberdeen and Commonwealth liner *Jervis Bay*. Her fight against a German pocket battleship and her deliberate self-sacrifice to save the North Atlantic convoy under her protection will never be forgotten.

The early days of the war in the docks of London were a period of much hard work, frustrated by irritating difficulties and with little excitement; this period of the "phoney" war was by no means the easiest for London dockworkers.

The principal contribution made by the docks to the Dunkirk evacuation consisted of rounding up boats, barges, schuyts and coasters and despatching them to the rendezvous at Tilbury. This was done principally by the dockmasters. The language difficulty tended to cause the crews of one or two Allied vessels to regard the commandeering of their boats as high-handed piracy, but dockmasters are experienced in conveying their meaning to uncomprehending foreign seamen and in every case they obtained the boats without actually fighting for them. Much of the little fleet from London was equipped, provisioned and crewed at the Ocean Landing Stage and in the Tilbury Basin where all types of port workers toiled to get them away. One Tilbury Dock officer, peremptorily summoned from his bed, found his store locked and the custodian of the keys out of town; he discovered in himself, to his surprise, a flair for midnight burglary.

After Dunkirk, aerial attack on the docks became a certainty. The bombardment of the port has already been described in broad outline and even in this more detailed chapter it is hard to focus upon individual acts among hundreds of cases of devotion and endurance exhibited by dock workers. It was a full-scale battle which decisively affected world history.

The passive defence force at the docks was composed of very ordinary men but the attack disclosed in them hitherto unsuspected reservoirs of courage, endurance and comradeship and ability to lead. Some were killed; many were wounded; but they persisted. The property which they guarded did not belong to them, but they were intensely loyal.

All grades of dock employees extinguished incendiary bombs as a matter of course just as thousands of other men and women extinguished them in or around their homes; but in this case they were dealing with huge warehouses, many of them filled with highly inflammable material. A hole in the roof or wall of these buildings might instantly create an inferno with little chance of escape. Many thousands of tons of valuable cargo were saved by their efforts. It must be remembered that in those early days the fire brigades had not been expanded and merged into the

National Fire Service and they were stretched to the limit. The initial fire defence of the port, therefore, largely fell to the dock staffs. By night they clambered over warehouse roofs to reach distant fire bombs, the next footstep or handhold being revealed only by the bomb flashes; upon them rained debris and splinters. When their attempts to save the warehouses failed, they worked to remove undamaged cargo until they were driven away by the heat.

The dock railway staff isolated burning trucks, in some cases knowing full well that they contained ammunition or other explosives. Dockmasters and their staffs went afloat in dock tugs to save imperilled ships and craft. Docking of ships had to go on, raid or no raid, and in the midst of a rain of missiles the dockmaster's whistle signals would cause the lock gates to open to allow a ship to enter or leave dock. First-aid parties, all volunteers, went out when called, whatever the conditions; sometimes they were knocked down by blast, but they picked up their stretchers and carried on. Ambulance drivers in their flimsy vehicles went to and fro under the rain of splinters. The dock police were everywhere and there were few major incidents in which they were not involved. The engineer's staff patched, strutted and carried out other temporary emergency measures until more permanent repairs were possible. Royal Navy and Merchant Service seamen in ships in dock frankly expressed their wish to get away to sea, but they came ashore to help the dock staff in the fight; when the ships were hit, the dock staff went aboard to repay the debt. On one occasion, seamen came ashore with bare feet to help extinguish incendiary bombs.

From this brief review of the Battle of the Docks it will be seen how impossible a fully detailed account of dock defences during the "fifty-seven nights" would be. The following records but a few of the outstanding incidents which happened during the heat and smoke of action.

The London & St Katharine Docks contained many ranges of warehouses; some of them were more than a century old, but they had modern appliances and were suitable to store a great part of London's commercial wealth. As already described, a large amount of foodstuffs and other vital cargoes were dispersed outside the London area, but warehouses in the docks of London represented such a big proportion of the nation's total cupboard space that they had still to be used to a great extent. Safeguarding these acres of floors packed with overseas wealth was a problem shouldered principally by the dock staff.

In common with all the other docks, the London & St Katharine received a hammering from the enemy on the night of 7th/8th September, 1940. Several major fires were kindled among the ware-

houses, and the fire services, assisted by the dock staff, were soon in action. During this first attack a naval magazine in the London Docks was threatened by a burning wool warehouse. A dock police party forced open the door of the magazine and, with the fire already licking the magazine walls, persisted in their efforts to remove the contents until all the twelve-pounder shells and cases of fuses had been removed. Five George Medals were awarded in recognition of this action.

The next night, the attack was repeated; again the fires broke out. A fire party playing their jets upon a burning warehouse were threatened by the bare high-tension electric cables spanning the roof. A foreman electrician, ignoring the still-falling bombs and flying embers, climbed to the warehouse roof and crawled three hundred yards to cut off the main switch. He, too, was awarded the George Medal.

In October the London Dock police, assisted by four volunteer wardens, again distinguished themselves by removing shells and fuses from a threatened magazine. Throughout the winter the police fought fire bombs, saved cargo and craft and assisted the wounded, co-operating with all the defence services. On one occasion, as if they had not enough to occupy them at the docks, they sent a party outside to help in the rescue of thirty-nine horses from burning stables.

The most disastrous "incident" in this dock system occurred on the 8th/9th September, 1940, when fires in "E" Warehouse ignited barges laden with copra in the Eastern Basin, St Katharine Dock. The flames spread to a range of warehouses full of copra and paraffin wax. The burning fat and wax floated upon the water until the basin became a cauldron of flame. The fire services fought magnificently but the inferno defied their efforts and the area was laid waste after burning for several days, yet by the ingenuity of the dock staff a useful proportion of the wax floating on the water was later recovered and shipped away to be refined.

One of the lighter stories of these docks under fire concerns a fire-watcher who developed a fiercely protective instinct for the particular warehouse which he watched. One night incendiary bombs were showered upon it and, realising that he could do nothing alone, he ran to seek assistance. He stopped a passing fire engine, but the crew had orders to proceed to a more dangerous fire. So the burly fire-watcher, threatening unspeakable things to the crew if they failed him, climbed upon the bonnet of the engine and forced the fire crew to deal with his warehouse before he let them drive on.

Bomb damage to "A" Shed on the East Quay, London Docks, uncovered relics of the past, hidden for more than a century. On two of the stout oak supporting pillars which defied the blast there were revealed inscriptions obviously engraved with a scribing iron, the

traditional tool used to mark barrels and cases. Most of the inscriptions were merely names flanked by the year "1806", but one idle doodler had recorded: "Lord Nelson Dyed in Victory, October 21st 1805."

Another story, before passing on downriver, concerns one of the dock tenants who, after an all-night raid, called at the Estate Department of the Authority to arrange for temporary repairs to his office. When arrangements had been made he remarked casually, "And you might send someone to take away the end of a barge which is lying on the roof!"

At the India and Millwall Docks, one of the worst "incidents" occurred during the first weekend of the 1940 blitz when the Rum Quay was burned out. About one and a quarter million gallons of rum were destroyed, rivers of blazing spirit flowing into the dock while burning puncheons exploded, flinging jets of flame at the firefighters.

During that weekend the dockmaster and his assistants were at work for forty-eight hours with little rest or food. First they shifted ships imperilled by the blazing rum and then towed away several barges containing oil which were accumulating hot embers from the adjacent fire. The work was made more difficult by the tremendous draught caused by the fire which created a stiff breeze across the waters of the dock. Early in the attack the machinery that operated the lock gates was put out of action, but the docking staff continued to work the gates by means of wires leading to an hydraulic capstan.

Considerable quantities of sugar in store at these docks gave rise to special problems. The glutinous, fiery rivers which crept from the burning warehouses resembled the effects of a volcanic eruption.

During the afternoon raid on 7th September, 1940, the s.s. *Bennevis* in the West India Import Dock received a direct hit by a high explosive bomb and took fire. While the raid was still in progress a party from the dock control boarded the ship and removed six badly injured members of the crew from the vicinity of the fire. Then, although the fire was known to be under the gun turret and the ready-for-use ammunition might explode at any moment, they remained to give attention to those and other injured men until ambulances and firefighters arrived to help them. Some of the casualties could only be landed by crane, but twenty-four injured seamen were saved; one member of the Authority's first-aid organisation made a dramatic dash by car through the height of the attack to take a supplementary supply of medical stores from the head offices to this hard-pressed control.

Once again the dock police were at all the major "incidents".

Steel-helmeted members of the London Fire Brigade fighting a blaze in a range of dockside warehouses during the air attacks on the port.
London Fire Brigade

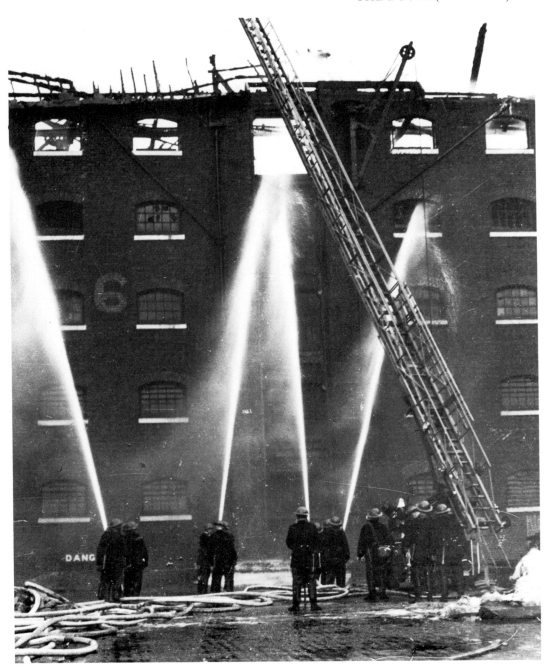

Considerable courage was shown by one policeman later in the attacks when a mine was discovered on the dock premises. The Navy decided to turn the mine over by remote control in order to expose the fuse, and the constable volunteered to remain near the mine in order to transmit signals during the operation. The mine exploded and only by a miracle was the policeman unhurt.

In one of the big fire raids in March, 1941, the East Wood Wharf was burned. A small number of folded canvas and plywood skiffs was consumed in this fire and an excited fire-watcher temporarily created

A Port of London Authority policeman boards an inward-bound vessel for a war-time interrogation.

P.L.A.

despair in the heart of the Control Officer by reporting over the telephone: "All the boats are on fire!"

An unusual incident occurred when a foreman ascended by an outside lift to the top of the Central Granary, Millwall Dock, to examine the roof. The Central Granary was the largest grain store in London, a landmark for many miles. As the foreman, after completing his inspection, was starting to descend in his flimsy open-work cage, a high-explosive bomb burst on the roof of a silo only a few feet away. The foreman was temporarily blinded and the lift jammed some ninety feet above the ground. He was eventually rescued from this position and, after treatment, insisted on returning to his duties.

60

An amusing story of those grim days is told by the dockmaster. During the height of the attack he offered to take six parched firemen to his nearby home for a pot of tea. They started off in single file. On hearing the "whoosh" of a falling bomb the file went down like a row of ninepins. Unhurt, they picked themselves up. After a few more steps the same noise sent them flat again. During their journey of a few hundred yards they repeated the performance some six or seven times.

As might be expected, this dock system received a large share of the honours and awards given to port workers.

At the Royal Docks a tragedy occurred early in September, 1940. The fire services arrived to deal with a fire in the roof of a shed. A P.L.A. Police sergeant and a constable were sent to unlock the door of the shed for the firefighters, but when nearing the shed they were warned by a military sentry of an unexploded bomb in the immediate vicinity. Both policemen put duty before personal safety and persisted. By the greatest ill-luck, the bomb exploded while they were unlocking the door of the shed and both men were killed.

First-aid parties at the Royal Docks distinguished themselves on many occasions, particularly regarding ships damaged and on fire. It was not a time for job demarcation, and staff went outside dock premises to aid hard-hit and burning ship repair establishments under a hail of bombs and incendiaries. The dockmaster and his men also assisted in saving imperilled ships, and George Medals were awarded to two tugmen who helped to shift the m.v. *Abbekirk* under appalling raid conditions. The crews of the P.L.A. dock tugs *Walbrook* and *Beverley* found the vessel abandoned and on fire. They extinguished the blaze and then, realising that the vessel was still in danger from a neighbouring fire, one of the tugmasters called for volunteers from the crew of the s.s. *Otaio*. With a tug hand acting as dock pilot on the ship's bridge, manned by volunteers from the *Otaio* and towed by the two tugs, the *Abbekirk* was moved to a safer berth.

The Seamen's Hospital at the Royal Albert Dock, situated in the heart of the target area, was frequently straddled by high explosive and showered by incendiary bombs, the medical and nursing staffs devoting themselves to their patients and to the many dock casualties which every raid brought to them.

Although nearest to the sea and the enemy's bases, the Tilbury Docks suffered least of the five main dock systems. Nevertheless, these docks have a proud record of courage and initiative under bombardment. Members of the first-aid parties, for instance, distinguished themselves by rendering help to a Clan liner which had been hit by a bomb and set on fire. Despite the sporadic explosion of ammunition, the

An aerial view of the Surrey Commercial Docks where stacks of softwood timber blazed during the air attacks of September, 1940. _P.L.A._

first-aid party worked coolly and methodically attending and removing casualties.

One of the worst disasters at the Tilbury Docks was in November, 1940, when two P.L.A. dock tugs, the _Deanbrook_ and the _Lea_, were both destroyed by an enemy parachute mine. It was a Saturday, about noon, and the two tugs were due for a crew change which customarily took place at their berth alongside the return wall of the inner knuckle on the lower side of the 1,000-foot-long lock entrance. For this reason many of the crews were below decks cleaning up after a busy morning watch and packing their personal gear for home, their relief crew mustering a fifth of a mile away in the foreman's cabin. Suddenly the mine exploded, sinking both tugs in seconds. There were seven fatal casualties; rescue work was carried out by the docking staff, police, merchant seamen, port workers and a first-aid party. Tragically the tugs' busy morning of ship movements may have released the mine from its previously safe situation

62

in some remote corner where it had eluded earlier Royal Navy minesweeping and drawn it down to the berth where the tugs had safely moored during the preceding week.

It was during the "siege" period that the dockmaster at Tilbury had an adventure which illustrated how invasion-conscious all port workers had become. One brilliant winter night, while a raid was in progress, he saw a parachute descending on the docks. Accompanied by several of the docking staff he collected a policeman with a rifle, and the party hid behind a wall ready to give the parachutist a surprise as soon as he landed. It was as well that the wall was stout, for the parachute was attached to a mine which exploded in the air not far from the intended ambush.

The Surrey Commercial Docks on the south bank of the river suffered most severely. Mention has already been made of the huge stocks of softwood timber normally stored in these docks. The enemy knew, only too well, about this potential beacon and from the first day of the attack it received his most violent attentions. During the weekend 7th/8th September, 1940, forty-two major fires occurred here, and some areas became isolated behind flames. Thousands of standards of timber stored in sheds and on open ground were deluged with high explosive, delayed-action and incendiary bombs, causing an area of about 250 acres to become an inferno. Hundreds of firemen fought the fires, some brigades coming from as far afield as Bristol and Rugby. Along the south bank of the river flanking these docks there was an unbroken wall of flame some three miles long, and fire floats and other craft trying to slip past on the north side of the river three hundred yards away were either turned back by the heat or had their paintwork blistered.

The timber stocks consisted of pitch pine, fir and other resinous woods stacked in piles usually about twenty-five feet high, but in some cases very much higher. The firemen soaked these stacks with water, but as fast as they moved to a new area the drenched timber steamed, dried and then burst into flames again owing to the intense heat generated by nearby fires. To add to this danger, some delayed-action high explosive bombs had fallen unnoticed among the timber piles. For several successive nights the enemy returned to stoke up the giant target so that it burned for many days and nights.

Throughout this ordeal the Surrey Commercial Docks staff worked magnificently. Features of the defence organisation there were raid observation posts on the tops of steel pylons, sixty feet high. The men watching on these towers during the first weekend of attack had an unenviable task, but, grilled and blistered, they remained on duty reporting the fall of bombs and fresh outbreaks of fires. The watcher on

one of these pylons straddling a timber pile was forced temporarily to quit his post when the timber beneath him caught fire, the ironwork blistering his hands and feet as he descended.

The control officers, A.R.P. officials, ambulance parties, police, engineers and docking staff worked until they almost dropped from exhaustion. The dockmaster and his staff managed to close a set of lock gates whose hydraulic gear had been put out of commission. Docking staff and a dock pilot, together with the dock tug *Canada*, the motor tug *Jean* and a firefloat, saved a number of ships and much floating equipment. Blinded by smoke, straddled by high explosive bombs, machine-gunned from the air, and obstructed by a road bridge only opened by unorthodox means, these men snatched the ships away from an inferno where the very air seemed on fire. Among the awards for this gallant work were two Royal Netherlands decorations for saving four Dutch ships.

The following condensed version of a report by Mr T.L. Mackie, a gas identification officer of the Port of London Health Authority* on duty at the Surrey Commercial Docks during the first major air attack which began on 7th September, 1940, gives a clear picture of what dock workers endured:–

The air raid siren wailed the "Alert" as A-A gunners fired into a sky which was filled with droning bombers. The Communications were manned and a G.I.O. scaled the pylon to check on bombed sites. It was a tense moment. Here it was, the event for which much preparation had been made. Would it be gas? The aircraft were high and like small silver specks gleaming in the light of the setting sun. Formation after formation dropped H.E. bomb loads as they flew over the docks and riverside areas. While some dropped H.E. bombs, others followed to cascade incendiary (Thermite) bombs on the already stricken docks. From the pylon, one saw more bombs explode in the water than on the dock premises. The pylon quivered and swayed in the repeated blasts. To the north-east of this observation tower one saw fires and dense black smoke on the riverside, and, in the immediate dock area, hundreds of incendiary bombs were starting their destructive work, first as small magnesium flashes, then as pillars of red flame and smoke.

Messages were sent by telephone from the pylon to H.Q. until one heavy H.E. dropped on the concrete arterial road close to the pylon. The structure swayed and telephone lines were broken. Messages for H.Q. were then relayed by a megaphone to a nearby raid control shelter, which was equipped with a telephone. After what seemed an eternity, though hardly an hour, the "all clear" sounded.

The question of "who" and "what" no longer existed; it was no specialist's work, but a task for all able and willing men. The G.I.O. assisted wherever possible in the immediate area. Incendiary bombs and small fires were promptly dealt with. The crater on the arterial road had to be made safe for the passage of the fire services. This was done and warning lights set up to direct the increasing stream of traffic.

Searching for delayed action bombs, something new was located. A large metal container had been dropped and had burst on striking a stack of timber. It spread its

*Chapter twelve

contents over a wide area, a brown oily liquid with a slightly pungent smell. "It may be Mustard Gas." The G.I.O. lost no time in clothing himself, harnessed his apparatus and made a test. The result was negative. The sample proved to be fuel oil. The enemy aircraft had obviously scattered these containers of fuel oil to supplement the incendiary bombs. At sundown, all local fires had been extinguished, but, alas, in other sections of the dock where an enormous quantity of timber was stored, there were still major fires.

By this time only trousers and shirt were worn; the sky was aglow from huge fires but there was a lull and cups of tea were served. Then the siren wailed the "Alert" once more. The fires now raged from the north-east to the south-east, so the airmen concentrated their night attack on areas where incendiaries had been extinguished. The bombs fell to the south-west perimeter of the docks, new fires started and a fresh southerly breeze carried glowing splinters to the inner sites. Thus, despite all efforts to prevent fires in the central area, the smoke, heat and splinters were overwhelming. The incendiary bombs which fell at night were smaller and contained traces of sulphur, for noxious fumes were prevalent. Scores of them were booted into the water and many others easily smothered. The two factors which contributed to the defeat of all efforts to cope with the initial fires were, first, that the foundation surfaces of timber storage sheds were partially covered with tindery wood chips, which had evidently accumulated over the years, and the steady, dry breeze.

At length the area was ringed by great fires. The fire brigades were doing their work and the control shelter was licked by flames. It was impossible to carry on from there so the G.I.O. reluctantly asked H.Q. if the control could be abandoned. It was only then that the building containing all his belongings and equipment was also found ablaze. He entered through a window and salvaged some of his clothes together with the gas testing equipment. Somewhat discouraged by the blazing spectacle and feeling a sense of helplessness, he fought his way through the blazing ring of fire until he arrived at H.Q. Half-dressed, carrying his salvaged equipment and bearing some slight wounds, he was admitted to the shelter to make a report to the Superintendent at 03.00 hours on Sunday the 8th. A short sleep on a wooden bench was a happy release from this experience.

At 07.00 hours, after some milk and a sandwich, a survey was made of the damage. The daylight exposed a terrible scene; the greater part of the timber docks, like a smouldering, barren wilderness, and huge warehouses completely gutted. Ships which only a few hours ago had been discharging cargoes were torn by the blast and defaced by fire. Some had been holed and sunk, showing only a small part above water. Steel girders were twisted to indescribable shapes and surviving masonry lay at dangerous angles. Alas, this shambles proved to be more than unsightly wreckage, for the bombs and fire had claimed toll of human life, and the bodies still lay among this charred debris.

Sunday was another warm day, and most of the time was spent in checking up at H.Q. Plans were laid to meet any more attacks and a spirit of determination prevailed. The G.I.O. now operated from H.Q. where he put himself at the disposal of the Control Officer. As soon as dusk had fallen, the enemy aircraft were overhead again, bombs began to fall on scattered areas, many on sites already completely devastated, so comparatively little damage was done. The incendiary bombs which were showered down at intervals were extinguished in most cases by the men on duty. So the long night passed, in period of telephoning, patrols and rest.

Monday, the 9th September, was also a perfect summer day. With meagre equipment the G.I.O. began the task of locating all damaged foodstuffs and

nuisances to health. In short, he put into operation all the plans which had been laid to meet such circumstances, while at the same time keeping a sharp eye on anything which suggested poisonous substances from bombs. However, the enemy was soon overhead in the forenoon. Work had to be done and willing staff continued to push ahead when circumstances appeared fairly reasonable. Chances had to be taken, not only with falling bombs, but also with unstable and damaged structures during inspections.

<div align="center">

* * * *

</div>

In March, 1941, H.M.S. *Helvellyn* was sunk by a bomb in these docks. Six casualties were taken out of the water by the police and dock staff who, under the continued hail from above, rendered first-aid by flashlight in a nearby shelter.

The steel pylons continued to prove of great use during the winter. A watcher perched in one of these observation posts gave over the telephone a cool and detailed running commentary on the fall of two parachute mines. Both fell within a hundred yards of his post, one dropping in the Albion Dock. He gave such accurate bearings of its position that the Navy had no difficulty in locating and destroying it next morning.

Mobile canteens proved a boon in the docks in wartime. Here the twenty-fifth mobile kitchen subscribed for by the citizens of Guelph, Ontario, Canada, is being presented to the Port of London. *P.L.A.*

On another occasion a pylon watcher reported the fall of a distant bomb to the Control Officer who immediately telephoned the post nearest to the explosion. Far from giving information, the post crew had not had time either to pick themselves up or to decide what had knocked them down.

During that second winter of the war, the difficulties caused by delayed-action bombs, damaged roads and bridges, and the almost daily appearance of new craters can hardly be imagined. Fires broke out long after the raiders had passed owing to the time taken by unsuspected incendiary bombs to burn through lead sheeting on warehouse roofs. A valuable contribution to dock defence was made by members of the P.L.A. Police who volunteered for a bomb recognition course. Their expert location and appraisal of suspected, embedded, unexploded bombs prevented much unnecessary delay. For most dock employees of those days the memory of details has faded, but there remains a blurred impression of fire, smoke, heat, noise, collapsing buildings and the comradeship of their fellows.

The first mobile canteen started at the West India Docks when a retired docker operated an ancient car containing a ten-gallon milk churn of tea and a number of jam jars in lieu of cups. When, as frequently happened, the car broke down it was hauled to the next serving point by impatient and thirsty men. This impromptu effort was followed by a fully-equipped mobile canteen service operated in all docks mainly by the Women's Legion. It is difficult to write too highly of the zeal and courage shown by these women in voluntary work which was arduous, dangerous and exposed, and which paid none of that compensation of glamour surrounding other women enrolled in the Services. Statistics revealed how fully their work was appreciated at the docks, for the 26,000 cups of tea served during the first two months of heavy raiding had expanded to 860,000 cups and one million snacks during a corresponding later period. The mobile canteens were later supplemented by twelve large industrial canteens provided and operated throughout the docks by the Authority. These canteens played no mean part in the defence of the port.

On 25th June, 1941, Mr Winston Churchill, in secret session in the House of Commons, said: "In the last war an inquiry was made into the possibility of feeding this island if the Port of London were closed, and the report was extremely pessimistic. The Port of London has now been reduced to one-quarter. The traffic of all the ports on the East Coast is enormously shrunken, the traffic along the South Coast is a tithe of its normal, and the English Channel, like the North Sea, is under close air attack of the enemy."

CHAPTER EIGHT

The Docks (Part Two)

B Y THE spring of 1941, the Luftwaffe, defeated in its mass attacks against London, had drawn back. But the port remained low on the nation's list of ocean terminals, since ships were still menaced by the dangers lurking in the Estuary because effective air and sea protection was not yet available. Most of the cargo arriving in the docks was now carried by coasters, somewhat less vulnerable to enemy attack than the larger vessels but nevertheless acutely at risk during every voyage.

A few ocean-going ships continued to be routed to the Thames and during this period inward bills-of-lading in dock offices recorded with some regularity the arrival of steel billets and softwood from Canada and the United States. With the virtual closing of the Mediterranean, an occasional vessel berthed in the docks after voyaging round the Cape. If the cargo of these vessels included perishables, the London stevedores were sometimes faced with problems such as cargoes of figs which had spoiled on the enforced detour leaving a foot or more of fig juice in the bottom of the ship's hold.

Abnormal conditions had become routine after eighteen months of war. Instead of some 150 or more different consignments, each with a different identity mark and owned by different consignees, ships now carried two or three large blocks of supplies consigned to the Government Ministries concerned. In many cases the firms normally handling the different commodities acted as Government agents, so ensuring the continuity of expert attention. In the urgent quest for more cargo space, chilled meat had disappeared in place of the more economically stowed frozen meat, and methods of stowage were radically altered. Shortages of baling and casing material abroad often affected the normal standard methods and sizes of packages and helped to disrupt what was left of the old routine.

Exotic cargoes from the Far East had long since ceased to arrive at the docks. Gone, too, were the consignments of mechanical equipment from New York, bananas from Jamaica, oranges from California and Brazil, and apples from New Zealand and America.

There was not, however, enough direct overseas cargo being discharged in the docks during this period to cause any serious difficulties; the bulk of Britain's imports was arriving at the West Coast ports. General cargoes destined for London were transshipped mainly to

coasters, meat supplies for the Metropolis being usually sent by rail. These vital supplies arriving by water or rail in London went to the Royal or the West India Docks. Both these dock systems were well equipped with rail and road links, and barges could load at the idle ship berths. Skilled staff and all the dispersal experience of a great port thus continued to be used, and the docks of London became the principal junction between West Coast ports and the markets and storage centres of the Metropolis. All deliveries of meat, bacon and other foodstuffs for London and southern England continued to pass through the port.

The "Buffer" depots established in connection with the evacuation of foodstuffs from dock warehouses and wharves, mentioned in Chapter One, were in many cases organised on behalf of the Ministry of Food by members of the port warehousing staff. They were responsible for "Buffer" depots at Watford, St Albans, Luton and Boreham Wood, for cold stores at Peterborough and Bishops Stortford, and a number of other minor stores. P.L.A. staff also managed for the Ministry of Supply a rubber sorting depot at St Albans and tobacco depots at High Wycombe and Edmonton.

Deal porters handling softwood timber in the Surrey Commercial Docks. *P.L.A. Collection, Museum of London*

A limited supply of softwood timber continued to arrive in the Surrey Commercial Docks, but this was principally barged direct to consumers and dispersal points. The staff at these docks, lacking many of the gantries and other handling equipment destroyed in the fires, showed considerable ingenuity in improvising substitutes.

A feature of the great scrap metal drive was the recovery of twisted and tortured sheets of lead from some of the old warehouses destroyed at the London & St Katharine Docks. This lead was found to contain no dross, a type not manufactured commercially for more than half a century.

While the docks were busy with salvaging cargo from broken warehouses and with shipping rubble and scrap*, valuable dock equipment was released on loan to the Services and to other ports. It was not without regret that dock staff saw it go, for they had firm faith in the ultimate triumph of the London port; but the times demanded any expedient to relieve the pressure. Among the equipment relinquished were sixty-four electric cranes, eleven locomotives, a floating derrick, tugs and launches.

The loss of this equipment was immediately felt when Lease-Lend began to send overseas trade back to the docks of London. In the normal way the docks would have taken this flood of supplies and—later—military equipment in their stride; in peacetime large circuses, herds of prize cattle, locomotives, buses and other out-of-the-ordinary cargo had been dealt with as expeditiously as the more normal cased and barrelled goods. But wartime difficulties called for a concerted effort. The effect of the loss of dock equipment, destroyed and on loan, was increased by the fact that discharging gear installed in most ships had received little attention during the war at sea and was often out of commission. Many ingenious improvisations overcame such difficulties. There was, too, an acute shortage of labour due to transfer of dockers and stevedores to other ports and to the Services. Again, the difficulties were enhanced by the advanced age of the men available; instead of the customary average age of thirty years, now nearly all dock workers were aged fifty, while some were over seventy. Many administrative officers had entered the Royal Engineers and many departmental records had been lost in the air attacks.

As the Lease-Lend phase gradually merged into the even more strenuous period of the build-up for D-Day the speedy turnround of ships, always desirable, became vital. Neither cost, raids nor blackout were allowed to interfere. In most docks in London, discharging of ships was done by stevedores of companies which contracted their skilled

*Chapter three

70

labour to the shipowners. The West India Docks were the larger of the only two docks groups of London which had P.L.A. staff for discharging ships. When an output committee, formed to remove bottlenecks at our main ports, reviewed the records of this group it reported that although the work undertaken there was among the heaviest the speed of discharge was second to none. Gangs worked from 8 a.m. to 7 p.m. and 5 p.m. on Sundays, a long day for middle-aged and elderly men engaged on heavy manual labour only sustained on wartime rations.

As was to be expected, the enemy soon became aware of the increased activity across the narrow sea and there followed an increase in the number of tip-and-run raids on the port. A certain amount of damage was done, but the results were negligible compared with the

A Liberty ship flying the Stars and Stripes arrives in the Port of London. These ships were built in considerable numbers in American yards, employing prefabrication techniques to speed up production. *P.L.A./Beckley*

The Chief of Combined Operations, Vice-Admiral Lord Louis Mountbatten, on a visit to the Port of London in 1943. *P.L.A.*

1940/41 raids. An outstanding loss from this cause occurred in January, 1943, during a surprise daylight raid when the second of two cold air stores at the Greenland Dock, Surrey Commercial Docks, was destroyed; the first had been demolished in an earlier raid. Under training nearby at the time was an A.R.P. party which abandoned its fireworks and turned to the real fire raging in the cold store, thereby saving hundreds of tons of bacon before being driven back by the heat.

An earlier chapter contained a brief description of the great build-up in the Port of London. The very core of this task was at the West India, Royal and Tilbury dock systems. Allied naval and military headquarters and stores were installed at these docks and cordial relations were soon established between their personnel and dock staff. Thousands of tons of explosives, guns, lorries and other war materials, locomotives and bridge components swelled the ever-increasing flow of grain, sugar, canned goods, tractors, fertilisers and timber for home use. All available warehouse and shed space was filled and still the supplies poured in. Large areas which since the 1940/41 raids had borne only the shells and debris of former warehouses were cleared and levelled and became great storage dumps. Vast quantities of material were routed out of the docks for factories, warehouses, dumps and supply centres outside the London area.

During this period indirect proof that our American benefactors were fast learning the war lesson emerged at the Royal Docks. Large numbers of landing craft were arriving regularly from America in three prefabricated sections, each section being lifted by one of the Authority's floating derricks. For a time each section was found to be well above the weight recorded on the relevant documents. The mystery was not explained until detailed investigation revealed that the Americans, impressed by the need to conserve every inch of shipping space, were filling the fuel tanks with oil and cramming the lockers with spare parts.

Short of men and equipment, the docks were able to cope with this task only by rigid planning. Planned speed is normally the keynote of successful port administration; and now every piece of equipment, every wheel and each pair of hands had to be used to the maximum efficiency. There is a tendency to criticise rule by committee, as if successful action comes only from individual control. There was little of the spectacular in

Lord Woolton, the wartime Minister of Food, discussing rationing with dockers in a Port of London canteen. *P.L.A.*

the committee work behind the invasion build-up in London but there was much solid planning and thoughtful improvisation which is worth recording as a vital preliminary to D-Day.

In the Diversion Room of the Ministry of War Transport a committee met daily to consider the latest shipping intelligence consisting of a list of ships in the next convoy to arrive at the United Kingdom, with full details of the cargoes carried. After considering the speed of the convoy, the draft and tonnage of each ship, the peculiar nature of any special cargoes carried and the capabilities of the derricks and discharging gear in each vessel, the committee heard spokesmen of the various Government departments on the final destinations and other relevant details of the consignments. Tentative decisions were referred to the representatives of the ports attending the meeting, and within an hour or two every ship had been given her destination.

The list of ships allocated to London was passed on to the London Port Emergency Committee which sifted still further the factors of tonnage, draft, type of cargo, etc., and allotted each ship her individual berth. The information and directions were given to dock superintendents and dockmasters concerned who would be responsible for docking the ships. Dock officers with the military representatives then arranged storage of the cargo destined to remain in dock sheds, dumps and warehouses.

Simultaneously came the question of cargo for delivery outside dockland. The Port of London Transport Liaison Sub-Committee was formed to ensure the most efficient use of all forms of transport serving the port, and only through this committee were congestion and confusion at the docks and wharves avoided. The advance list showing every separate item of cargo in the expected convoy was put before the committee, which at the peak period nearer D-Day met daily in the head office of the Port of London Authority. This committee, like the Diversion Committee, included representatives of the relevant Government departments and the Services, who were able to give details of the nature and destinations of each parcel, and the Ministry of Transport's London shipping representative. It also included, besides the appropriate port officials, representatives of the railway companies, road transport, lighterage and canal services, and the coasting trade.

A London convoy might consist of up to twenty-eight ocean-going vessels laden with separate parcels for different destinations. Each

General Bernard Montgomery addressing London dockers on the eve of the invasion of Europe. He told them that their contribution to the D-Day preparations was a particularly important one. *P.L.A.*

destination was considered by this committee and the various consignments were allocated to the most convenient form of transport.

The National Dock Labour Corporation, which had been painfully building up the labour force, was also informed of the expected arrivals, and plans would be laid to have sufficient men ready to discharge these ships as quickly as possible.

By these means the disposal of every ton of cargo in the expected convoy was provided for before its smoke showed above the eastern horizon. It was not always as easy as it may now seem. Enemy attack, storm, breakdown and other contretemps might delay the convoy or some of its individual ships. Apart from holding up berths, men and equipment, late arrivals upset plans already made for the following convoy, so efforts had to be redoubled to iron out the ripple of disorganisation.

Coinciding with this great increase in trade, craft were being built wherever suitable sites could be found in the docks, slipways being constructed on waste ground or bombed sites and the craft being launched into dock basins. Tank landing craft were built in the Royal Docks and the Millwall Docks. By the end of 1943 work on these vessels was proceeding night and day. If a warning were sounded at night, the arc lamps were extinguished on the "Purple"; by day, work ceased only during the "Danger overhead" period. The success of these dock-built craft was a triumph for the London ship repair and engineering firms responsible.

As was fitting in a port from which before the war cement accounted for the largest export tonnage, concrete work of many types predominated, the busiest building areas being the Surrey Commercial Docks and the West India Docks. It was at Centre Yard, Surrey Commercial Docks, that the "Minca" (Made in Canada) prefabricated 100-ton wooden supply barges were put together.

In Chapter Ten details will be found of a training scheme for Inland Water Transport personnel organised by the lighterage trade at the Surrey Commercial Docks. Other training schemes also came to fruition in the docks of London, the training of army crane drivers beginning early in the war and continuing until 1945. The Crane School started at the West India Docks but its success caused it to be extended to other docks. Crane driving is a highly skilled operation and much damage is possible if the crane is handled by an inexperienced driver. The training syllabus was accordingly very detailed and included steering, hoisting, luffing, grab work, making up sets, maintenance, etc. More than six hundred men were trained and received certificates of competency.

At a later stage in the war the National Dock Labour Corporation,

warned of the certainty of increased demand for skilled dock labour with the approach of D-Day, asked the Port Emergency Committee to start a similar scheme. The result was that some hundreds of civilian trainees passed through the dock crane schools.

Men of the Royal Engineers were trained in the docks of London for a new Dredging Company formed for service in captured Continental ports. Dock schools for general port operation were also organised for the Royal Engineers, lectures and sessions of practical work being given by dock staff. The dock police also gave instruction in their branch of police work and particularly in security to members of the Corps of Military Police and, nearer D-Day, to American Service Police.

Ferro-concrete barges with substantial timber fendering were among the craft built by Thamesside yards in wartime. *P.L.A.*

In addition to all this work carried out by Port of London staff, dock facilities were readily granted to the Navy and Army for other training and experimental schemes. In the St Katharine Docks the Royal Engineers trained some of their men in assembling and dismantling Bailey bridges. In the Surrey Commercial Docks the Admiralty experimented with submersible craft and with chemical deposits to camouflage large areas of water likely to provide navigational marks for enemy planes. "Human Minesweepers", naval divers who cleared all the captured Continental ports between Cherbourg and Bremen of enemy mines and underwater charges, were largely trained in the Tilbury, Royal, Surrey Commercial and London Docks*.

Late in 1943 and early in 1944, structural alterations at the docks, including the construction of new roads and loading hards, were forerunners of coming events. Next came the construction of great vehicle parks in hardcore; practically every square inch of unoccupied ground within dock fences was used.

To the planning of this great adventure must be added the work of the Port of London Authority Railway Department. Contrary to the normal working of the port, which relied to a major extent upon barge and road traffic, the dock railway system became the mainstay of plans for D-Day. In common with most other Port of London services it had suffered frequently from enemy attack and it had already supplied many men and locomotives and much other equipment for the Services and for other ports.

It now became essential to plan for the greatest possible use of the dock railway systems. The estimated daily turnround was rated at five hundred waggons at Tilbury Docks, twelve hundred at the Royal Docks and two hundred at the West India Docks. This meant an even flow of nearly two thousand waggons a day to and from the three principal operational docks; the Port Emergency Committee visualised the results of even a few hours delay in this daily programme and took steps to ensure that no congestion occurred. Direct telephone lines were installed between the headquarters of the P.L.A. Railway Superintendent and the main lines feeding the three docks. As each train was made up in different parts of the country it was given a code number for identification. When it began its journey to London the Railway Superintendent was informed of its progress and whether it was gaining or losing on the estimated time for the journey. As it neared London he could gauge within a small margin the exact time of its arrival on the dock sidings. If, on the other hand, fog, storm or enemy action delayed the

*Open the Ports—the Story of Human Minesweepers, by J. Grosvenor and L. M. Bates, Kimber, 1956.

arrival of the ships once sustained movement for the invasion had begun, he could ask the main lines to "stable" the train at suitable sidings until the even flow could be resumed.

The success of this organisation is revealed in the fact that more than

The former Exchange Sidings at the Royal Victoria Dock played an important part in the build-up for D-Day. At one period some 2,000 wagons entered and left the port each day.
P.L.A.

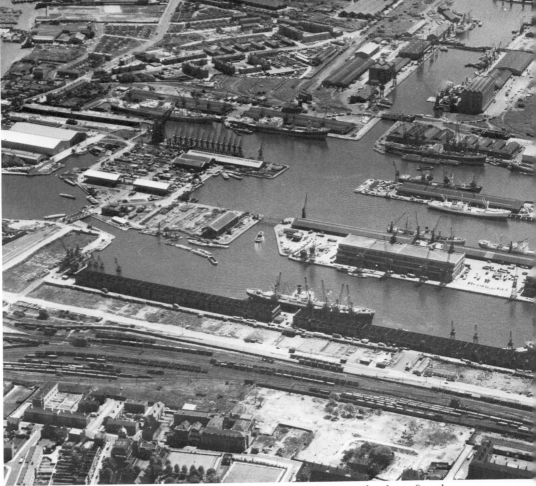

The West India and Millwall Docks seen from the air in a photograph taken after the war.

P.L.A.

89,000 waggons inward and outward were handled in the docks of London from D-Day to 31st August, 1944.

At the beginning of 1944 the enemy stepped up his occasional nuisance raids. During an attack on the Tilbury Docks a locomotive fireman who had reported for raid duty as a member of the Home Guard found a number of waggons containing smoke generators on fire near sidings full of waggons loaded with bombs and ammunition. He raised steam in a dock locomotive, drove it single-handed to the threatened sidings, adjusting en route no fewer than eight sets of points, coupled up the burning trucks and isolated them.

In February, 1944, the Tilbury Hotel, landmark to ships arriving in

80

the inner estuary and place of entertainment for many overseas visitors to the port, was fired and burned to the ground by enemy attack. This loss was particularly felt by the large number of Service personnel preparing for D-Day at Tilbury and living at the hotel. During the same raid the shipping office, which had been requisitioned and equipped as headquarters for the Tilbury Movement Control organisation, was also destroyed, so that emergency quarters had to be found elsewhere almost on the eve of operations.

The broad outline of D-Day in the Port of London was principally the story of the Tilbury, Royal and West India Docks and the river. The spirit that permeated dockland on the eve of D-Day can never be recaptured in print; thousands of men were inspired to give of their best, and an immense team toiled with enthusiasm to get ships away on time. The men at the docks saw large numbers of their compatriots making ready for the greatest adventure in our national history and were themselves infected with the prevailing mood to withold nothing that might help the invasion.

It is hard to say who bore most of the burden sustained by all port workers, but perhaps the dockmasters and their staff were tried the hardest. The incessant derrick work for loading, tugs for internal movement and the never-ending arrival and departure of ships, all these were only made possible by the steadfastness of war-depleted docking crews, hardly one of whom was below middle age and who, by reason of the skilled nature of their work, could not be supplemented by emergency labour. Most of the locks were working incessantly, twenty-four hours a day for about four months. Schedules were arranged irrespective of the state of tide and other factors which normally govern the convenience of ship movements; whatever the schedules, the dockmasters and their staffs never fell behind. If circumstances outside human control interrupted the schedule, then the schedule was re-arranged; there was no break in the flow of troopers and supply ships which entered and left.

After the initial launching of the invasion military supply traffic was largely centred at the Tilbury Docks, where all commercial work ceased in the interests of the British Liberation Army. From before D-Day until the end of the sustained movement, a special committee representing dock staff, the three Services, stevedores, shipping managers, trade unions and the National Dock Labour Corporation met daily to plan the most efficient use of all dock facilities. Co-operation between these bodies, on a high plane throughout the port, transcended at Tilbury all prejudices, and the determination to overcome all obstacles was almost fanatical.

Introduction of the enemy's long-range weapons soon after D-Day threatened to dislocate the plans upon which the build-up in Normandy depended. Once again the docks of London were the principal target. All the docks suffered from these attacks, one of the worst incidents in the flying bomb period occurring on 23rd June, 1944, when one burst on the Exchange Sidings at the Royal Victoria Dock, the heart of the port railway system which bore the brunt of the great movement. Fires immediately broke out in trucks containing petrol and ammunition. The railway staff, military personnel and dock police acted so promptly that a catastrophe was averted. One member of the dock staff crawled under a burning truck containing petrol, uncoupled it and helped push it clear. Then, noticing debris burning on the tarpaulin cover of a truck containing ammunition, he climbed to the cover and extinguished the fire. Similar action was carried out by other members of the railway staff and by police. This flying bomb fell at 09.30 and seven roads were affected. Railway staff, dock engineers and Army personnel, with help from one of the main line companies, restored normal services within two days.

There was a malignancy about these seemingly aimless weapons which was almost uncanny. A ship lying at the Brunswick Buoys, Surrey Commercial Docks, was hit and damaged by a flying bomb. She was moved to a dock quay for repair work and, in this new position, four days later was hit by another flying bomb.

The Exchange Sidings were also the scene of one of the worst rocket-bomb incidents at the docks, on 31st October, 1944, at a time when the great build-up of supplies at Antwerp was making the dock railway system more than ever an important line of communication. A dock pointsman had just pulled a points lever towards himself when something happened and he found himself dazedly clutching the lever some fifty feet away; where the points had been was an enormous crater. It is alleged that a lighterman, one of those who came to the railwayman's help, made a comment about "strength through joy". The damage done by this missile was very heavy, the delay might have been extremely serious to the Continental armies had not magnificent co-operation lessened the effects. Within twenty-four hours two lines had been cleared and were accepting traffic, while a bulldozer was filling in the crater and hardening the ground. Rails and points were brought by road from the Royal Engineers' stores at Longmoor, and with the assistance of the Army and railway personnel from Stratford the port railway staff and engineers had the sidings working normally by 6th November—six days after the incident.

On 22nd February, 1945, when London was nearing the end of the

last of its ordeals, a rocket-bomb made a direct hit on the lockside of the King George V entrance lock, wrecking one half of the bascule bridge over the lock. This lock was the principal ship entry into what was then the most important dock system of London. The heavy counterbalance weight box was propped and the damaged section of the bridge cut away and lifted clear by the *London Mammoth*, a 150-ton capacity floating derrick, use of the lock entrance for shipping being made available within a few days, though road communication across the entrance lock was considerably delayed.

A floating crane towers over the merchant aircraft carrier *Empire MacAlpine*, one of a class of ships built from 1942 onwards to help provide air cover for convoys, as she discharges bulk grain in a London dock.
P.L.A./Beckley

83

CHAPTER NINE

The Harbour and River Emergency Services

THE Harbour Service and its wartime auxiliary, the River Emergency Service, became something of a backbone to the port at war. Their practical knowledge of the tideway was a perpetual pool into which all freely dipped; they were tested to the last tired muscle, patrolling, improvising, warning, helping and advising the military services and others who were trying to understand and harness the often wilful and always temperamental tides.

In common with other departments of the Port of London, the Harbour Service had laid plans in anticipation of the emergency so that when war broke out men and craft switched over to a new routine with little disruption. Immediate problems were many—the difficulties of night navigation in the blackout, the secrecy enshrouding all ship movements, the arrival and departure of vessels in convoy, and the necessity for closer observation and control of river moorings and anchorages.

The first of the Harbour Service's many protégés was the River Emergency Service, whose craft and crews were mobilised on the outbreak of war and were for a time something of a liability. With the best will in the world, these amateur watermen had to learn by their mistakes and it was only their enthusiasm and the patient guidance of the Harbour Service that produced an efficient and useful auxiliary organisation within a comparatively short time.

At the outbreak of war the R.E.S. consisted of fourteen ambulance vessels and 135 tenders manned by yachtsmen and others with some knowledge of handling craft. Each of the ambulance vessels also carried a doctor, two trained nurses, ten V.A.D.s and two orderlies. The ambulance vessels were not in great demand until the big raids began in 1940, but the crews of the tenders speedily showed that they had assimilated not only the professional skill but also the spirit of the Harbour Service. Their work was noticed in official quarters and in June, 1940, most of the men and craft in the R.E.S. passed under the White Ensign to become the Thames Royal Naval Auxiliary Patrol Service*, leaving the R.E.S. consisting of only the ambulance vessels and a few tenders. The tenders, manned by part-time volunteers, continued to function in the Thames until the end of the war.

*Chapter eleven

In November, 1940, before the Admiralty had completed its river minesweeping organisation, the Harbour Service carried out the first sweeping operations in the port. With the indifference engendered by complete ignorance of magnetic mines, members of the Harbour Service carried out an amateur sweep in a well-meant effort to clear a suspected area. To their surprise and consternation the party fished up a mine parachute. Luckily for them, no mine was attached to it.

It was during this early period that the Harbour Service surrendered some of its craft to the Admiralty, a measure which entailed closer fusion between the Harbour Service and the R.E.S., and later, the Thames Royal Naval Auxiliary Patrol Service. Among the craft which exchanged the defaced Blue Ensign of the Port Authority for the White Ensign of the Royal Navy were the survey vessel *St Katharine*, which joined the Thames Examination Service in the estuary, the harbour launch *Havengore*, which went to work for the Naval Control Service, and the notorious drifter *Girl Pat*, which entered the minesweeping service. Before the war, the civilian skipper of this little vessel had rebelled against the boredom of fishing in home waters and, navigating by a

Junior-Commander Mary Churchill in A.T.S. uniform with the Right Hon. Thomas Wiles, P.C., after presenting gallantry certificates to members of the Port of London staff.
P.L.A.

school atlas, had illegally taken his craft on a world cruise which gained him wide publicity.

The surveying officers attached to the Harbour Service put their intimate knowledge of the river bed to good account throughout the war. In November, 1939, they assisted the R.A.F. to place waterborne barrage balloons in position and in May, 1940, they helped the Navy to establish degaussing* ranges in the river where ships could be "wiped" to protect them against magnetic mines. In October, 1940, they advised the Army on the positioning of waterborne high-angle guns for river defence. They did the surveying work for defence booms, controlled minefields and mine-watching barges, and did much else.

It was during the Dunkirk crisis that the Harbour Service, supported by the R.E.S., was able to show its worth. The organisation by which barges, launches and ships' boats were collected and delivered to Tilbury was principally in the hands of these two services. Tilbury Dock Basin and the Ocean Stage became the main outfitting depot where Harbour Service and other port officials co-operated with the Navy in checking equipment, issuing food, water and fuel, paying expenses, executing temporary repairs and advising civilian volunteers concentrated in the Tilbury area. Like many other good men eating out their hearts in the port, they were tied to their duties in the river, but a few of the R.E.S. men managed to obtain leave whereby they were able unofficially to assist in the evacuation.

After Dunkirk the Harbour Service made a nightly selection of the ships available for sinking in the river to block the navigable channels if the threatened invasion occurred. These men, to whom their normal work of keeping the channels clear of wreck and obstruction was almost a religion, viewed this melancholy duty as the last measure of our desperate plight. Craft were held at emergency stations and "scorched earth" plans were ready to be carried out at all river landing points.

As in all other sections of the port, the raids which began in the autumn of 1940 laid a heavy burden on the men of the Harbour Service. Damaged ships required their attention, barges and other craft on fire came within their sphere, collapsed barrage balloons attended by a nightmare of wires had to be cleared, expert advice was urgently demanded by the Navy, the fire services and other bodies having emergency business in the Thames. Every raid found Harbour Service launches participating in the battle. When the raid was over it was their sad duty to visit casualties, for each craft sunk in the channel, every

*The degaussing process, in which an electric current was passed through a cable hung around the hull, neutralized the ship's magnetisation. The process was named after a German mathematician, Johann Gauss (1777–1855), who made a major contribution to the study of terrestrial magnetism.

smashed pier or wharf had to be marked clearly to warn shipping likely to be endangered by the obstruction. The green wreck-marking flag began to appear on and along the Thames, spreading swiftly until the Harbour Service was forced to send out an urgent appeal for green bunting with which to replenish its stock. Sunken craft or aeroplanes reported in the river were not always easy to find and the search often involved many hours of tedious sweeping before the wreck-marking boat could be accurately placed in position.

A wartime story of the Harbour Service is centred on the barge *Hoylake*. This vessel was blown out of her berth by a high explosive bomb and sank in the fairway. The Harbour Service swept the area, located the wreck and marked it with an illuminated warning signal. The Harbour Service launch was turning away when there was a loud explosion and the sunken vessel broke into two pieces, demolishing the wreck-marking signal. The *Hoylake* had chosen to sit upon a delayed-action bomb. Half the barge was secured and beached but the other portion defied all efforts to find it again.

A few days later H.M.S. *President*, the R.N.V.R. drill ship in King's Reach, reported that there was a wreck beneath her which would endanger her safety when the tide ebbed. On investigation the Harbour Service found the wreck to be the missing half of the *Hoylake*. As dusk was falling they cleared the wreckage from beneath the *President*, only to be faced with further difficulties. The tide was rolling the wreck along the river bed, doing its best to tow the tug to which it had been secured. The crew decided to take the line of least resistance and follow the wreckage, endeavouring to work it into a suitable beaching site. They were negotiating the temporary works of Waterloo Bridge when the nightly raid started. Flames soon began to lighten the blackout, making their task a little easier, although they were covered in dust and debris from an explosion on the Embankment. Eventually they succeeded in beaching the remains of the *Hoylake* on the south shore. But the very next night a bomb struck a nearby wharf and the rubble completely buried the remains of the barge.

After one such night, one of the assistant harbourmasters had an amusing encounter. Homeward bound at the end of a raid, he boarded a late-night bus. The only other passenger informed him that his job was exposed and that he was very cold. To this the harbourmaster replied that he, too, had been doing exposed work and was very cold. Harbourmasters wear a slight variation of the uniform of Merchant Navy officers and the other passenger looked at this with respect. "Yes," he said. "You must get frozen. The way the wind sweeps round them platforms every time a train comes in..."

In March, 1941, the Ocean Passenger Stage at Tilbury, an important riverside key point, received a direct hit. Luckily the bomb struck the only spot where the wound was not vital, and although extensive damage was done it failed to put the stage out of commission. Minor problems were caused to the Navy and the P.L.A. but there were no casualties.

In April, 1941, there occurred the disaster to the tanker *Lunula* at Thameshaven*. The resulting fire burned for ninety-seven hours before it was put out. Torpedoes mounted on a nearby jetty were fired as a precaution and they buried themselves in the mud on the south bank without exploding; this was probably the first time torpedoes had ever been loosed in the Thames. The Harbour Service craft *Westbourne* co-operated with the fire services afloat and ashore and with a number of auxiliary patrol craft in minimising the effects of the catastrophe. They

Nurses of the River Emergency Service were trained in signalling as well as other nautical accomplishments.

P.L.A.

fought fires at the oil jetties and extinguished the flames raging in the tug *Persia* which had also been involved in the disaster. As well as exploding ammunition in the *Lunula*, burning oil jetties and the blazing tug, patches of burning oil floated on the river, while showers of red-hot debris and cascades of blazing oil added to the difficulties.

The River Tug Fire Patrol (described in the next chapter) was operated under the supervision of the Harbour Service. This involved a nightly visit to each tug by a Harbour Service launch. Considering the difficulties of navigation in the blackout, the dangers from the sky and the fact that reaches of the river were sometimes closed to all other craft owing to the suspected presence of mines, the nightly visit became a highly adventurous undertaking.

As regards the problems of Harbour Service work during the

*Chapter two

blackout, a story is told of one launch which got under way in the dusk to pay crews of the R.E.S. vessels scattered up and down the tideway. The launch visited the usual patrol haunts, discovering them one by one with the utmost difficulty. Dawn was breaking when the last ambulance vessel was found secured to a barge road. The crew of the Harbour Service launch, pleased with its success, was preparing to go alongside when a stentorian voice from the R.E.S. craft howled: "Shut that bloody engine off; you'll wake the nurses."

On 11th May, 1941, Tower Pier was completely destroyed by a high explosive bomb. This pier, from which hundreds of thousands of trippers had sailed in the summers before 1940, was almost as important to the upper tideway as the Tilbury Ocean Stage was to the lower river. The casualties were mainly R.N.A.P. personnel, but three members of the Harbour Service also lost their lives. Following this tragedy, Westminster Pier became the principal Harbour Service station in the area.

When the Port of London emerged from the concentrated attack and began the happier phase of preparation for the invasion of the Continent, there was no cessation in the calls made upon Harbour Service skills, for each new offensive and enterprise with which Thamesside industry was charged, Maunsell forts, Conums, Phoenix units, etc., required the help of P.L.A. marine surveyors to establish constructional sites and advise on depths and tidal peculiarities. Harbourmasters were on hand when launchings took place and towage up or down the river was invariably escorted by a Harbour Service launch.

In the D-Day preparations and operations the Harbour Service co-operated to ensure that every mooring, anchorage and pier was used to best advantage. Hundreds of small coasters selected for that enterprise were allocated berths in the river; when they were loaded, watered and provisioned they returned to their river berths to await sailing orders. All this river movement, including a large number of special D-Day anchorages extending from Long Reach to the east end of Gravesend Reach, was controlled by the Harbour Service. Not the least onerous duty was the issue of a confidential daily station list of ships, as the Harbour Service was the principal medium for shipping intelligence in the Port of London.

During the war the Harbour Service gave major or minor assistance to more than four hundred ship casualties, involving collisions, strandings, sinkings, loss of anchors, fires or damage by enemy action. It assisted in and recorded the degaussing of over 12,000 vessels. More than 7,000 ships were provided with fresh water, and fuel was supplied to hundreds of small craft.

CHAPTER TEN

The Lighterage Trade

T HE lighterage trade, an important service of the Port of London at war, was closely linked to the tides. Twice daily they flood and ebb to and from the heart of the Metropolis. These are no ordinary events; despite the decline in waterborne traffic, the Thames tides are still as much a motive power in the movement of London's commerce as steam, electricity and oil. Daylight and darkness, Greenwich Time and Summer Time were, and to some extent still are, subordinated to tide-time, which transcends all other hours and is the signal for London's ships and craft to move up or down river. Before the war this twice-daily pulse of the Thames circulated more food, necessities and comforts than any other waterway.

Some seven thousand barges or lighters were employed in the tidal Thames. They were nearly all "dumb" (they had no propulsive power of their own), and ranged from fifty-tonners to five-hundred-ton craft. Many of them were designed and equipped to deal with specific trades; insulated barges carried meat, tank barges were provided for oil, hatched barges protected "fine" cargo, and so on.

With the exception of those beautiful anachronisms, now alas almost extinct, the Thames spritsail barges, steel had almost entirely superseded wood in barge construction. They were strictly utilitarian craft designed to carry the maximum amount of cargo.

The movements of this fleet were aided by steam or diesel-engined tugboats. These craft tugs should not be confused with the bigger ocean-going ship-towage tugs; their spheres of use are quite distinct and, except in abnormal circumstances, they are not interchangeable. Today, steam has been almost completely vanquished by the diesel engine in towage work.

About two hundred firms were directly engaged in this carriage of tide-borne cargo. Many of them specialised in the transport of particular classes of goods, some of which presented problems as regards weight, bulk, perishability, etc.

The barges were handled by skilled workers known as lightermen. In many cases the calling was carried on from generation to generation of the same family, and these men had unrivalled knowledge of the river and its ways. There was a touch of the sailor about them, but they were

essentially landsmen, almost aggressively so, and the bowler or soft hat yielded not an inch to the uniform cap.

Tug crews, too, had to be equally experienced. Each master was a Thames waterman. Lightermen and watermen are licensed by their ancient guild, the Company of Watermen and Lightermen of the River Thames, after serving some seven years apprenticeship. A tug towing a number of barges on a three-knot tide needs a master who knows exactly what he is going to do before it becomes necessary to do it; he has no brakes, his road surface is also moving, and a dragging tail of some hundreds of tons in weight is apt to make steering uncertain. Add a dark night, a few bridges and brilliantly moving traffic lights on the riverside embankments and the work begins to look difficult.

The grapevine by which news spread quickly through the port owed much to Thames watermen and lightermen. An old river story tells of two lightermen, in charge of barges passing each other, exchanging news, their voices rising as the craft drew further apart. Then, when they were almost out of range, one man called out: "If I tell you something will you keep it dark?" The other agreed and the first man used leather lungs to cry: "Well, Liz is in the family way again."

Lightermen working on the river navigated their barges with thirty-foot sweeps, though more often these craft were to be seen towed by small steam tugs.

P.L.A. Collection, Museum of London

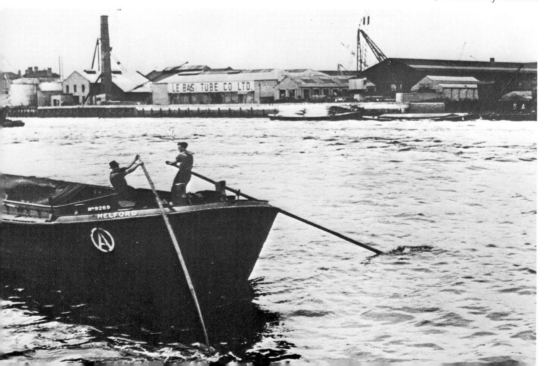

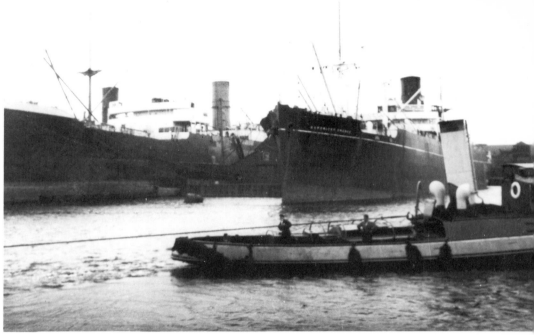

A scene in one of the London Docks, with a small tug going about its work. The tug's funnel can be lowered to pass under the London bridges.

In normal times Thames lighterage undertakings operate as separate units, although conferring together for common purpose through various trade associations, the most representative of which is the Association of Master Lightermen and Barge Owners. Another organisation to which many belong is the Council of Rough Goods Lighterage Employers. "Rough" goods as the name implies are cargoes such as coal, ballast, ores, etc., as opposed to "Quay" goods, the cased and baled products of commerce normally landed at wharves and quays.

During the months that followed Neville Chamberlain's return from Munich, it appeared to some that a pool of all tugs and barges would best meet the needs of the port if war came, and the lighterage trade formed a committee to plan accordingly. Full-scale "emergency" exercises carried out in the port during the early summer of 1939 revealed two important facts; they proved that the separate undertakings of which the lighterage trade was composed could sink their competitive viewpoints and co-operate in the interests of the port, and that the industry could count upon the whole-hearted backing of its employees. If the separate

undertakings and their employees could be trusted to give of their best, why substitute a new and complicated routine for a system with which the trade was so familiar? If the industry was ready to adopt self-discipline and able when required to introduce more flexibility and adaptability into its methods, why scrap the old and tried ways of operating the trade?

With faith in its members and their employees, the Association of Master Lightermen and Barge Owners agreed to abandon the complicated plan for pooled craft and men and decided to substitute a simple control organisation which would provide the necessary liaison between the wartime Port Administration and the trade, allocate overloads and retain the valuable experience of individual operators in their specialised services. This wartime control of the lighterage trade was known as the Lighterage Emergency Executive. With the coming of war, it became responsible to the Port Emergency Committee and so to the Ministry of War Transport.

The early wartime problems which confronted the lighterage trade included the lighterage of prize cargoes sent in by the Contraband Control Service, the dispersal of London's food stocks and the call for craft for the overside discharge of stranded and damaged ships.

One of the first wartime tasks of the Lighterage Emergency Executive was the provision of a number of craft suitable for conversion into bases for river-borne barrage balloons off Southend and Sheerness. The craft required were the big self-propelled barges used principally in the ballast trade. Only a limited number was available in the Thames, and the committee obtained a supplementary fleet from the Humber. These craft were equipped with winches and other gear necessary for operating the balloons, the vessels being handled by civilian crews provided from the lighterage trade.

It was at first arranged that these craft would run into Sheerness under their own power to obtain supplies of gas, food and fuel, and reliefs for the R.A.F. balloon crews. Within a short time, however, it was found that self-propelled barges were required urgently for work of a higher priority and, again through the services of the Lighterage Executive, big dumb barges were substituted, permanently moored in the river at strategic points and serviced by three craft tugs, the *Lion*, *Denton* and *Hurricane*. These little craft did good work, keeping to their schedules in fair weather and foul, so that the balloons could continue their invaluable work of protecting the convoy anchorages from divebombers.

The Dunkirk evacuation created many urgent problems for the London lighterage trade. The multitude of boats and small craft collected from all areas in the Thames were, in many cases, delivered to

the depots at Tilbury, Sheerness, Southend, Dover, Ramsgate and Margate by the London craft tugs. This tug had to drop everything at a moment's notice and proceed to such and such a point to pick up so many lifeboats; that tug had to take in tow so many motor yachts, and so on. If a priority call for so many barge loads of fuel to be delivered to Ramsgate or Dover was received, the craft and their cargo were under way in record time. One lighterage firm towed 187 mixed craft between points as far apart as Sheerness and Wargrave, a distance of 125 miles. Another towed eighty-two boats and fifteen barges to Tilbury, sixteen launches to Southend or Sheerness, and fourteen motor yachts to Ramsgate. Although their work was principally carried out in home waters, a number of craft tugs managed to get into the thick of it at Dunkirk. At least one, the *Fossa*, never returned.

The fifty-seven consecutive nights of aerial attack in 1940 were the greatest test that Thames lightermen and watermen had ever been called upon to endure in their long history. Between raids they carried on the routine of the port or helped to extinguish the fires which burned, sometimes for days on end, in riverside premises. When tide-time coincided with raid-time, they carried on undeterred by bombs, incendiary or high-explosive, or shell splinters. Their native philosophy stood them in good stead, for they argued that as there were no deep shelters in the exposed waters of the tideway one might as well take a chance and go through the raid as remain tied up to a buoy.

Almost every tow was an adventure during those fifty-seven nights. One craft tug, standing by some tank barges loading six hundred tons of petrol during one of the early night raids, was straddled by bombs which blew out the fires in her furnaces. No other damage was done, so when the craft were loaded the tug took them in tow and carried on through burning London. In an almost impenetrable blanket of smoke the tugmaster groped through the arches of several bridges, his crew and the lightermen (with colourful epithets) kicking overboard the burning debris which showered on to the craft. The tug and its barges with their quick-triggered cargo reached their destination safely. On another occasion the same tug was lying alongside an empty petrol barge when a bomb made a direct hit and the barge disappeared loudly and abruptly. "Well," said the skipper philosophically to his mate, "that's one barge we shan't have to tow tonight!"

There were countless other incidents in which incendiaries and flaming debris were kicked off petrol barges and lighters laden with equally dangerous cargo. The pattering of shell splinters on steel decks became almost monotonous; it must be remembered that craft tugs usually have no bridge shelter.

At least one craft tug seemed to be under special protection, for her escapes were close and many. Once she was moored to a pier which was showered with incendiaries and which burned so fiercely that the tug crew had only just enough time to get themselves and their craft away. Soon afterwards a high-explosive bomb burst on the quay to which she was secured and blew off most of her upperworks. Her recovery in a repair yard was delayed by another near miss. Soon after she had returned to service another bomb again removed most of her upperworks. It may be added that later in the war she was shaken up on three occasions by her apparent attraction for pilotless flying bombs.

Through it all, these Thamesmen never lost their sense of humour. One tug skipper, finding he had left his "tin hat" at home, was seen during a raid going up river wearing an old opera hat which he had retrieved from a dump.

When the River Tug Fire Patrol was organised, tug crews of London River had adventures which had never before come their way. Here is a record of one such crew during a night raid. First they butted a burning barge clear of barge roads; the fire was too fierce to be extinguished and the barge being constructed of steel was difficult to sink, so it was shepherded to a quiet corner and left to burn itself out. The tug next

Goods being discharged into lighters in the Royal Victoria Dock. *P.L.A.*

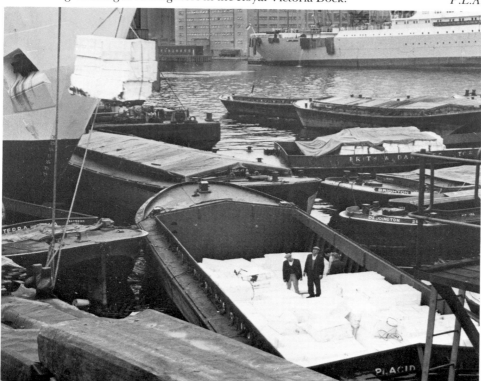

towed three barges containing valuable cargo away from a burning wharf and secured them to a buoy, then pushed another burning barge clear of a barge road, rammed and sank her. On the same beat they rammed and sank a blazing waterman's skiff and boarded a hulk to extinguish a fire in her hold. Next, eleven barges were towed away from a burning pontoon. Then the tug rammed and broke up a burning barge containing lumber, extinguishing the burning pieces as they floated clear. The next evening they repeated much the same performance.

All the time there was a constant hail of incendiary bombs and splinters, and the crew cast anxious glances in the direction of their homes. A sidelight on the fire-raising raids was the discovery that the steel holds of damaged barges could be repaired to provide excellent emergency water supply tanks for the fire service.

Several craft and their crews were lost before the Navy could take effective action to counteract the menace of parachute mines dropped in the docks and the tideway and scores of barges were sunk by bombs but for a time good luck attended most of the craft tugs. Among the first to go in January, 1941, was the *Lion*, which had been doing such good work with her two consorts attending the barrage balloon craft in the lower tideway and rendering help to ships which had come to grief in the vicinity. She was completely destroyed by a mine near Number 3 Medway Buoy, all her crew of five and a number of R.A.F. personnel on board at the time being lost. It is significant of the tideway tradition of family service that two fathers and their sons died in this disaster.

A few weeks later the motor tug *Charlight* was sunk by a mine just below the Millwall Dock entrance lock, her master and engineer and six lightermen all being killed. Again it is significant that the names of two pairs of brothers appeared in the list of casualties. Altogether more than a score of powered lighterage craft were lost by enemy action, though some like the *Charlight* were salved and returned to service.

Undismayed by this new menace, lighterage trade employees continued to give full loyalty and service to their hard-pressed principals. They were often unable to find the means of travel to the battered areas in which they lived and a ferry service of tugs was introduced, men coming off duty being landed at points from which it was possible to make their way home. Another boon during this winter, the second of the war, was the extra rations arranged for the men of the lighterage trade through the Port Emergency Committee.

During the period of expected invasion the Lighterage Emergency Executive positioned a number of old barges in the quiet waters above Teddington ready to be moved to positions where they would provide obstacles to seaplanes trying to land on the Thames; these were the

A steam tug and barges alongside a Houlder Line steamer, the *Hardwicke Grange*, in a London dock. The *Hardwicke Grange* was sunk by a U-boat in the North Atlantic in 1942.

counterpart of the poles and wires which protected our fields and roads from land-based aircraft.

When in the spring of 1942 the Navy took over a thousand barges* a new form of control was introduced, the London Tug and Barge Control, which largely superseded the Lighterage Emergency Executive. The principle of the new body was still voluntary co-operation but, as the title of the new organisation implied, the trade now voluntarily accepted more control of its operations.

At the beginning of 1943, at the request of the War Office, the Port Emergency Committee asked the lighterage trade to shoulder yet

*Chapter Three

another commitment by organising short training courses for Inland Water Transport recruits joining the Royal Engineers. A further 260 men had been taken away from the trade for Naval service and still more were required to man Army craft, and it was clear that the tideway could spare no more. To train landsmen in all the intricacies of tidal navigation, a training which took its own men seven years, was at first considered impracticable in the available time, but by that stage of the war everyone was used to overcoming seemingly impossible problems.

The late Charles Braithwaite, of the firm of Braithwaite and Dean, volunteered to become Training Officer and with the assistance of an enthusiastic committee organised a scheme aimed at turning landsmen into watermen in three months. The training syllabus was rather formidable, subjects to be taught including craft construction, knotting and splicing, fender making, wire splicing, anchor work, rowing and sculling, moorings, craft loading and discharging, rafting, chartwork and the compass. Practical work was to be taught aboard the tugs and craft in the river, headquarters for the school and facilities for dock training being provided at the Surrey Commercial Docks. It was soon discovered that there were no text books available to teach lighterage work, so the Training Officer and his committee produced and printed their own booklets entitled *How to tow Barges*. Models were made for theoretical and examination work, instructors were appointed from the trade and within a short time the new school was ready for its first class.

The Training Officer and some of his assistants were then asked to visit an Army depot to select candidates. It was decided to interview each man and by means of a series of questions to pick those with a little knowledge of craft work or kindred subjects, but the Training Officer was at first nonplussed to find that most of the men, very raw recruits to the Pioneer Corps, had only recently quitted trades and professions connected with almost everything except navigable waters. In the end the question crystallised into "Can you row a boat?" If the answer was "Yes" the candidate was passed into the school, if his answer was "No" he moved on to other spheres. The only hopeful gleam in the eye of the Training Officer during these interviews came when one man replied "Yes, I've been boatman on the Serpentine for seventeen years."

In due course the first class of ex-clerks, bricklayers, butchers, plasterers, bookmakers, bakers and others assembled at the Surrey Commercial Docks and training began. During the peak period 640 men were under training, 1,636 men passing through the school during the thirteen months of its existence. No fewer than 1,475, more than 93 per cent of the pupils, survived the passing-out test, the top pupil of the school being a former hotel waiter.

The lighterage trade approved of the zest with which these men devoted themselves to the work, and the soldiers were given far more than full measure, happy Saturday afternoon pulling regattas, boxing shows, concerts, a Christmas dinner and other relaxations being provided for the pupils. One enthusiastic volunteer from the trade instituted swimming classes and taught the art to no less than 70 per cent of the non-swimmers. When at the end of the war a fleet of craft manned by the school's former pupils put into the Thames the lighterage trade turned out to meet them and led the way to an "old boys'" reunion in their late quarters at the Surrey Commercial Docks. This training scheme made Thames history, for never before had the jealously guarded professional knowledge of the London watermen been made free to those outside their guild.

By the autumn of 1943 plans to strike back at the enemy were well under way, with more and more ships arriving in London with supplies for the invasion build-up; more and more food and daily necessities for the armed camps in the London area required transport. Much of this extra burden fell upon the lighterage trade, which found itself with a substantially reduced number of men and craft; for nearly four years there had been a constant drain on its manpower and its plant. About a hundred reinforced concrete barges being built for the Ministry of War Transport at the West India Docks were to be held in London for hiring by the trade as and when required, but this fleet would constitute only a small island in the sea of difficulties. It was soon evident that if the lighterage trade was not to stumble in the last lap of the race even more flexibility must be introduced into the industry.

In October, 1943, the London Tug and Barge Control instituted a licensing scheme under which, in return for a licence, individual lighterage firms guaranteed to work under the direction of that authority as and when required. The Control, established in the City at Plantation House in Fenchurch Street, was manned day and night; the duty officers were principally those members of the Association of Master Lightermen who had performed similar duties for the Lighterage Emergency Executive.

The last vestige of traditional craft operation now vanished; it was agreed that in an emergency quay goods would be carried in craft normally reserved for rough goods and vice versa. A daily report of the state of the industry compiled from daily returns sent in by the individual operators was placed before the Port Emergency Committee by the London Tug and Barge Control. This daily return, which would appear to the outsider as merely another irritating wartime form to be filled in, was the germ of the reorganisation scheme; by it the authorities could see

at a glance how loads were to be distributed and also whether the industry as a whole was overloaded or underloaded.

The assembly of the huge concrete "Phoenix" units for the Mulberry harbours demanded a large effort by the tideway craft tugs; the work of towing from the construction points to the fitting-out berths was almost exclusively their commitment. Overside loading of some of the supplies for D-Day threw a further burden on the lighterage trade, and the special bunkering scheme for the invasion fleets and other emergency plans had to be dovetailed into a daily routine.

To gather strength for this last effort every ounce of loyalty and co-operation was demanded from the operators and their employees. Just before D-Day an unusual conference was held at the trade's headquarters in Plantation House on a Sunday, the only day out of which a few hours could be spared. The delegates to the "Sunday Conference," as it was dubbed, consisted on the one hand of more than a score of the principals of the lighterage trade and on the other hand the full executive bodies of the employees' two trade unions, who gave full support to this unorthodox measure. Pipes were lit and in an informal atmosphere employers and employees discussed the problems the industry was facing.

The good effect of the meeting was apparent in the way in which the emergency was handled when it arose. A second Sunday Conference, equally successful, was later held to discuss in the same frank and friendly spirit some of the other problems affecting both employers and employees.

Among the last tideway disasters of the war was the loss of the tug *Naja*, which was hit by a flying bomb while standing by to assist any vessel having difficulty in negotiating the passage of Tower Bridge on 12th July, 1944. The crew were being relieved at the time; two men of the first crew had gone ashore and so escaped, but six lost their lives.

The lighterage trade provided one of the strongest pillars of the Port of London, enabling it to stand the long and heavy strain of the war. It was symbolic of its spirit that the captured enemy U-boat which came to the Thames for public inspection was escorted and assisted by two tilt-nosed little Thames craft tugs.

The Royal Navy

AT THE outbreak of war the Admiralty created a new Naval base in the Port of London. Apart from the Coronation festivities in 1937, Thamesside workers of this century had rarely seen a White Ensign in the river and they knew little of the routine in R.N. dockyards. Yet as the war progressed the traditions of the Royal Navy and the port were interwoven by intimate co-operation into a single pattern of service. The appointment of Flag Officer in Charge, London, was held in succession by two gallant and distinguished Admirals, Rear-Admiral E.C. Boyle, V.C., 1939-1942, and Admiral Sir Martin Dunbar-Nasmith, V.C., 1942-1946, each of whom gladly made full use of the experience and existing organisation of the port. The Flag Officer and his staff occupied accommodation in the head offices of the Port of London Authority, from which could be seen the mellow stones of the Tower of London, which inspired the name of H.M.S. *Yeoman* for the new London base ship.

The Royal Naval Auxiliary Patrol was one of the Navy's largest organisations in the tideway. The name of its base ship was also inspired by the same source; it was H.M.S. *Tower*. The R.N.A.P. had its genesis in the River Emergency Service formed by the P.L.A., and only those associated with the Thames during its years of endurance know what London owed to this organisation. From main depots at Tower Pier, Greenhithe, Tilbury, Cliffe and Holehaven, R.N.A.P. craft were continuously employed as handmaidens of the tideway, answering any and every call made on them by other Naval departments, the Merchant Service, the Army, the Air Force and the Port of London Authority. They worked in close collaboration with the London Harbour Service, learning much tideway lore thereby.

During the period when invasion threatened, the R.N.A.P. was one of the main waterborne defences of the Thames. Small yachts, their crews armed only with cutlasses and an occasional rifle or revolver, were reinforced as soon as possible with tugs and other more seaworthy craft armed with modern automatic weapons.

When mines were reported in the fairway, it was the duty of the R.N.A.P. craft to warn or turn back all river traffic likely to be in danger. If the report came too late to avert casualties, the men of the R.N.A.P. were on hand to tow the damaged vessels, aid survivors and help in a

dozen other ways. When the great fires of London raged night after night, the R.N.A.P. towed barges out of danger and assisted the Harbour Service, the N.F.S. and A.R.P. organisations. With the inevitable night "alert", R.N.A.P. craft immediately went to action stations. When parachutes fell like autumn leaves over the Thames, dismounted airmen, Allied and enemy, had occasion to bless the speed with which R.N.A.P. crews got under way; rivalry between the crews as to the number of airmen picked up became very keen.

Between such excursions the R.N.A.P. vessels ran a kite balloon

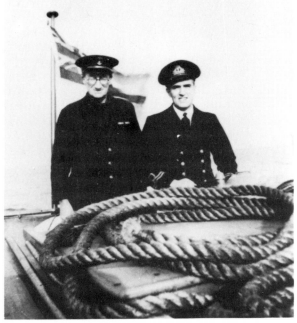

Petty Officer Sir Alan Herbert with the author in H.M.S. *Water Gipsy*, one of the vessels operated by the Royal Naval Auxiliary Patrol.

delivery and collection service for merchantmen entering or leaving the port, cheerfully accepting ribald suggestions that their little ships might become airborne. Another important duty of the R.N.A.P. was the manning and servicing of some sixty mine-watching barges and other craft moored in the river below Dagenham.

The R.N.A.P. suffered a number of casualties in men and craft when Tower Pier was destroyed by a high-explosive bomb. Their sub-station at Tilbury was also damaged when the Passenger Landing Stage was hit; while the other depots at Greenhithe (H.M.S. *Worcester*), Cliffe and Holehaven were no strangers to the effects of bombs exploding uncomfortably close.

When D-Day was projected it was recognised that the amateur crews with whom the R.N.A.P. had been founded had acquired expert knowledge of the river and the power of its tides, this knowledge being fully used, for example, in assisting the Harbour Service during the initial stages of herding to their rendezvous the great concrete "Phoenix" units and later in controlling the unprecedented flow of traffic taking part in the Normandy operation.

As might be expected from the type of man who volunteered for the Thames R.N.A.P. the organisation is believed to have supplied more lower-deck candidates for commissioned rank than any other branch of Naval service. A feature of the Naval base in the P.L.A. building was an A.B. doing sentry duty with rifle and bayonet—and wearing a monocle.

Because it was deemed that they operated only in "sheltered waters" the men of the Royal Naval Auxiliary Patrol Service were refused the 1939-1945 Star. Sir Alan Herbert raised the matter in Parliament. "From what were those vessels sheltered?" he asked. "They were not sheltered against bombs above or mines below, and, during the material times, these vessels were patrolling night and day, ready to repel invasion by land, by air, and indeed, by water. So that what they were sheltered against we do not know." Sir Alan received much support but their Lordships of the Admiralty were not to be moved.

An equally important section of the London Naval Command was the Minesweeping Service. Minesweeping inside the Nore was not part of the Navy's programme until November, 1939, when the first magnetic ground mines were laid by air in the estuary, two of these new weapons being discovered intact on the sands at Shoeburyness, at the mouth of the Thames. Lieutenant-Commander J. D. G. Ouvry and Lieutenant-Commander R.C. Lewis, of H.M.S. *Vernon*, the Naval school of torpedoes and mines, took the impressions necessary for the urgent manufacture of special non-magnetic tools, and then with complete disregard of the danger they rendered the mines safe, so laying bare the mechanism of Hitler's vaunted secret weapon and enabling British scientists to prepare an antidote. Following this attack a minesweeping base was established at the Southern Railway Pier, Gravesend. The first attempts to sweep magnetic ground mines were made by the Harbour Service, and the early efforts of the Navy were only a little more advanced; they involved a wooden barge laden with old iron, much courage and considerable luck. When the effort was successful, another barge and a further supply of old iron, courage and luck were necessary.

Enemy aircraft dropped parachute mines in the Thames as high upstream as Hammersmith and a regular comprehensive sweep of many miles of tideway had to be organised, the principal minesweeping base

being established in the P.L.A. head offices. The London flotilla made a daily sweep which was divided into two sections. The sub-base at Gravesend, home of the larger sea-going minesweepers using the highly scientific "Double L" (double longitudinal) sweep, swept from an imaginary line drawn between Canvey Point and Yantlet Creek up to Ford's jetty at Dagenham. Seaward of this beat was the responsibility of the Sheerness Command.

Above Dagenham it was difficult to us the "Double L" sweep owing to the lower salinity of the water, so from Ford's jetty upstream various tugs and launches were employed to tow skids, the skid being an earlier and more clumsy method of sweeping than the "Double L" but one which was suitable for use in fresh or semi-fresh water. The daily spectacle of minesweepers working under Tower Bridge and other London Bridges was perhaps the most dramatic demonstration of total war in a capital city.

In all sections of the river there were minesweepers equipped to deal with acoustic ground mines, those which were set off by sound waves from a vessel's propellor. A record of the number of mines destroyed is not available, but the results were highly satisfactory.

The daily sweep safeguarded only the main channel and it was impossible to search all the berths, barge roads, docks and creeks in which mines might be and were in fact laid. This gap in the defences was painfully brought to light by the loss of the *Lunula* (described in Chapter two), while other vessels were damaged in similar circumstances owing to the unsuspected presence of an enemy mine in a dock or riverside berth.

What was needed was detailed knowledge of where raiders had sown mines, a point which was stressed at a conference held in the P.L.A. head offices soon after the mining of the *Lunula*, as a result of which a minewatching service was organised. Nothing like it had ever before been envisaged and the Navy had no manual of rules but only imagination to guide them. As a first measure, all night watchers, sentries and patrols on the river banks were asked to co-operate, and within a short time fire-spotters, policemen, A.R.P. wardens, Navy, Army and Air Force personnel, Home Guard, watermen and others were organised into a skeleton mine watch. A reward of £5 was offered for each proved mine reported, and at least one old waterman put out in his skiff each time the night "alert" was sounded to drift under the rain of shrapnel and splinters, determined to earn what he considered to be easy money.

Each minewatching position was numbered and plotted on a key chart in the Naval Operations Room at the P.L.A. head offices. A bearing board, set to true north, was supplied to each post; in many cases the figures were outlined in phosphorescent paint for easier use on dark

nights. The watcher had only to report the number of his post, the bearing in degrees of any missile seen to enter the water, the estimated distance and the time for an accurate plot to be instantly forthcoming in the operations room. A network of communications including a number of "walkie-talkie" wireless sets was improvised over the whole port to ensure speed in reporting.

The Thames organisation worked so well that it was eventually adopted as a standard for United Kingdom and overseas ports threatened by aerial minelaying, but there were gaps in this voluntary line of defence. To fill these a number of Naval ratings unfit for more active service were recruited to man some sixty wooden barges permanently moored at intervals along the edges of the channels in the lower reaches of the river where distance rendered observation from shore posts impracticable. The co-ordination of this floating minewatch was in the hands of the R.N.A.P.

A special problem was posed by tunnels under the river, for a train passing through might activate an acoustic or magnetic mine lurking in the mud overhead, with fearful consequences for the passengers. Observation posts were constructed overlooking tunnel sites and other vital targets, and the watchers in these posts could use direct telephone lines to speak to railway signalmen in the signal boxes concerned. Flood gates in most of the tunnels under the river were closed when the "alert" sounded and were not opened again after an air raid until clearance was given by these posts.

In the upper tidal reaches the observation posts were manned by members of the Women's Royal Naval Service, who evoked the admiration of all who saw their keenness and courage under bombardment. Fiercely patriotic, they carried out boring and unspectacular duties without complaint. It is hard to realise that those girls are now grey-haired matrons. One wonders what happened to the Wren, little more than a schoolgirl, who when she appeared before the Commander as a defaulter pleaded in a whisper: "Please, sir, I was drunk." It appeared that the sentry, an old sweat, had advised her to plead drunkenness as being likely to incur the most lenient punishment.

By these methods the tideway was watched from Teddington to the sea and several thousands of men and women turned out to combine minewatching with their other duties each time a night "alert" sounded. To train them in taking bearings and judging distances and to maintain their enthusiasm a fortnightly exercise was arranged involving the use of a balloon which could be illuminated and rapidly hove down to the deck of the exercise launch, H.M.S. *Water Gipsy*. That they were of the utmost value was in no small measure due to the careful night positioning (in a

blacked-out river) and excellent seamanship displayed by Petty Officer Sir Alan Herbert, M.P., who was the naval coxswain employed on this work. Sir Alan, who was Member of Parliament for Oxford University and a writer of distinction, was a most enthusiastic volunteer in the R.N.A.P.

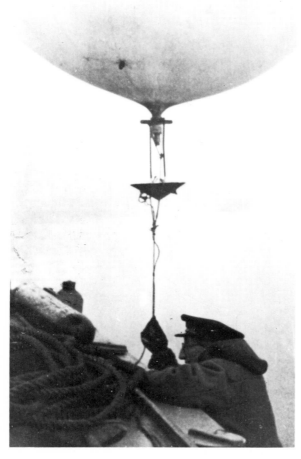

Petty Officer Sir Alan Herbert seems to be having some trouble with the balloon used for mine-watching exercises.

For her size, and due to unofficial additions to her armament, *Water Gipsy* was probably the most heavily armed vessel in the Navy. Once she opened fire with her battery of miscellaneous machine-guns on an enemy plane over Westminster, and Herbert afterwards claimed that it was the only occasion in history that a warship had opened fire in defence of the Mother of Parliaments.

The tideway grapevine spread many stories about A.P. Herbert during his wartime service, one of them concerning the events of a winter's night when the *Water Gipsy* was secured to a barge road. Just before dawn another barge road upstream broke adrift and descended upon the *Water Gipsy* in an ebb tide running at about five knots, and in the ensuing melee Herbert's dinghy was sunk. He was subsequently presented with a standard Naval collision report for completion, one of the questions to be answered being "Course and speed of opposing vessel?" As there were at least six barges in the attack, Herbert's reply was almost mutinous.

Near the end of the war, the Admiralty asked all members of the Senior Service to complete a questionnaire about pre-war employment. Herbert answered the first question "How were you employed before the war?" with the one word "Gainfully". To a question about the character of his work he replied "Good." A.P. Herbert will be long remembered in literary, legal and Parliamentary circles, but the river remembers him as a fully paid-up Thamesman.

The work of the minewatchers enabled the minesweepers to deal quickly and effectively with these potentially lethal weapons. Should the mine have fallen in a position in which it could not be detonated by the minesweepers, or if it was discovered squatting on a wharf or lying in a factory, mine-disposal teams had to be called in to defuse it. Sometimes the mine-disposal experts had to don diving gear to deal with mines laid in docks or in the river.

Not all the reports of mines having fallen into the Thames were entirely accurate. Most ships included among their defensive armament anti-aircraft rockets incorporating a parachute device from which hung a length of steel cable, and on occasions the firing cord which set these rockets off was pulled in mistake for the ship's whistle lanyard. Scores of Thames mine-watchers gleefully noted the bearing and distance of these parachutes and then enthusiastically swamped the control room with reports of mines having fallen into the river.

The bomb-disposal squad was also in urgent demand in the port, but because their particular quarry came down at five hundred miles per hour as compared with the thirty miles per hour of the parachute mine, digging and the construction of cofferdams played a large part in their work. The members of both mine and bomb-disposal squads were all volunteers, and most were also temporary sailors; one wonders all the more at the cold-blooded courage and ingenuity shown in their work. Still remembered is the strident voice of an Australian mine-buster telephoning a protest at the invasion of his territory by an officer from another command: "I'll thank you in future to keep your thieving hands

Left: Unexploded bombs some-times penetrated so deeply into the Thames foreshore that cof-ferdams had to be constructed to allow the bomb-disposal experts to reach them and render them safe.

Opposite: Lieutenant Gordon Fane, R.N.V.R., mine and bomb-disposal officer in the Port of London, with his team and some of their "trophies".

off my mines." And the bomb-disposal officer, delving after an unexploded bomb, who was asked how he had come to take up such work, and who tersely replied: "Influence".

During the "backs-to-the-wall" phase after Dunkirk when invasion seemed to be only a question of time the Naval defences of the port were particularly alert. Two booms were laid across the river, the outer one running approximately from Shoeburyness to Minster on the Kent shore and the inner boom running from Scars Elbow on Canvey Island to the Kent shore near St Mary's Bay. Royal Naval gate vessels stood by with steam up to close the gap if the enemy attempted a dash into the river, the gates being shut each night. Had enemy vessels succeeded in bursting through several torpedo tubes were mounted on one of the Thames Haven oil jetties ready to poke something more than fun at them. Still further upstream was an extensive controlled minefield guarded by Naval watchkeepers and capable of blowing an invading fleet to pieces. The Navy also mined most of the piers and jetties in the lower reaches as well as much of the equipment and many of the berths in the Tilbury Docks in order to prevent their use by the enemy.

Much of the tideway Navy was engaged in nursing merchantmen using the port. In addition to Naval kite balloons supplied by the

R.N.A.P. from a depot at Tilbury, merchant ships were equipped during the last three years of the war with an armament which would have been the envy of the captain of many a Naval vessel in the early days. The installation of guns in merchant vessels was the work of the D.E.M.S. (Defensively Equipped Merchant Ships) Section, whose fitting out gunnery officer was responsible for arming nearly 2,500 ships in the Port of London. This department also supplied key ratings for laying and training guns and also instructed selected members of the Merchant Navy crew in manning them. The London Naval gunnery schools were accommodated in H.M.S. *President* and H.M.S. *Chrysanthemum* in King's Reach, while to train Merchant Service gun crews a double-deck bus, stripped and painted the traditional Naval grey, was equipped with dummy guns and on most days was employed in dockland as a mobile lecture room. Actual firing practice was given on a riverside marsh.

Yet another form of merchant ship defence was organised by the Navy in the form of the degaussing girdle which gave vessels a high degree of immunity from the magnetic mine. When the ship's magnetic field had been so neutralised she was taken over a range either in the Lower Hope or at the Tilbury coaling jetty, nearly 78,000 vessels being so "ranged" in the Port of London.

The merchantman, now armed, with trained gunners aboard, degaussed and ready to pick up her kite balloon and other defensive equipment, was allocated to a convoy. The principal Naval Control Service station responsible for assembling and routing convoys from the Port of London was Southend, where the mile-and-a-quarter pier temporarily became H.M.S. *Leigh*. The pier railway, solely devoted to anglers, sunbathers and trippers in the days of peace, became a strategic line of communication in time of war, with Royal Navy and Merchant Service crews, top secret documents, arms, munitions and casualties passing over its tracks. The dance hall at the end of the pier became the conference room where shipmasters were given their sailing orders. Throughout the war, Southend was the hub of the coastal convoy system; more than 3,000 convoys made up of ships from 10,000-tonners to coasters of under 1,000 tons were sailed by H.M.S. *Leigh*.

For the convenience of ships using the upper docks and wharves, a sub-station was established in the P.L.A. head offices. Here masters of

Southend Pier, which became the operational headquarters of the Thames Naval Control Service. Convoys assembled off the pierhead and the pier railway was used to carry men and supplies. *Michael Rouse*

inward-bound merchant ships would report and those outward bound would receive route instructions, identification signals and confidential books before being sent downriver to join their convoy at Southend. It was a brave sight to see a large convoy weigh and proceed in line ahead at the stipulated convoy speed out past the Nore, with Naval Control Service tugs beating up stragglers and attendant destroyers and other escort craft streaming out from Sheerness past the Bar Buoy to join them. When, as sometimes happened, an inward-bound convoy arrived at the same time, the Thames saw a gathering of ships which was only surpassed just before D-Day.

Imposing necessary convoy discipline on some of the merchantmen was not always easy, for the crews were sometimes inclined to be bloody-minded at receiving peremptory orders. The masters, too, had difficulties with war-diluted crews; one told the Naval Control officer that when he asked a newly joined seaman what course he was steering, the man peered at the compass and then replied: "About half-an-inch to the right of E, Sir!"

These, then, were the special duties of London's tideway Navy. In addition there was a vast routine machine which fed, watered, paid, ammunitioned and served in other ways the itinerant Naval vessels using the port. Throughout the whole of the war a Naval Intelligence service, centred in the P.L.A. head offices, kept its ear close to the ground in dockland, for the ship has always been an important link in espionage work.

Motor transport for a score of Naval services was supplied from and serviced at an Admiralty garage in Stepney. Accommodation for the many hundreds of Naval ratings in the London Naval Command was widespread and varied; it ranged from the training ship *Worcester* at Greenhithe to a derelict fort at Cliffe practically rebuilt by the R.N.A.P. ratings living there, dismantled paddle steamers in the London Dock and church halls at Forest Gate and a vicarage at Richmond, as well as a hostel at Hampstead.

Communications in the London Naval Command were a triumph of organisation, and a mesh of telephone and teleprinter lines, radio, and despatch riders was centred in a section of the basement of the P.L.A. head offices. There a twenty-four-hour watch was maintained by businesslike Wrens who stoutly observed the traditions of the Silent Service on the two occasions that the building was hit by bombs.

As D-Day approached, tension grew. Some of the men decided it was a matter of eat, drink and be merry, while others more thoughtful quietly put their affairs in order. One Naval Chaplain held a brief service which the congregation of seamen felt was a sort of dedication, but

solemnity was dispelled by a lusty Leading Stoker. The Chaplain had given out that the first, second and fourth verses of the chosen hymn would be sung. The stoker failed to take this in and began singing the third verse. Realising that he was out of harmony with his fellows, he paused and then asked in a loud voice: "'Ere! What bloody lark's this?"

D-Day sailings from London brought all this activity to a peak, for on the Navy fell much of the work of organisation, but the hard work was still leavened by a sense of humour. It also had a lively sense of its duties in defence of the port and, anticipating that the enemy might try to carry out a disruptive raid as a counter to invasion, arranged an exercise involving all the armed forces and including the Home Guard and the police. The code word was "Gadfly". One Petty Officer reported that while liaising with the Home Guard he had forgotten the code word and, when challenged, had said: "Flyblow—or something like that!" to which the Home Guard replied: "Near enough, mate, come on in."

While the build-up of Allied forces on the Continent was in progress the Naval Officer in charge at Tilbury noticed that a supply ship returning to the Thames to reload had made a record number of trips, so he sent her a signal "Congratulations on your score. Do you need a new bat?" The ship replied: "No, thank you. But the pitch needs rolling."

In many ways it was all very new to Father Thames; in other ways it was a familiar routine, for he at any rate has had a long and intimate acquaintance with ships of war.

The pierhead, a mile and a quarter offshore, where shipmasters were given their sailing orders before their ships joined the convoys assembling in the estuary. *Michael Rouse*

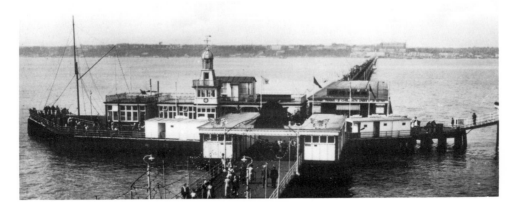

CHAPTER TWELVE

Passive Defence

SOME YEARS before the outbreak of the Second World War the Government asked the Port of London Authority to draw up a plan in consultation with the Services for the defence of the tidal Thames and its docks, a plan which could be adapted for the defence of all major ports in the event of hostilities. The need for protection against attack from the air had already become plain from events in Spain, where civil war was raging, and from the Japanese campaign in Manchuria and the Italian campaign in Abyssinia.

As the European situation deteriorated, the P.L.A. established a passive defence organisation ready to be put into effect if the worst happened, and when it was realised that Munich had gained time and not peace this organisation was expanded and improved.

Passive defence measures in the Port of London were complicated by its size and nature. Some four thousand acres of docks, grouped in five separate systems between Tower Bridge and Tilbury, had to be covered, together with sixty-nine miles of tidal river, fringed for long stretches by wharves and quays; there were also warehouses storing hundreds of thousands of tons of foodstuffs and raw materials, vital static and mobile plant, highly vulnerable machinery of various kinds, as well as the many miles of roads and railways of one of the world's greatest transport terminals. The whole comprised an unmistakable target within comparatively short range of Continental airfields, one certain to be regarded by the enemy as of the highest priority. There were, however, some compensating advantages. As a statutory dock and harbour body, the Port of London Authority already had in its peacetime organisation a police force, medical staff, first-aid parties, skilled repair squads, wreck-raising plant and a fleet of tugs equipped with firefighting plant, all of which provided a firm base for wartime training and expansion.

Some of the industries and services within the port were responsible to various government departments and they drew up their own schemes to meet special requirements. In the case of essential direct port services, the authority took the initiative and invited the co-operation of the separate official and private interests concerned.

The primary objective of the port's passive defence scheme was the protection of people, cargo, port installations, ships and craft against air bombardment. The secondary objective, hardly less important, was the

provision of alternatives and substitutes for key units likely to be put out of action. The scheme worked out and submitted to Whitehall proposed that for passive defence the port, although sited in a number of different counties and municipal areas, should be regarded as a separate Air Raid Precautions (A.R.P.) group, ranking with local authority bodies in London, each dock system and the River Thames itself becoming a quasi borough with its own report and control centre and top-level control from Trinity Square. The Government not only accepted this passive

FRUSTRATE
HIS
KNAVISH
TRICKS !!!

PREVENT

SABOTAGE

(Fire and Wrecking)

Report suspicious persons & things
AT ONCE

An anti-sabotage notice of the kind displayed throughout dockland in the early years of the war. *P.L.A.*

defence plan but adopted it as a standard for all large ports in Great Britain.

The most pessimistic view was wisely taken as a basis for the plan, widespread destruction of docks, wharves, warehouses and quays, of ship-discharging plant, ships, craft and cargoes being visualised. Offices, complete ancillary undertakings and enormous numbers of skilled staff would probably be wiped out, and normal transport for employees and their food supplies would probably be paralysed. In other words, the state of siege which nearly overtook London during the winter of 1940/41 was foreseen.

Shelters for some forty thousand port workers were provided by the P.L.A. Chief Engineer's Department close to the main working areas, so as to avoid unnecessary interruption of work. Where possible existing buildings were strengthened, and elsewhere reinforced concrete and other shelters such as steel pillboxes and timbered trenches were sunk into the ground as far as the water level permitted. For bridgemen, lock staff, police, and others whose work kept them at their posts until—and even during—attack, special arrangements were made.

Before the outbreak of war and in the early stages of the war poison gas was the biggest bogey. There is little doubt that the precautions taken in this country to meet the gas threat and the training given to volunteers in dealing with such an attack were the principal reasons why use of poison gas was rejected by the enemy. The port provided a large number of gas-proofed shelters, while cleansing stations could be transformed into additional first-aid posts if required. Anti-gas instruction was given to more than three thousand key employees. The Port of London's anti-gas measures aimed at protecting workers and cargo, particularly foodstuffs, and provided for the treatment and disposal of contaminated goods and the decontamination of ships, offices, sheds and warehouses.

As a first step, the Port of London Authority and the Port Health Committee of the Corporation of London (the health authority for the port) agreed upon close collaboration. The Port Health Committee, through its Port Medical Officer of Health and his staff, is responsible for visiting ships entering the port with a view to detecting cases of infectious disease and it also examines all imported foodstuffs to ensure their fitness for human consumption. This organisation was therefore well

Policemen of the Thames Division of the Metropolitan Police practising anti-gas drill soon after the outbreak of war.

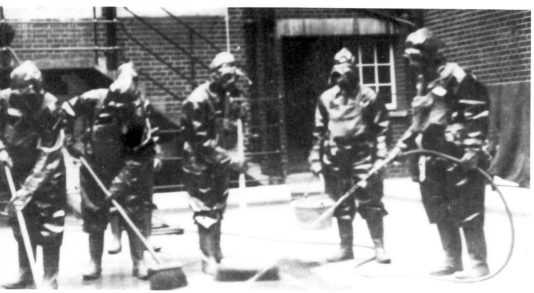

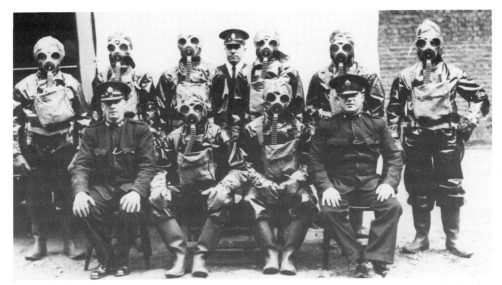

Men of the Metropolitan Police Thames Division wearing anti-gas clothing and Service respirators in 1939.

equipped to undertake anti-gas measures. The Port Medical Officer was appointed Anti-Gas Officer in the P.L.A. defence scheme and his inspectors, jointly with selected officers of the P.L.A., became Gas Identification Officers. To help decontamination of ships lying in the river a self-propelled lighter, the *Pretoria*, was acquired and fitted out as a floating cleansing station.

The outbreak of war found the organisation well advanced and there is little doubt that the problems of gas defence in the port would have been overcome rapidly and satisfactorily if such an attack had been mounted. Other wartime port defence measures handled by the Port of London Health Authority included bomb damage to sewers and drains, hazards to fresh water supplies and plagues of rats in damaged buildings.

First-aid and the medical side of the defence scheme came under the control of the P.L.A. Medical Officer. So far as the docks were concerned, first-aid stations were planned so that no part of the estate would be more than a mile distant from any post and even before war broke out eleven first-aid stations had been established and equipped, the dock ambulance service having at the same time been increased by

twenty-nine vehicles. Four hundred trained men were available to act as first-aid parties and stretcher bearers and for manning posts. Liaison with neighbouring civil authorities, on the basis of mutual assistance in emergencies, was planned.

The protection of cargo, ships and craft was carried out as far as possible by dispersal, but the almost unbroken phalanx of sheds and warehouses flanking the docks and tideway, accommodation for more than two million tons of merchandise, remained a vulnerable target. All the docks and most of the river wharves had equipment and trained staff to deal with outbreaks of fire, but it was recognised that a much larger organisation would be required to meet fire-raising attacks by the enemy. The problem was eased by the close co-operation of the municipal fire services, later the National Fire Service, N.F.S. for short. Sub-stations with crews and land appliances were established at strategic points throughout the port, and fire floats were made available up and down the river. The fire crews afloat proved particularly valuable; their equipment ranged from the small four-pump barge and standard float, each delivering about two thousand gallons of water per minute, to the big fire float *Massey Shaw* with pumps of four thousand gallons per minute capacity.

The next step taken by the authority was to plan the decentralisation of key staff and records, emergency headquarters for certain staff being leased at Thames Ditton, well outside the Metropolitan area. Communications and the blackout were further vital problems for which plans were laid during this period. The difficulty was to ensure rapid communication, which in certain circumstances might be of supreme importance, between the five dock groups, some hundreds of wharves, scores of piers and other river posts, and the nerve centre in the P.L.A. head offices on Tower Hill. All obstacles, some of them seemingly insuperable, were overcome, and rarely, even when the attacks were at their peak, were any of the links connecting the various parts of the port severed for long.

The engineers of the P.L.A. and of other undertakings were called upon for many unorthodox works during the initial stages of the passive defence scheme, a great deal of ingenuity being displayed in the protection of lockside machinery, bridges, dry docks, caissons and other key equipment. A notably successful defence measure against incendiary bombs was the provision of layers of sand and gravel, or platforms of old bricks, on the flat roofs and top floors of the warehouses. During one raid about thirty incendiary bombs fell on the roof of a new warehouse at the Royal Victoria Dock and burned out, only minor damage being done to the roof surface thanks to the protective layer provided.

The breathing space between Munich and the end of the "phoney war" provided opportunity for a period of intensive training. Volunteers drawn from the authority's staff and from private undertakings serving the port were given courses in first-aid, rescue, firefighting, control, repair and decontamination duties. Special transport and communication services linked each local controller and the Port Control Centre at the P.L.A. head offices. Mock air raids and exercises were constantly staged; there is no doubt that the Port of London passive defence organisation was as ready as foresight could make it when the first attack came.

Among the many ingenious training methods devised was a dart board which pictured the Port of London, darts being coloured to represent high-explosive bombs, fires, gas, etc. A dart having been selected and thrown at random, the trainees had to determine immediately what action should be taken. In the year between Munich and the outbreak of war, more than six thousand P.L.A. staff and other port workers were trained in the many branches of passive defence.

Early in 1939, in the dangerous springtime period when threatened nations are usually attacked, the port was ready to put itself into a reasonably good state of defence. But no attack came, so during the summer the various components of the emergency plan, both defensive and operational, continued to be exercised. These exercises were realistic and visualised even worse conditions than those experienced during the actual attack.

The reaction of the port's passive defence organisation when the first blow was struck in September, 1940, is recorded in other chapters of this book. The effects of the attack certainly proved to the full the necessity for a well-rehearsed and efficient organisation. When local headquarters collapsed, alternative quarters were ready and manned with scarcely any interruption of contact; when a telephone exchange was put out of action, other lines already installed were promptly brought into use; thanks to the shelters provided, casualties were far fewer than had been feared. Owing to the number of private undertakings included in the port services, casualty figures for the port as a whole are not available, but so far as the docks are concerned the chance of a casualty occurring among the duty staff during the first two months of concentrated night raids was about one in five hundred.

Evidence of the grim ordeal endured by passive defence personnel in the port is scattered throughout these pages, but one dock story serves to show the lighter side. A Chinese deckhand who had been blown off his ship staggered into a nearby first-aid post chanting "Me all light!" The first-aid party promptly turned to their sodium bicarbonate solution,

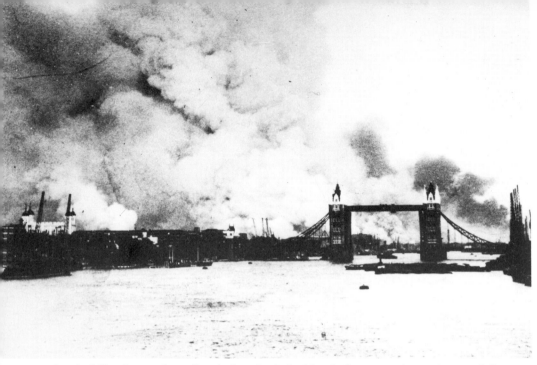

Smoke billowing up from fires in London's dockland after more than a thousand German aircraft had attacked the Port of London on 7th September, 1940. It was the prelude to fifty-seven consecutive nights of bombing. *Imperial War Museum*

assuming the man required attention for burns, but the Chinaman sturdily resisted examination until the staff realised that his pidgin English meant that he was "all right".

The Duty Engineer, already referred to in the chapter on the Control Room, was on duty each night, and all reports of air raid damage to port installations were immediately sent to him. If in his opinion the results of an incident made immediate action necessary he could muster the repair gang. A frequent contretemps was the fracture of hydraulic mains supplying the machinery by which some lock gates operated, and in such cases the local knowledge of the engineering staff often enabled them to isolate the damage and provide power by an alternative route.

Electric power for cranes, cold stores, lifts and other port equipment was equally vital, one of the most serious incidents occurring when the electricity converting station at the Royal Victoria Dock was completely destroyed by a direct hit, leaving practically the whole of the Royal Docks group without power. The position looked grave. The engineers, however, had been holding back a trump card. Before the war an

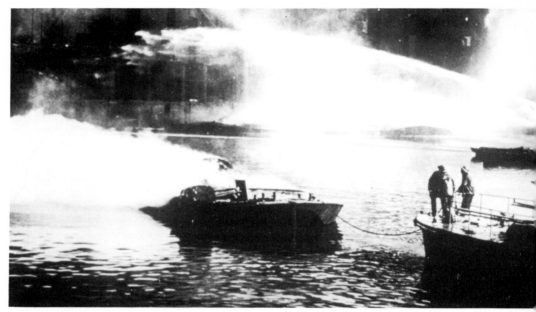

Firemen manning a fire float attempt to deal with a burning lighter while others play their jets on blazing dockside buildings.

oil-fired steam-driven floating power station, the *Volta*, had been acquired and held for such emergencies; within a very short time she was supplying the cold store and other installations with sufficient power to keep them in operation. Semi-permanent measures were then taken by the acquisition of a rotary converter and by begging small supplies of current from nearby undertakings until the availability of labour and materials permitted the reconstruction of the station.

The emergency duties of the engineering staff were not always so orthodox, a dock engineer once being called upon to remove a fire appliance which had been blown on to the roof of a dock office. Another time the engineer, faced with the possibility of a major catastrophe through damage done to the banks of a canal, showed considerable initiative by setting his men to siphon water from the damaged section of the canal into a sewer. When the second cold store at the Surrey Commercial Docks was hit* the engineer, one of the first officials on the

*Chapter eight

120

scene of the incident, was professionally astonished to find the surrounding area looking like a Christmas card scene; the silicate cotton used as insulating material had been blown all over the place.

Fire was the most formidable of the enemy's weapons and the work of the fire services in the port cannot be rated too highly. After a fire-raising attack the enemy usually deluged the burning target with high-explosive bombs, greatly increasing the normal dangers of the firefighters. Only too often did trained men and valuable appliances fall victim to this method of attack. The fires themselves in many cases presented unusual difficulties by the nature of the commodities involved*.

During the first great air attack nine fires broke out in the port, each occupying more than a hundred pumps. Before the war a fire involving thirty or more pumps was considered a major conflagration. Of the many fires started at the Surrey Commercial Docks on the night of 7th September, 1940, one engaged three hundred pumps and another required one hundred and thirty.

Fire floats played a heroic part in fighting riverside and shipboard fires. The London Fire Brigade, even before it was merged in the National Fire Service in August, 1941, had ranged down river beyond the London area to assist marine casualties in the lower Thames, and as the war progressed the floats became an extremely efficient arm. Flagship of the flotilla was the *Massey Shaw*, which earned fame by making three trips to and from Dunkirk Roads; all told, she brought back 646 men. When she returned from that adventure she was cheered all the way up the river by firemen from the various fire stations, and the brigade's commanding officer collected the wives and mothers of the crew for a reception at the Lambeth headquarters. Other craft were converted and some were specially built for the National Fire Service. Among the emergency fire stations established in the tideway was the famous old training ship *Exmouth*, which then lay off Grays. She later became the cadet ship *Worcester* at Greenhithe and was broken up in 1978.

The creation of the National Fire Service resulted in even more flexible co-operation between firefighting units in the port. Had the enemy resumed great fireraising attacks in the later stages of the war he would have found his efforts much less devastating than during the 1940/1941 winter. The N.F.S. was an important factor in the planning for D-Day, as during the huge supply build-up the normal safety regulations for the handling of hazardous cargo were largely in abeyance. A National Fire Service officer was attached to the organisation of the London Port Emergency Committee and was advised of the

*Chapter seven

expected arrival of any potentially dangerous cargo. Under his control were mobile firefighting squads who, with foam extinguishers and similar equipment, met these ships and stood by during discharge.

Passive defence in the Port of London became something of a misnomer, for it was an active and often bloody business; the defence services both erected and manned the barricades. The foundations of the wartime port rested on their fortitude, for had they failed all the steel and concrete would not have stemmed the attack.

The London Fire Brigade fire float *Massey Shaw* returning from the Dunkirk evacuation. In three trips to and from the beaches she brought back more than six hundred men.

P.L.A.

CHAPTER THIRTEEN

Extended War in the Tideway

ABOUT half a mile downstream of Tower Bridge on the north bank of the river is Wapping police station and its pier, headquarters of the Thames Division of the Metropolitan Police, just one of the many organisations which had a special role to play in the wartime life of the Port of London. Always the enemies of wrongdoers, the little police launches and their crews became in wartime virtually the friends of all the world, both afloat and on the riverside.

With their radio-equipped launches and with a vast and detailed knowledge of the habits of tideway villains, these waterborne policemen waged a successful fight against plunderers of cargo and other criminals on the river. Before the war their "beat" had covered some thirty-six miles of London River, within which lay the busiest section of the port; later they came to patrol fifty-four miles of river.

In wartime their duties and responsibilities were extended to include co-operation with Naval, Military, Royal Air Force and various civilian public bodies, the guarding of vulnerable points such as power stations, gasworks, oil installations and certain commercial undertakings, and the protection of river bridges and other places which might be the subject of sabotage attempts. Close liaison was maintained with Naval Control in all matters affecting shipping, and the police had to enforce regulations under the various port navigational orders, besides carrying out minewatching duties. To cope with all this the Thames Division had to be enlarged, additional launches being requisitioned and pensioners, Special Constables and War Reserve Constables being brought in to man them.

Co-operation with the Holding Battalions at the Royal group of docks was close and police launches were held in readiness to convey troops across the river at any given point to suppress sabotage or looting or to deal with enemy parachutists. Ships containing valuable cargo destined for foreign ports but intercepted by the Royal Navy were directed to London and placed under the supervision of H.M. Customs, and to assist the Customs in preventing sabotage or theft of this cargo, armed guards were ferried by the police launches from the Royal Docks as far downriver as Gravesend.

Lighting exemptions issued by the Commissioner of Police to certain riverside undertakings where ships worked cargo at night meant an

added responsibility, as the regulations allowed no spillage of light on the water or above the horizontal, and steps had to be taken to ensure that these regulations were strictly observed.

When war really came to the Thames on 7th September, 1940, and much of the dock area was turned into an inferno the River Police found themselves in the thick of the action. One incident which stood out concerned six barges laden with blazing copra (the dried and broken kernel of the coconut, the source of coconut oil) which broke adrift and drove down river as far as Rainham Creek, only to return, still blazing, on the flood tide; police managed to work some of these craft inshore where they took the ground.

The River Police were very much a part of the tideway community. They knew it in the bad old days when poverty was rife; they knew the steady workmen; they knew the crooks. They would organise Christmas parties for dockland children and outings for the old people. They would turn over skiffloads of coal, claimed to have been "drudged" from the river bed and convincingly wet, to find the coal dry underneath and therefore stolen from a bunkering barge. With this profound knowledge of the people of the river they were foremost in helping them during the blitz.

When the nightly bombing of London was at its peak it was decided to evacuate certain waterside dwellers for whom life was becoming impossible, one of the worst areas being the district of Wapping which, bounded by the river and the docks, is virtually an island. Bombing had made roads and bridges impassable and evacuation by river was the only feasible means, so some two thousand women and children were collected by the police, aided by civil defence workers, and shepherded to Wapping police pier, where they were embarked in tugs, barges and launches. The little flotilla was escorted by police craft which sent radio reports of their progress upriver back to headquarters at Wapping. The evacuation to safer quarters at Richmond took about three days.

At South Wharf, Rotherhithe, patients and nurses of what was then the L.C.C. Hospital whose landward retreat was cut off were evacuated by police launches and at Silvertown residents on the river front, unable to withstand the dense fumes from burning tar products, were carried to safety on the opposite side of the river at Woolwich after having taken refuge in a small coaster. On another occasion members of the female staff at Albion Wharf, Woolwich, were taken from the wharf front to the Free Ferry when the landward entrance of the wharf was blocked by fire. Many times police crews were successful in salvaging valuable commodities which as a result of fires due to bombing were adrift in the river.

Wapping, Waterloo Pier and Blackwall police stations suffered many

The Metropolitan Police launch *Vigilant* on patrol in Woolwich Reach in the early years of the war. Several warships can be seen in dock in the background.

near misses and Wapping received a direct hit, but fortunately from a bomb of small calibre. Blackwall station had to be evacuated owing to the presence of a delayed-action bomb on the foreshore.

At the entrance to Bow Creek, on the western bank, is Trinity Wharf, Blackwall, the London depot of the Trinity House steamers tending coastal lightships and buoys. The Trinity House of Deptford Strond is an ancient institution incorporated by a Charter granted by King Henry VIII in 1514 to the "Shipmen or mariners of this oure Realme of Englond that they or their heires... may begyn of newe... and stablisshe A Gilde or Broderhed... to make lawes ordinances and statutes in relevyng encrease and augmentacion of Shippes of this oure Realme." The Charter granted to the Corporation certain rights, powers and privileges, including the holding of all lands and tenements they then possessed, and this Charter was subsequently confirmed by King James II. In the reign of Queen Elizabeth I an Act of Parliament was passed which also conferred on the Corporation the right to establish and maintain seamarks on the coasts of and in the waters of England and Wales.

These rights and powers remain operative at the present day under the authority of the Merchant Shipping Act, 1894, which nominates

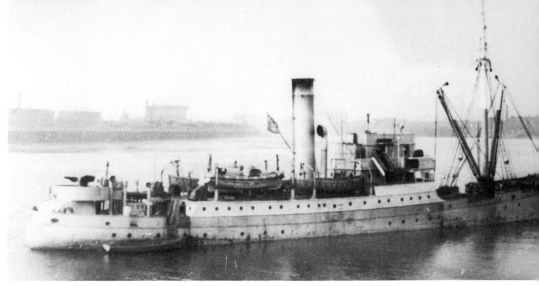

The Trinity House Vessel *Alert* in wartime grey paint at Blackwall. She was mined off the Normandy beaches in 1944. *Cdr Richard Woodman*

Trinity House as the General Lighthouse Authority for England and Wales, the Channel Islands and Gibraltar. Trinity House is thus responsible for the navigational lighting and buoyage of the waters of the Thames Estuary and also of the River Thames itself from the sea upstream to London Bridge. Under peacetime arrangements Trinity House maintained in this area about a dozen manned lightships and a large number of light buoys as well as ordinary navigational buoys and beacons. To maintain these seamarks Trinity House employs lighthouse and buoyage tenders, seagoing ships specially built and equipped for their particular duties, one of which was based on the Blackwall Depot, assisted when required by similar tenders stationed at Harwich.

The outbreak of war naturally involved a radical alteration of the peacetime arrangements for marking the sea approaches and the river leading to the Port of London but Trinity House, with its experience of shipping needs in the First World War, had made plans in advance and was ready when the time came to meet the requirements of the Admiralty, who had the final say regarding arrangements for the safety of merchant shipping using the port. Among the many wartime duties of Trinity House was the extinction or reduction of shore navigation lights, the withdrawal of lightships (in some cases substituting light buoys), the opening up of new channels in the Estuary, the marking of the very many

wartime wrecks, and the placing of light buoys for operational purposes in the river itself. A special type of beacon light of low power which had been found useful for helping ships during the blackout was established by Trinity House in the Thames at Shornmead, Chapman, Mucking and Northfleet.

While the war lasted there was, of course, no finality in the matter of Thames lighting and buoyage. Continuous minelaying by the enemy and the inevitable sinking of ships demanded constant activity by Trinity House in marking wrecks obstructing existing channels and buoying alternative ones to meet situations which changed from day to day. All this work had to be carried out under difficult and dangerous conditions, often under enemy air attack.

The peacetime arrangement of lightships in the Estuary underwent radical changes to meet wartime needs. They were moved frequently and some were equipped with radio telephony so that their lights could be controlled by the Naval authorities on shore. The lightships were maintained on station as long as possible, but ultimately nearly all of them were withdrawn to avoid unnecessary loss of life as it became apparent that the enemy did not respect their non-belligerent character. One of these lightships, the Nore, well known to Londoners who before the war went down to the sea in pleasure steamers from the Pool, remained at her station from the outbreak of war until June, 1943, when she was withdrawn at Admiralty request, the establishment of other lights nearby rendering her services no longer necessary. While she was on station she sustained no serious casualty, although she lay on the doorstep, as it were, of the Port of London and was thus well in the area of enemy activity.

Trinity House, however, suffered many casualties. The Corporation's headquarters on Tower Hill, called Trinity House, a delightful and beautiful old Samuel Wyatt building dating back to 1796, was destroyed by incendiary bombs in the night of 29th/30th December, 1940, and the depot and workshops at Blackwall Wharf were repeatedly hit, extensive damage being done to premises and equipment, but neither the workshops nor the depot closed down throughout the war.*

Four of the Trinity House lighthouse tenders became casualties; the *Alert* and the *Argus*, both twin-screw steamers, the motor vessel *Reculver* and the twin-screw motor vessel *Strathearn*. The *Alert* was permanently based at Blackwall and worked in the Thames area during the war until in the late spring of 1944 she helped in the laying of buoys across the English Channel in preparation for the invasion of Normandy. After D-Day the *Alert* continued on buoyage work in the invasion area until on

*For a full account of the Trinity House tenders in wartime see *Keepers of the Sea*, by Richard Woodman, Terence Dalton, 1983

16th June, 1944, she was mined and sank off Arromanches, fortunately with only one or two minor casualties among her crew.

Less fortunate was the *Argus*, which on 12th November, 1940, had been attending the Mouse lightship and had just got under way to return to base when she was mined, foundering almost at once with the loss of all on board except one seaman who was picked up by the former Thames pleasure steamer *Royal Eagle*, serving as an anti-aircraft vessel. The m.v. *Strathearn* was lost in the Thames estuary on 8th January, 1941; she had been carrying out some buoyage work when she was mined in the Wallet, many of her crew losing their lives and many others being injured. The *Strathearn's* sister ship, the m.v. *Reculver*, was lost off Spurn Point on 14th October, 1940. The vessel was proceeding along the swept channel entering the Humber to refuel at Killingholm when a mine exploded abreast of the engine room on the port side; five of the crew were injured but happily there was no loss of life.

In spite of the hazards and dangers inseparable from work at sea and related difficulties concerning manpower and materials imposed by war conditions, the Elder Brethren of Trinity House can be justly proud that

The beautiful Trinity House on Tower Hill, built by Samuel Wyatt, was destroyed in an air raid. The present Trinity House, built on the same site, incorporates the original facade. *Trinity House*

their service was able throughout the war to meet all demands made upon it.

At the eastern end of Woolwich Reach the Free Ferry steamers of London County Council (as it then was) plied between Woolwich proper and North Woolwich, this being the only borough with territory on both sides of the Thames. These vessels, which transported a daily average of 21,000 passengers and 2,800 vehicles, were a valuable cross-river link in wartime lines of communication and supply. Menaced by mines and bombs, their short passages of about one thousand feet were often as

The gun's crew of the Trinity House Vessel *Argus* closed up during gun drill.
Captain R. Dove

adventurous as those of ships serving in wider waters. The finest hour of these paddlers came on 7th September, 1940, the first day of the London blitz, when the residents of Silvertown, virtually an island bounded by the Royal Docks and Woolwich Reach, found themselves menaced by a wall of fire; all that night the ferries steamed to and fro, carrying people to safety across the river. The scene was reminiscent of Pepys's description of the Great Fire for, just like the citizens of the year 1666 who tried to save their goods by wherries and lighters, these twentieth-century refugees came with their dogs and cats, canaries and budgerigars and valued household treasures.

On the north and south banks at the end of Gallions Reach are the northern and southern outfalls of London's sewerage systems, where the L.C.C. maintained important installations for the treatment of sewage.* The solid matter remaining after treatment was pumped into a fleet of sludge vessels which took their cargo to the Black Deeps in the outer

*This responsibility was transferred to the newly formed Thames Water Authority in April, 1974

estuary, an average of 47,000 tons a week being dumped in this way. These little vessels were among the best found ships in the river; not for nothing were they known as the "L.C.C. Yachts." From the end of the "phoney war" this fleet ran the gauntlet of bomber and minelayer on nearly every tide. Three of its four ships were damaged by enemy action during the early days of the main attack, though this was not the only danger they faced. One dark night in the winter of 1939 a sludge vessel was in collision with a Naval Examination Service ship and was cut down to the waterline. The master promptly opened the valves to eject his cargo, thus giving the ship added buoyancy and raising the damage well above the water line and also giving the Naval officer in command of the examination vessel something of a shock. He was astonished to see a ship in danger of foundering suddenly rise up triumphantly above her former self.

At one time the Estuary Naval Command feared that these vessels might be seized by a lurking enemy submarine and sent back into the port with a crew of saboteurs, so a special secret code was arranged whereby the masters could identify themselves on every inward passage. This measure, however conducive to the safety of the port, must have caused their crews to sympathise with the tethered goat awaiting the arrival of the tiger. Tragedy came to this little fleet on 29th October, 1940, when the *G.W. Humphreys* was sunk in the Warp by an acoustic mine, seven of the crew being lost. From then until the end of the war these vessels discharged their cargo near Mucking in the Lower Hope.

At any state of the tide one almost invariably saw a number of colliers in the river. All through the war, defying submarine and E-boat attack off the East Coast and bomber and minelayer in the estuary, they maintained a vital service to the Metropolis, suffering grievous losses. A book could be filled with accounts of their adventures on passage and in port. The London colliers principally fed Thamesside gas and electricity undertakings and bunkering establishments, a yearly average of some thirteen million tons of seaborne coal being consumed on the tideway. Many of the vessels were specially designed to pass under the London bridges and discharge as high upriver as Wandsworth; the design of this type, colloquially called a "Flatiron", involved fine calculations regarding draught and headroom under bridges.

It is no exaggeration to state that this collier fleet was essential to the continued existence of London. Even during the war no other means of transporting the necessary huge yearly tonnage of fuel could be found, and had these ships failed the war effort of Thamesside industry would have shrunk almost to nothing; ships would have been immobilised through lack of bunkers.

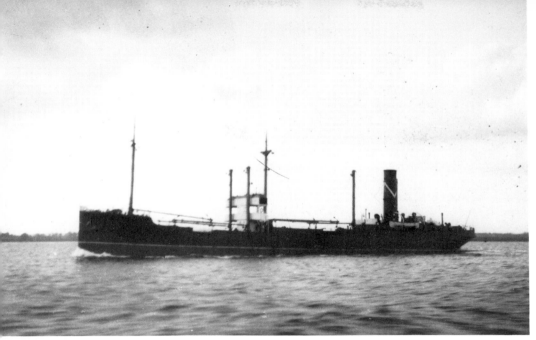
A steam coaster belonging to Coast Lines Limited, typical of the smaller vessels which traded to the Port of London.

The Gas Light & Coke Company* lost no fewer than nine colliers by enemy action and one by marine perils. The following accounts of the adventures of some of their ships are compiled from reports sent in by their masters.

s.s. *Gasfire*: The stern of this vessel was carried away by a torpedo during an E-boat attack in October, 1940; eleven members of the crew lost their lives. The main engines were destroyed yet the ship was towed into harbour for repairs and put back into commission in April, 1941. Her end came when she was mined in the following June, the forepart of the vessel being blown away; she was towed out of the swept channel and sunk about six miles east of Southwold.

s.s. *Flashlight*: In March, 1941, she was machine-gunned and bombed by enemy planes, the engine room and stokehold being flooded and the engines stopped. She was taken in tow but foundered under tow after the crew had abandoned her.

s.s. *Gaslight*: This vessel was bombed in April, 1941, while anchored in convoy, necessitating a tow back to port for repairs.

s.s. *Icemaid*: In October, 1941, this ship set off a mine which damaged the main engines, auxiliaries and accommodation throughout the ship. Kept

*Nationalised after the war to become the North Thames Gas Board of British Gas

131

afloat only by the efforts of a salvage tug, she was towed into harbour, receiving further damage on the way from the heavy swell.

s.s. *Horseferry*: While on passage in convoy to the Thames in March, 1942, loaded with coal the stern was blown away by, it was believed, a torpedo fired from an E-boat. She turned over and sank by the stern, eleven of the ship's crew losing their lives; the remaining six were rescued.

s.s *Firelight*: Her fore end was blown off by a torpedo during an E-boat attack in November, 1943. The master manoeuvred for nine hours to keep clear of shoals before the *Firelight* could be towed into port.

s.s. *Lady Olga*: While in convoy during darkness in February, 1944, the s.s. *Philip M* was torpedoed and sunk. The *Lady Olga* headed the tide to intercept survivors drifting towards her and sent away the boat, eleven survivors being rescued, most of them being found only by means of their illuminated life-jackets.

Two colliers of the Gas Light & Coke Company, the s.s. *Mr Therm* and s.s. *Halo*, were requisitioned by the Government and took part in D-Day operations. The *Halo* had been mined and sunk in the Thames in March, 1941, but had been raised and refitted. She was eventually lost by enemy action in January, 1945.

Out of its original fleet of seven colliers, the South Metropolitan Gas Company* lost no fewer than four. The *Brixton* was sunk by a mine in August, 1940, luckily without loss of life; the *Old Charlton* was dive-bombed and sunk in February, 1941, only one man being lost; the *Effra* was torpedoed and sunk by an E-boat in April, 1941, with the loss of two lives; and the *Catford* was attacked from the air in November, 1940, damaged by a mine in January, 1941, and finally sunk by a mine in May, 1943, going down with her master and four of her crew. The remaining vessels in this fleet had their full share of adventures and escapes.

Such are the fortunes of war that the Wandsworth and District Gas Company**, owning four colliers, reported the loss of only half a "flatiron", bearing the famous name of *Wandle*. Her predecessor of that name, also a "flatiron", successfully fought, and is believed to have sunk, a U-boat during the First World War. This later *Wandle* beat off an E-boat in March, 1940, and is believed to have sunk her and also claimed several enemy aircraft for her guns. While she was on passage for the Tyne in November, 1942, the fore end of the ship was blown off by a torpedo from an E-boat. Awash forward and on fire aft, she was abandoned by the crew, but believing that she might float for some time the master and a number of volunteers returned to her. After the fire had been extinguished a rescue tug took the *Wandle* in tow, stern first,

*Now part of the South Eastern Gas Board
**Also now part of the South Eastern Gas Board

132

and eventually, seventeen hours after the attack, the *Wandle* reached harbour towed by three tugs.

Another ship of this company's fleet, the *Tolworth*, suffered severe damage at sea from a near miss in June, 1941, but she was able to carry on. Later she saved fourteen survivors from the s.s. *Haytor* and fourteen more from the s.s. *Stad Aldmark*. The s.s. *Wimbledon* of the same fleet was attacked at sea more than once but suffered only minor damage.

The fourth ship of the Wandsworth and District Gas Company's fleet, the s.s. *Ewell*, was in collision with another vessel in bad weather while sailing in convoy in March, 1941. Because of the damage sustained and the high winds blowing the ship would not steer, the steamer's tall funnel right aft catching the wind and forcing the stern round. A "flatiron's" funnel is hinged so that it can be lowered to pass under low bridges, however, so the funnel was lowered and the vessel brought back on course as nearly as possible. Without the draught provided by the funnel steam pressure dropped and the funnel had to be raised again until the pressure gauge needle had crept back to its normal position, and then the funnel was lowered once more; the process was repeated again and again until the ship reached the shelter of the Humber, where repairs could be carried out. This was not the *Ewell's* only wartime adventure, for in September, 1940, she had been machine-gunned, her master and chief officer being wounded.

The firm of Stephenson Clarke Limited had owned nineteen colliers at the outbreak of war, many of them regularly serving Thamesside undertakings. The first erosion of the fleet occurred in October, 1939, when the s.s. *Borde* was taken over by the Admiralty to become a mine destructor vessel, one of the earliest attempts to combat the magnetic mine. Then the company's s.s. *Horsted* was sunk by a U-boat in December, 1939, with the loss of five lives; in January, 1940, the s.s. *Keynes* was sunk by enemy aircraft, and about the same time the "flatiron" *Pitwines* was badly damaged by bombs; the s.s. *Ashley* was lost by stranding in March, 1940; two months later the s.s. *Henry Woodall* was sunk by a mine, losing seven members of her crew.

In July, 1940, Stephenson Clarke lost three vessels in one week, the s.s. *Pulborough* and the s.s. *Portslade* by air attack and the s.s. *Broadhurst*, torpedoed by E-boats with the loss of four lives. The "flatiron" *William Cash* was sunk in the Royal Albert Dock during the first heavy air attack on London in September, 1940, and the s.s. *Ilse* was mined and beached in June, 1941; she was repaired and returned to service. A month later the company's new vessel *Betty Hindley* was lost on her maiden voyage as a result of stranding. Soon afterwards the s.s. *Sir Russell* was sunk by E-boats in the Channel.

133

In November, 1941, the s.s. *Pitwines* came into the news again when she was lost after a night collision, and a month later the company's oldest vessel, the *J.B. Paddon*, built at Ardrossan in 1914, was bombed and sunk. During 1942 the fleet was fortunate until October when the s.s. *Ilse* was torpedoed by E-boats with the loss of two men. Despite repeated attacks the company's vessels suffered no further casualties until February, 1945, when their latest ship, the *Rogate*, commissioned in July, 1944, was torpedoed, two of the crew being killed.

No wartime record of the Stephenson Clarke fleet would be complete without mentioning the s.s. *Nephrite*, which was instrumental in lifting more than five hundred Allied soldiers from Dunkirk. Later in the war she was requisitioned with the company's s.s. *Flathouse* to take part in the invasion of Normandy and was at Granville when the Germans made a commando raid on that port in March, 1945; she was seriously damaged and two of her crew were killed during the raid.

Colliers serving Thameside power stations also paid heavy penalties to maintain London's lighting, heating and electric transport in the war years. The London Power Company lost four of their ten colliers; practically all the fleet suffered damage by enemy action. The first casualty was in January, 1940, when the s.s. *Leonard Pearce* sank in the Bristol Channel after a collision. In July, 1940, the s.s. *Joseph Swan* suffered minor damage by bombs in the Thames Estuary, and in

The coasting steamer *Middlesbro*, belonging to the Tyne Tees Shipping Company, in the Thames.

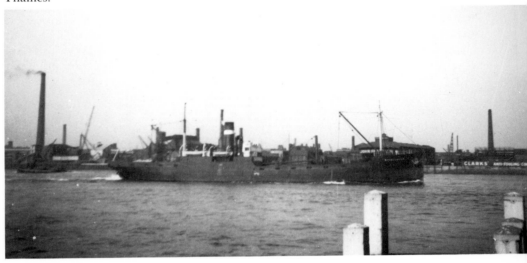

September of the same year she was torpedoed, only two of her crew being saved.

The s.s. *George Balfour* was badly damaged by a mine in October, 1940, and was abandoned, but the master and some of the crew returned and managed to save her. In June, 1942, she was attacked by enemy aircraft, suffering only superficial damage and then in October, 1942, she was torpedoed by an E-boat and the fore part broke away and sank. Again the crew returned after abandoning the ship and succeeded in saving her, a new fore part being fitted. After suffering further damage by enemy bombs in 1943, the *George Balfour* survived the rest of the war. The s.s. *Colonel Crompton* was set on fire by enemy aircraft in November, 1940, and was completely burnt out aft. Eventually the fire was extinguished, though not without the loss of one of the crew and one of the naval gunners.

In December, 1940, the s.s. *Charles Parsons* was attacked by enemy aircraft, but on this occasion she escaped damage because two bombs which fell close to the ship failed to explode; the ship's guns winged the enemy bomber. When she was again attacked in December, 1941, however, she received extensive damage. The s.s. *Ambrose Fleming* was torpedoed by E-boats in April, 1941, nine members of the crew and one naval gunner being killed. German aircraft machine-gunned the s.s. *Ferranti* twice in 1940; then in September, 1942, six bombs lifted the vessel out of the water, causing severe damage.

After being attacked unsuccessfully several times the s.s. *Alexander Kennedy* was sunk off Land's End by a U-boat in February, 1945. By good luck only one member of the crew was killed.

The ships of another fleet owned by the Electricity Department of the Borough of Fulham were among the luckiest in the coal trade. The *Fulham* was violently shaken by bombs in September, 1940, but suffered neither casualties nor serious damage, and in March, 1940, her sister ship the *Fulham II* suffered several near-misses by bombs and was hit by machine-gun bullets; she, too, escaped severe damage and casualties. In July, 1940, this ship rescued the entire crew of thirty men from the s.s. *Kolga* which had been bombed. Twice in November, 1940, she was attacked from the air and suffered near-misses, and in February, 1941, the *Fulham II* set off an enemy mine, the chief engineer being killed and considerable damage being caused to the vessel.

The *Fulham III* was attacked in September, 1940, March, May, July, September and November, 1941, and yet again in March, 1942, yet on each occasion she suffered only trifling damage and there were no casualties. During the attack in July, 1941, she was the first ship in her convoy to open fire and brought down an enemy aircraft. In January,

1940, *Fulham IV* rescued five members of the crew of the s.s. *Granton*, which had been attacked, and in June, 1940, she was machine-gunned and bombed, after which she had to be towed in for repairs, but she suffered no casualties. Put back into commission, she was again attacked in March, 1942, escaping once more with only slight damage and no serious casualties. The *Fulham V* was torpedoed and sunk in September, 1940, but the luck of this fleet held good, for all the crew were saved uninjured. Twice in January, 1943, the *Fulham VI* was attacked, escaping both times with minor damage and no casualties. *Fulham VII* opened fire on enemy bombers in June, 1942, and brought down one of them.

The fleets operated by London bunkering firms also had their moments. The following is an extract from a report by the master of the s.s. *Corduff*, owned by Wm. Cory & Son Limited:

> On the morning of November 11th, 1940, we were in the vicinity of the Barrow Lightship when a formation of about sixty enemy aircraft attacked the convoy, three of them selecting the *Corduff* as a target. Several near-misses by heavy bombs occurred, and then the enemy turned to dive-bombing; two or three small bombs burst on the ship but did not disable her. Then the last plane hit the ship with a 1,250lb bomb which went through the mainmast, taking the derricks with it and nearly putting the steering gear out of action. When the ship arrived at the Nore, a bomb disposal squad attended to the unexploded missile which had fetched up in the engineers' mess-room after tearing through all the living quarters of the starboard midship house.
>
> The next day the tail fin of another bomb was discovered on the coal in No 3 hatch. This menace could not be dealt with for some days until the bomb had been uncovered by the discharge of some of the coal.

The *Corduff* was subsequently sunk by an E-boat with the loss of seven men killed and two taken prisoner. The survivors, who escaped in a ship's boat, were interrogated by the commanding officer of the E-boat, and only the loyalty of the crew, who swore he had gone down with the wreck, saved the master from capture.

Another coasting collier company, Wm. France, Fenwick and Company Limited, lost twelve ships out of its fleet by enemy action in the North Sea, six of them in the Thames Estuary. This company had the unenviable distinction of owning the first ship to be sunk by enemy action in the North Sea, the s.s. *Goodwood*, torpedoed by a U-boat off Flamborough six days after the declaration of war. By an unfortunate coincidence, one of the last vessels to be torpedoed by an E-boat in the North Sea was also named *Goodwood*, sunk on 22nd February, 1945. She had been built as a replacement for her predecessor. Many of these disasters were accompanied by most regrettable human casualties. In addition to the ships lost, every one of this company's vessels suffered damage, most of them more than once.

A unique collier operated in the Thames by Harrisons (London) Limited during the last stage of the war was the *Chemong*, which had been built for service as a Canadian Lakes grain carrier. On the outbreak of war she was loaned to this country, her unusual silhouette becoming well known on the tideway, and from March, 1941, to August, 1942, she ran coal into London, having several narrow escapes and fighting off attacks with her guns. She also served in the Clyde Anchorages and later, during the D-Day period, in the Solent, returning to London in the last phase of the war. Between 6th February and 30th July, 1945, she supplied a total of 18,406 tons of bunkers to eighty-three vessels running between the Thames and the Continent.

These little colliers, manned by civilians, were true to the traditions of the armed merchantmen of former times and played an epic part in the survival of London.

Gravesend, outport of the Port of London and the centre of much wartime activity, was the headquarters of the Thames river and sea pilots. When the Port Emergency Committee for the Port of London was constituted in 1937 it was decided to set up a Pilotage Co-ordination Sub-Committee and the Elder Brethren of the Corporation of Trinity House appointed their Ruler of Pilots at Gravesend to be their representative on this sub-committee. From January, 1938, much time was spent in preparing to deal with all emergencies likely to arise in case of war, and in July of that same year arrangements were made with the

A vessel built for service on the Canadian Great Lakes which served in British coastal waters and in the Thames during the war.

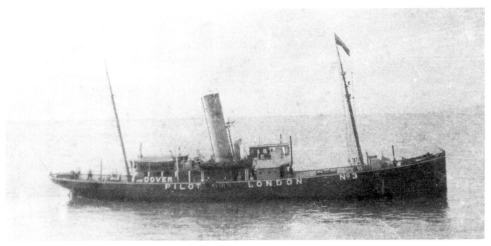

A London pilot cutter on station: the war greatly affected the pilot service.

Admiralty for the London District Sea Pilots to undergo a modified Merchant Navy Defence Course; by September, 1939, practically every sea pilot had been through it. The pilots also assisted the Admiralty by drawing attention of all officers of British ships which they boarded to the desirability of attending the Merchant Navy Defence Courses.

From experience gained in the First World War the Admiralty was fully alive to the important part pilots would have to play in any future war, so when on 1st September, 1939, it appeared that war was inevitable the Lords Commissioners of the Admiralty conferred on the Elder Brethren, by an order known as the Trinity House Pilotage Districts (Emergency) Order, 1939, very wide powers to deal with pilotage. Under this order the Elder Brethren withdrew all existing pilotage licences and substituted temporary ones. The pilot cutter was moved from Dungeness to the Downs on Admiralty instructions, and during the first six months of the war sea pilots worked under great pressure owing to the congestion of shipping in the Downs following the establishment there of a Naval Examination Service. In March, 1940, six pilots were specially licensed to act as berthing pilots in the Downs so as to reduce the congestion which had resulted in several shipping casualties.

A number of sea pilots assisted in piloting vessels to and from Dunkirk during the evacuation of the B.E.F. at the end of May, 1940. Three vessels in the charge of pilots were sunk, but the pilots were among

those rescued and they all succeeded in making their way back to this country.

In July, 1940, on the advice of the Admiralty, the executive staff and all the London pilot vessels were transferred from Dover to Gravesend, though a few pilots remained at Dover for the whole of the war piloting vessels into and out of Dover Harbour under the very nose of the enemy. This work was particularly difficult as all movements had to take place at night and it was not possible to provide the usual aids to navigation. Many times ships were led into or out of the harbour with one pilot ahead in a small motor boat with a flash lamp and another pilot on board the vessel being led.

The years 1941-42-43 were lean ones so far as the traffic using the Port of London was concerned, owing to the major diversion of shipping which had taken place, and arrangements were made for some fifty-six sea pilots to be transferred to the Clyde. The Clyde Pilotage Authority and the Flag Officer-in-Charge, Glasgow, paid very high tribute to the work of the London District pilots who quickly became experienced in handling large vessels in that river. Three other sea pilots were transferred to Milford Haven, where there was considerable shipping activity. In his Mississippi memoirs, Mark Twain said that a pilot must steer by the shape of the river in his head and not mind the one before his eyes; it is accordingly a mystery to landsmen and even to some seamen how these London pilots could so quickly master the quirks and intricacies of strange waters.

All the tower forts in the Thames Estuary were placed in position by Trinity House pilots, work which called for considerable skill as the forts had to be placed exactly in position, often in weather which was not ideal for the purpose.

The preparations for D-Day brought a very considerable increase in traffic to the Port of London and responsibility for the pilotage of all commercial and many service vessels engaged in the operations fell on Trinity House, which is not only Pilotage Authority for the London District but for every port of any significance on the South Coast, and as such maintained the closest liaison with the Navy. All the Mulberry Harbour units constructed in the Thames were towed to their parking sites under the supervision of Trinity House pilots, and one sea pilot lost his life when the tug which he was piloting was torpedoed by German E-boats. The pilot of the second tug attending the unit probably owed his life to the fact that a torpedo severed the tow rope and he had the presence of mind to attempt to ram one of the E-boats, with the result that the whole pack withdrew. Altogether, sixteen London District pilots lost their lives by enemy action.

In the month following D-Day nearly three thousand ships were handled by eighty-eight River Thames pilots and nearly two thousand ships by 115 sea pilots. During this period many pilots worked continuously and did not manage to take off their clothes for days on end, snatching rest in railway trains, on board pilot boats and at pilot stations. In this way, not a single operational ship was delayed. Owing to the increasing volume of traffic using the Port of London it became necessary to recall pilots from the Clyde and from the Royal Naval Reserve, and also temporarily to transfer pilots from the Tyne and Tees.

Many pilots had narrow escapes during the blitz on dockland and during the flying bomb campaign, when several vessels were saved from

An inward-bound ship in the Thames Estuary, obviously in serious trouble.

becoming total losses only by the skill and courage of their pilots. Throughout the war the London District pilot vessels operated under the most difficult conditions: they often cruised in the vicinity of mines and several times had to leave the narrow swept channels to rescue survivors from mined or torpedoed ships. Much of the work of the pilot vessels was done during darkness and in complete blackout among convoys moving either in single or double lines, needing great care and skill on the part of the pilot vessels' crews. It is not surprising, therefore, that on occasion pilots were unable to land at the pilot station and were overcarried; one pilot had the unique experience of landing at New York instead of Newhaven.

The pilot vessels often came under fire; on 17th April, 1941, the T.H.V. *Pioneer* was savagely attacked by two bombers, but with the aid of the tug *Sun III* and the salvage vessel *King Lear* she was able to reach Gravesend safely and was ultimately repaired and returned to service.

Following the clearance of the French and Belgian coasts the pilot vessels were able to return to their normal stations at Dungeness and the

Sunk. Professional civilians working with the armed forces, pilots sometimes found it difficult to maintain their authority. One rather hoary wartime story concerning a pilot denied access to a ship by an armed gangway sentry, probably apocryphal, illustrates the problem: "But I'm the pilot," he said, to which the sentry replied: "You don't come aboard this ship, not even if you was Pontius Pilate."

Trinity House pilots are among the most skilled and highly respected tideway workers, but London River loves a yarn. Stories about pilots include that of the Dutch shipmaster who claimed that his pilot was greater even than Lord Nelson, for "Nelson sank only one ship at Trafalgar"—the pilot in question had had the misfortune to put a Dutch ship ashore in thick fog. Another pilot was said to be fond of his food and, arriving on the ship's bridge, would consult the luncheon menu, giving helm orders such as "Keep her on that buoy—I think I'll have the clear soup—Starboard five—Then I'll have the grill—Steady as she goes."

As an emblem of peace it would be hard to beat the Thames spritsail barge with her ember-coloured canvas, gently creaking cordage and spars, her slow-spoken philosophical sailormen and her graceful movement, formerly free in most cases from the racket of an engine. Like so many other peaceful traders, she was drawn into the vortex of war and played a not unimportant part in the struggle. A valuable feature of these craft was their shallow draught—"Sail 'em in a heavy dew," claimed their crews, known along the Thames as Sailormen. They could certainly negotiate swatchways and gutters denied to most other commercial vessels.

One story tells of a sailorman in doubt as to whether the gulls ahead of his barge were walking or swimming, and another describes how the mate, knocked overboard, ran after the craft.

Until degaussing and other measures had overcome the menace of the magnetic mine, the wooden spritsail barge was one of the few vessels which continued to trade with impunity. She was, in fact, considered immune from all types of ground mines until a barge under sail was blown to pieces in the Estuary; it was assumed by Naval experts that the noise of her bow wave had detonated an acoustic mine in shallow water.

Other troubles also lay in wait for these little vessels, which could not sail in convoy with adequate protection and continued to trade unescorted in the estuary and around the coasts. During the main aerial attack on this country they courted death and destruction on every passage, for two men armed only with a rifle in a wooden vessel under sail could not hope to put up a serious defence against a modern warplane. Nevertheless, they fought back when attacked, although all too

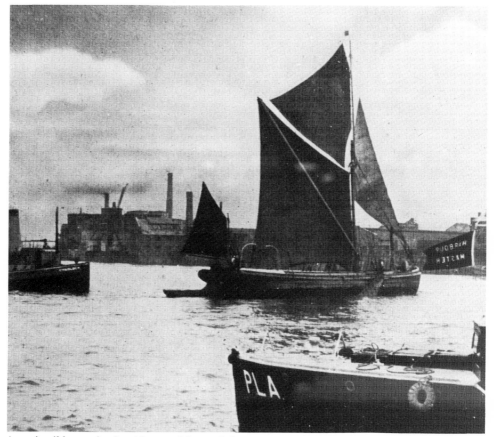

A spritsail barge in the tideway. Many of these vessels were lost by enemy action, while no fewer than sixteen took part in the evacuation from Dunkirk. *P.L.A./Buckley*

often the result was a tragic foregone conclusion. The exact number of barges lost by enemy action is not available, but the losses were substantial.*

At the end of the war only a few of these beautiful anachronisms remained, and today none is trading under sail, though some are still maintained for charter work and racing in the barge matches each summer.

*For an account of barging in wartime see *Coasting Bargemaster*, by Bob Roberts, published by Terence Dalton, 1984

CHAPTER FOURTEEN

The Towage Trade

GRAVESEND tugmen have inherited the spirit of generations of watermen who in former days defied the Crown, the Press Gang and the civic authorities; sturdier and more independent characters are not to be found in London's river.

In peacetime ship tugs escort vessels along the more congested river reaches, helping them to swing to anchor and manoeuvre into and out of the enclosed docks or to and from berths at riverside wharves and jetties. Before and during the war all London River tugs were steam driven, though the ubiquitous diesel engine has since ousted steam in such craft. The essence of successful towage work then lay in the uncanny co-operation between the master on the bridge and the driver in the engine-room; a good tug driver, hand on the throttle, would anticipate the next order and be ready to act immediately on the engine-room telegraph gong.

At the outbreak of war the Navy took over a number of these invaluable little ships. The tugs *Danube III*, *Danube V*, *Danube VI*, (the largest tugs in the port) *Keverne* and *Kite*, later reinforced by the P.L.A. survey steamer *St Katharine*, formed the Thames and Medway Naval Examination Service. They wore the White Ensign, were armed and were manned by Royal Navy crews, and for some of the time they acted as guardships to the port. When the main aerial attack on this country began, their patrol in the outer Estuary became one of the hottest corners in the sea lanes and they were frequently in action against enemy aircraft. H.M.S. *Danube III* was mined and sunk near the Bar Buoy on 13th October, 1940, with the loss of nine lives.

The Admiralty seemed to have a Nelsonian eye where the Estuary was concerned, for the crews of these R.N. Examination Service vessels, almost alone of H.M. sea-going ships, were denied the Atlantic Medal. In Whitehall, the Thames was regarded as "Sheltered Waters". Other tugs were taken up by the Navy for work with the fleet and in Naval dockyards, while several went to the Naval Control Service at Southend. Their masters' unchallenged knowledge of the river and its ways was tested by their new duties, which involved providing a ferry service between H.M.S. *Leigh* (Southend Pier) and ships in the convoy anchorage. On dark winter nights, often hampered by a fast-running tide, perhaps blinded by snow, fog or rain, they were called upon to find a

Commander J. R. Stenhouse, R.N.R., second from left, the senior officer afloat of the Thames and Medway Examination Service, with three of his officers.

certain ship among the score or more of vague dark shapes occupying the anchorage. Sometimes these little vessels were sent out to the Sunk in the outermost Estuary where, armed only with a Lewis gun and rifles, they acted as traffic police to inward and outward convoys, and at other times they were sent to seek and assist vessels in distress among the maze of deeps and swatchways outside the Nore. They were often attacked, gallantly answering a hail of bombs and cannon shell with their small calibre weapons.

Much has been written about the Dunkirk evacuation and a fair measure of praise has been accorded to the tugs, but the full story of what Operation Dynamo owed to the tugs has yet to be told. If it were possible to compute the amount of tonnage saved by their work at Dunkirk it would be found that they were a vital factor not only in the evacuation itself but in the survival of this country during the disastrous period following the loss of some hundreds of thousands of tons of Naval and mercantile shipping off the French coast.

Among records of the Dunkirk evacuation are reports from the tugmasters themselves, which means from most of the skippers of London ship tugs; all those available were there almost to the last keel.

Written by hands more used to wheel spokes and telegraph handles than the pen, they tell in simple understatements an epic story; a story of ships nudged into berths, of ships turned round and led out of the bombed and blasted harbour, of casualties plucked off shoals, of destroyers and transports towed out under bombardment by bombs and shells, of troopships which relied for survival solely on the rope and wire of gallant little tugs. Heroic ill-balanced duels with hordes of aircraft, survivors picked up, ferry work for transports, and sorting out the jumbled miscellaneous traffic of Dover Harbour (one London tug, *Simla*, assisted more than 140 ships in and out of Dover during the evacuation) are recorded as incidentals, each report reserving highlights for the main work of saving ships.

Something of what the tugs did at Dunkirk has appeared in *The Epic of Dunkirk*, by E. Keble Chatterton, *A Nine Days' Wonder*, by John Masefield, and *Dunkirk*, by A.D. Divine. From available reports, the work of two tugs has been selected as representative.

The steam tug *Foremost 87* commissioned on 18th April, 1940, with a

Balaclava helmets proved indispensable to the men manning the examination vessels in the Thames Estuary during the winter of 1939–40, which was among the worst on record.

Gravesend crew, who little imagined as they steamed out of harbour what they would do and see before they paid off. For a time the tug was employed on coastal towage, until on 22nd May she was urgently ordered to Calais, where her master was instructed to force open lock gates damaged by enemy aircraft. This task was carried out successfully and *Foremost 87* then helped the s.s. *Katowice*, loaded with refugees, to leave harbour and get away to sea, all the time under air attack. Still under attack, *Foremost 87* assisted the s.s. *City of Christchurch* into harbour, magnetic mines adding a new hazard to the operation. Back to the Calais Roads went the tug to fetch in the s.s. *Williamstown*. While in Calais the *City of Christchurch* was visited by uniformed Fifth Columnists who gave orders by which the tug would have taken the ship into danger; luckily the treachery was discovered in time, and still under air attack the tug eventually towed the *City of Christchurch* out of harbour before returning to Dover for coal and provisions. She made a second trip to Calais, but the port was about to fall and she was ordered back.

After another short spell of coastal towing, *Foremost 87* joined in the main evacuation work at Dunkirk on 30th May. There she was continuously employed under air attack assisting barges, transports and destroyers before herself returning to Dover with troops. She made a second trip with a tow of barges and was again fully engaged in helping the miscellaneous shipping. Her third trip began with a tow of lifeboats, but on the way she went to the assistance of the hospital ship *Paris*, which was sinking and still under attack from the air. The tug picked up ninety-five survivors and a mysterious boatload of Spaniards who could give no satisfactory reason for their plight; the tugmaster wisely segregated them from the other passengers and turned them over to the authorities at Dover. Even secured alongside Dover Harbour, *Foremost 87* was not to have a respite, for she had to cast off to pick up men thrown overboard by a collision between two evacuation vessels.

Another spell of coastal towing followed, during which she was twice attacked by enemy aircraft, and then *Foremost 87* paid off on 28th July and the crew returned to Gravesend.

The other representative case selected from the epic of the tugs is that of the London tug *Cervia*, which left Dover on 31st May towing the sailing barge *Royalty*, bound for Dunkirk. There was considerable trouble with the tow owing to the wash made by destroyers passing at speed. On passage a convoy of some twenty Belgian fishing boats asked the way to

The *Challenge*, the last steam tug in service in the Thames, was one of those which made an important contribution to the Dunkirk evacuation. Built in 1931, she is now preserved as part of the historic ships collection in the St Katharine Dock.

England; directions were given, the whole transaction savouring strongly of a casual exchange between motorists on a country road. The *Cervia* saw her tow safely on to the beach and immediately afterwards there began an air raid, during which the tug was machine-gunned and returned the compliment. During a short lull she managed to pick up a few men, but then a destroyer in the vicinity was hit. Seeing that other vessels were going to the warship's assistance the master of *Cervia* picked up a motor lifeboat full of soldiers. Then another destroyer and an oil tanker were hit. Before the *Cervia* could go to them she received an urgent signal to help the sailing barge *Tollesbury* with more than two hundred soldiers on board, so she picked up the barge and began the slow and dangerous tow home. Near No 5 W Buoy she and her tow and other vessels in the vicinity were attacked by about twenty enemy aircraft; five bombs fell so close to *Cervia* that she was lifted bodily out of the water. All the time the tug's guns were firing at the enemy. Next a mine exploded uncomfortably near the tug, but in the end the *Cervia* and her tow arrived safely at Ramsgate.

The following is believed to be a complete list of Thames tugs which took part in Operation Dynamo: *Sun, Sun III, Sun IV, Sun V, Sun VII, Sun VIII, Sun X, Sun XI, Sun XII, Sun XV, Contest, Challenge, Fossa, Betty, Crested Cock, Ocean Cock, Foremost 87, Fairplay I, Cervia, Doria, Fabia, Gondia, Hibernia, Java, Kenia, Persia, Racia, Simla, Tanga* and *Vincia*.

When the great air attack began on London the ship tugs left to the port carried on their vital work, the P.L.A. dock tugs sometimes having the most difficult time, for they were invariably in the principal target area.

Salvage is in the blood of all Gravesend tugmen, and stories of their efforts to be first at the rope of vessels needing help provided much colourful background to peacetime river yarns. Their efforts during the war transcended all previous salvage work, and almost every ship tug from the Thames had a splendid wartime record.

The work of one tug, the *Sun VIII*, owned by the towing firm of W.H.J. Alexander Limited, may be cited as typical. During 1940 she salvaged the *Thyra II* and the London Power Company's collier *Colonel Crompton* in the Barrow Channel and helped to salvage the Ellerman Liner *City of Dundee* ashore on the Long Sand and the *Ingineer N. Vlassopol* ashore on the Barrow Sand. While working on the *City of Dundee* she was called off to attempt the salvage of the same company's *City of Brisbane*, but before any help could be rendered the vessel was bombed and became a total loss. In 1941 she towed in the sloops H.M.S. *Lowestoft* and H.M.S. *Pelican* and the tenders *Halizones* and *Lieisten*, all damaged by mines. Assistance was also given to the Admiralty tug *St Clears*, and then

she salvaged the s.s. *Dicky* in the Barrow Channel. She picked up forty-eight survivors in the Barrow Channel from the British India Steam Navigation Company's s.s. *Winkfield* and then towed in the m.v. *Dixcove*, damaged by a mine.

During 1942 this same tug helped to salvage the tanker *Scottish Musician* and the s.s. *Camerata*. The Dundee, Perth and London Shipping Company's s.s. *Dundee* was towed in from the Barrow Channel and the s.s. *Nephrite* from the South Edinburgh Channel. The year 1943 saw *Sun VIII* refloat the s.s. *Maurice Rose*, the s.s. *Fort Frontenac* and the s.s. *Isaac Shelby*. She assisted at the refloating of the loaded half of the tanker *Josefina Thorden* ashore on the Cant Sand and helped to save the South Metropolitan Gas Company's collier *Brockley* ashore in a minefield on the Long Sand; a mine exploded uncomfortably close during this job. In 1944 she salvaged the s.s. *Valborg* and the s.s. *Florence Martus*, and plucked H.M. Submarine *Turpin* and the s.s. *Samos* off the Barrow Sand, while during the last year of the war she refloated the s.s. *Jersey City*, the s.s. *Fort Kootenay* and the s.s. *Empire Seaman*, salvaged the s.s. *Lossiebank*, and helped to quell a fire in the s.s. *Mount Othrys*, which was then beached.

Credit most of the other ship tugs in the Thames with similar successes and one begins to realise the valuable contribution made by these craft to the victory at sea.

Assisting at the salvage of the collier *Colonel Crompton*, disabled by bombs and on fire, was another Alexander tug, *Sun II*. While towing in the casualty the party was attacked by aircraft which attempted to bomb and machine-gun them, and the tugmaster's report of the incident was magnificent in its understatement. Describing the attack in a few words, the report ended: "We opened fire and they made off. My gunner was quite excited. I felt damned cold."

In December, 1940, the tug *Badia*, owned by another well-known towing firm, William Watkins Limited, distinguished herself in connection with the salvage of the steamer *Llandilo*, mined in the Estuary. The Port Salvage Officer called for volunteers to take him out to the damaged ship and, well knowing that more mines were in the area, the *Badia's* crew ferried him out, acting as a sort of marine guinea pig, for the almost irreplaceable salvage craft followed her and was thus assured of a fairly safe passage. At this time the Germans had just begun laying acoustic mines, against which degaussing provided no protection and against which the Admiralty had yet to devise counter-measures.

On 12th April, 1941, another of the Watkins fleet, the steam tug *Arcadia*, distinguished herself in a private duel when with two barges in tow she was attacked near the Roughs Buoy by enemy aircraft as she was

altering course for the Cork light vessel. Armed only with two Lewis guns and one rifle, the forty-six-year-old *Arcadia* accepted battle. For thirty-five minutes the enemy aircraft attacked with bombs and machine-guns until it was driven off by the *Arcadia's* valiant defence. When hailed by the commanding officer of a destroyer, the tugmaster reported that the only casualty was his funnel; a bomb had gone through it, luckily exploding in the sea. "What a hole to be in!" commented the destroyer captain.

When the Port of London was in a state of siege many Thames tugs followed the traffic diverted to less vulnerable ports, serving as far afield as Iceland. But there were enough left to provide valuable help in all major operations based on the Thames, notably the planting of the Maunsell forts and the Mulberry harbour at Arromanches. Like all other waterborne services of the Thames they worked to the point of exhaustion during the build-up for D-Day, and to use their efforts to the best advantage the Port Emergency Committee instituted a Thames Tug Control on 24th February, 1944. This control could not conjure up further tugs when they were all fully employed but it did make the most economical use of available craft during the vital early months of 1944.

The reports received from tugmasters of their work on D-Day read like the Dunkirk logs, except that many of the names are different; most of the regular London tugs were by then serving elsewhere. Nevertheless, many of these tugs with unfamiliar names were manned by London crews who regarded the rescue of ships as the highest form of service. Vessels of all types were saved, helped and advised; tugs grappled with the problems of handling the medley of strange and weirdly-shaped craft, blockships and "Phoenix" units concentrating on the enemy coast; ordered here and there, at everyone's beck and call, the tugs dodged in and out of the thick of it with the self-reliance of Cockney urchins.

Among the records is a letter from the Commanding Officer of a U.S. Navy task unit to the master of a tug manned by a London crew who had served under him on D-Day; in it occurs the sentence: "You are indeed a credit to the great nation which you represent and have made an important contribution to the cause for which it and we are fighting."

Some of the London ship tugs and their crews never again saw the London River and the Gravesend buoys. Only too often did the terse comment appear against familiar London River tug names—"Mined and lost with all hands."

150

CHAPTER FIFTEEN

Salvage and Shiprepair

ONE of the few redeeming features of modern warfare is that destruction and waste engenders powerful forces of ordered recovery and repair. No better example could be found of this good out of evil than in the wartime story of marine salvage and shiprepair.

Despite the most efficient defence, sea warfare inevitably means sunken and crippled ships, and ships lost or out of commission mean so many fewer carriers of food and supplies. To salvage and repair these vessels and return them to their lawful occasions is a blow at the enemy as far-reaching in its effects as many direct naval and military attacks.

During the war marine salvage experts worked almost without a pause in the Thames and its approaches. From beginning to end the Port of London was the enemy's principal target; from the laying of the first mine in 1939 to the firing of the last rocket bomb in 1945, the blocking of this vast sea terminal was foremost in Germany's plans. In spite of the best efforts of fighter 'planes and high-angle guns, many ships and hundreds of small craft were lost or damaged. Apart from the nation's dire need of ships for sea carriage, salvage work was vital to keep the channels clear so as to keep the port open for seaborne supplies.

By the end of 1940, the new P.L.A. Salvage Department had dealt with more than a score of ships sunk or badly damaged in the docks or the river, as many again damaged to a lesser degree, and hundreds of small craft, of which fifty-four causing obstruction were raised within six weeks. In December, 1940, five vessels were mined and sunk in the estuary in one day, yet it is to the credit of the salvage men that not once during this or later periods of the war did any obstruction prevent ships from proceeding up or down the river.

The vessels of the reorganised salvage service were superbly equipped; they carried divers and diving apparatus, and powerful salvage pumps; and ancillary craft were always available when required. Steel plating around the bridge and high-angle guns, used with good effect on many occasions, for defence against enemy aircraft gave some comfort to civilian crews employed almost daily amidst a non-stop battle, but the strain on the salvage men was heavy. Time and again exhausted men going ashore for a well-earned rest were recalled for further urgent and unavoidable duty. The salvage vessels were in constant danger of enemy attack, and there was the ever-present threat of mines. To add

further to their difficulties, normal means of communication were often disrupted. Yet these men never cracked; they were imbued with a traditional sense of duty as high as that in any of the armed forces, and they were determined, fair weather or foul, to keep the port open.

During the autumn of 1941, P.L.A. salvage craft undertook further duty, assisting in positioning the first four Maunsell forts in the Estuary. On one occasion when a fort was being sunk on site enemy aircraft were driven off by the guns of a port salvage vessel.

The summer months of 1942 and 1943 were mostly devoted to raising wrecks sunk in the estuary, but these operations were halted in the summer of 1944 by work connected with the planned invasion of the Continent. The resumed air attacks on London caused the salvage vessels to be once again fully occupied with damaged ships and barges. Several operational ships damaged in the D-Day operations were towed to the Thames for "first-aid" repairs in the way of pumping and patching to enable them to proceed to dry dock or to lie up until permanent repairs could be put in hand.

Some idea of the exacting work of the officers and crews of the port

Tugs belonging to the Union Lighterage Company in a London dock. The *Ditto* was built at Selby in 1930, and the *Bruno* was something of a veteran, having been built in Rotterdam as long ago as 1914.

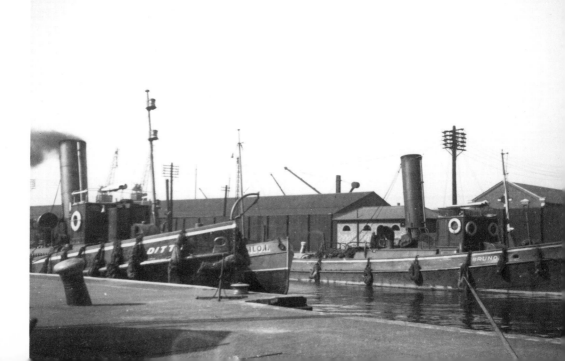

salvage fleet during the war can be gained from the following records.

In November, 1940, the s.s. *Dagenham*, a laden collier inward bound, was mined in the Thames Estuary and the vessel grounded on the East Cant Sands, her engine room flooded. Salvage vessels went to her help, pumping operations were begun, and as the water was cleared from the engine room the ship's head rose. In order to lighten her some of her cargo was jettisoned by the salvage crew, using shovels and baskets. During these operations the Salvage Officer observed that photographs were obviously being taken by an enemy reconnaissance plane; he decided to move the wrecked vessel at once, and tugs and salvage vessels succeeded in moving the *Dagenham* about four miles upriver to the Jenkin Sands, where she was again grounded. His decision was proved correct, for that same night enemy planes dropped flares on the previous position in an obvious attempt to locate and bomb the salvage plant. Emergency patching was undertaken on the damaged ship, which was later towed to Dagenham where the cargo was discharged. The *Dagenham* was eventually dry docked, repaired, and resumed regular sailings to and from London River.

Another collier, the s.s. *Colonel Crompton*, fell a victim to enemy attack in November, 1940, a bomb damaging the ship and setting her on fire. When a salvage vessel reached her she was alight in the engine room and stokehold and the ammunition in the locker was continually exploding, but in spite of the danger five lines of hose from the salvage ship played water on her and she was boarded by some of the salvage crew, who suffered some discomfort from having the soles of their boots burnt. The fire extinguished, the *Colonel Crompton* was pumped out and plugged and eventually docked in London. Two men of the salvage crew were decorated for their action.

Perhaps the most forlorn hope which the Salvage Service pulled off was the raising of the s.s. *Llandilo*, a vessel of 4,966 gross tonnage which was mined in the estuary off Southend in December, 1940. Owing to the presence of mines the Salvage Officer decided not to risk the loss of a salvage vessel while making the initial inspection and so called for volunteers. The master of the tug *Badia* agreed to take the Salvage Officer to the damaged ship and the tug accordingly led the way, with the salvage vessel *Yantlet* following in her wake at a reasonable distance in case of accidents. Further tugs were afterwards sent from Southend to the casualty, which was towed upriver and grounded on the Blyth Sands.

On inspection the *Llandilo* was found to have received extensive damage amidships and was practically broken in half, with both ends standing out of the water. The deck on the port and starboard sides was split and the port side of the hull from the foreside of the bridge

extending aft for fifty-six feet was badly corrugated from the main sheerstrake down to two plates below, where the plates were buckled and protruding outwards. The sea was flowing into the engine room and boiler space and number two hold. The vessel was strapped where she lay, but attempts to refloat her failed owing to lack of buoyancy, so it was decided to suspend operations until she could be towed upriver, a job which had to be postponed owing to other operations in the port being given priority. The *Llandilo* remained on the Blyth Sands for nine months, practically submerged at high water, with only her masts, funnel and bridge showing.

In normal circumstances the *Llandilo* would have been condemned as beyond repair, but because of the urgent need for shipping at that time salvage was resumed in September, 1941. With the aid of two 1,200-ton camels—pontoons which use the rising tide to lift sunken vessels—and other salvage craft, the *Llandilo* was raised, carried upriver and beached at Woolwich, where temporary repairs were carried out so that she could be dry docked. The ship was recommissioned in July, 1942, and took part in the North African landings in the autumn of that year.

An Admiralty oiler which was mined off Sheerness in January, 1941, proved a difficult vessel to salvage since she was regarded as "cranky" through being top-heavy, the oil having leaked out of the tanks which had filled with water and her engine room remaining at water level during all states of tide. Wires were swept under her, but salvage was hindered by the continuous explosions of nearby mines. During these operations it was necessary for a wire to be placed through the vessel's propeller aperture, and although the area was not declared free from mines a diver descended to carry out this work; had enemy air attacks, then prevalent, developed, there would have been little hope of his reaching the surface in time, while any bombs dropped in the area would probably have exploded further mines. The diver received a well-deserved British Empire Medal.

The oiler was raised, but while she was held in wires exploding bombs dropped during a night air attack caused the lifting wires to become taut, the shackles parted and the ship listed to port and was only saved by parbuckling—a salvage method of righting a wreck by winching on specially placed ropes to cause the vessel to roll upright as it lifts—hastily carried out in the dark. The ship was eventually carried into Sheerness, where she was beached and temporarily repaired before being towed to Tilbury for dry docking and permanent repair, after which she went back into service.

Another difficult proposition had to be faced in 1941 when for the

first time a large dredger was sunk in the docks. Normally used in dredging ballast, she was a bucket dredger with a long "ladder" on which the endless chain of dredging buckets was slung. She was under refit when sunk in Greenland Dock, Surrey Commercial Docks, by a bomb which went right through her and was believed to have exploded on the bottom of the dock. The raising of the dredger from the muddy dock bottom was rendered more difficult by the suction of the mud and the absence of any tidal lift in the impounded dock; to break the suction one of the camels was placed over the top of the dredger, and eventually she was lifted from the dock bottom. This was not the end of the problem, since it was necessary to take the dredger out of the dock for temporary repairs and as the salvage craft carried the vessel out of the dock entrance lock a 4½-inch shackle on one of the purchase blocks parted; the dredger had to be lowered to the river bottom, but the salvage crew were just able to avoid blocking the dock entrance and shipping movements were not hindered. The next day the dredger was raised again and beached on the foreshore, where a cement box was fitted over a damaged bulkhead. Later she returned to the dock for refitting and was soon back at work.

The sinking in the Greenland Dock of the paddler *Helvellyn* on 3rd March, 1941, while the former pleasure steamer was being refitted as an auxiliary anti-aircraft vessel, provided the salvage crews with a problem, for she was too badly damaged to patch and pump out, and because of the width of the sponsons, the outboard platforms supporting the covers over the paddle wheels, it proved impossible to carry her out of the dock entrance between lifting craft. The *Helvellyn* had to be cut in two, each piece being taken out of the dock separately. Even then there was only a few inches clearance in the entrance lock when the salvage craft carried out each portion.

The timely action of a P.L.A. Salvage Officer saved from damage a large part of a valuable grain cargo in March, 1941, at a time when the food position was precarious. A Danish vessel at a wharf just below London Bridge was damaged by a mine which caused her to sink by the head, the forepart of the ship being blown away, and the Salvage Officer, advised from the Control Centre in the P.L.A. head offices, proceeded to the damaged vessel by speedboat. After a cursory examination he arranged for a wreck lighter to be towed from the Surrey Docks, and when the lighter arrived a suction pipe was placed in the ship's stokehold so that pumping operations should keep the ship afloat until additional salvage craft could be brought to help. By this means ship discharge was able to continue and the bulk wheat in the after holds was saved from damage by water. The 1,262-gross-ton vessel was later lifted and carried downriver by salvage craft, a most hazardous passage as the forepart was

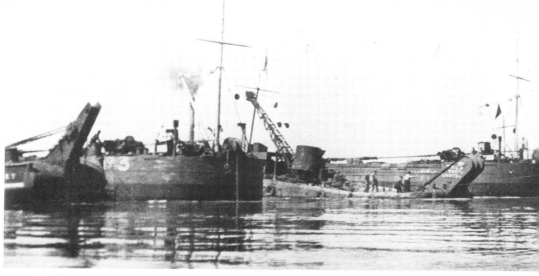

Port of London wreck-raising lighters at work on the s.s. *Kinnaird Head*, sunk by mine in the Thames Estuary off Southend on 27th December, 1940. *P.L.A.*

open to the sea. The ship was beached and a temporary bulkhead fitted to the bow, after which she was refloated and placed in dry dock where permanent repairs were carried out.

Another interesting operation was undertaken when a very valuable cargo remaining in the forepart of a tanker was in danger of being lost. When the tanker, a foreign ship, the *Josefina Thorden*, managed on behalf of the Ministry of War Transport, was mined off the East Coast the stern half of the vessel containing the engines broke away and sank. The forepart remained afloat, however, and rescue tugs began towing it to the Thames with its cargo of a valuable lubricating oil base in solidified form, of which 4,330 tons remained on board. The *Josefina Thorden* ran into further trouble while in tow, as a heavy gale sprang up and she ran aground on the East Cant Sands; the cargo was once more in jeopardy. A salvage vessel and tugs were sent to her, but it was obvious that the wreck would have to be lightened before she would move. Another tanker was brought up and the salvage ship supplied steam to melt the solidified oil cargo, which was then transferred to the waiting tanker. About five hundred tons were transferred before what was left of the *Josefina Thorden* showed signs of buoyancy, and the half-vessel was then taken off the sands and towed upriver to Shellhaven, where the rest of the cargo was discharged. Only thirty-one tons of cargo was lost during these operations, and the value of the cargo recovered was many times that of the ship, running into hundreds of thousands of pounds.

During the summer months of 1942 and 1943 several mined ships which had been so badly damaged that they could not be refloated in the normal way were lifted in the estuary. Each vessel presented her own difficulties. They had been sunk in the winters of 1940 and 1941 and had been under water for eighteen months or more before salvage operations began. Work on raising them could not start in the summer of 1941 as the area was not considered free of mines, and in the interim the wrecks had sunk into the sand, each forming a sizeable "dock" which greatly increased the weight to be lifted. The fact that the ships had been severely damaged by mines made the task more difficult because of the jagged pieces of plating obstructing the lifting wires, very often with destructive results to the wires themselves. Three of the ships had cargoes of cement, and this, of course, had set into hard concrete which could not be removed from the wrecks before raising them.

Three vessels had to be lifted each in two pieces, and another in three; each complete section was a major salvage operation equivalent to lifting a complete ship. All had formed an obstruction to navigation and, although the operations were often protracted and tedious, the work was essential and was possible only through the dogged perseverance of the salvage officers and crews.

During and immediately after the war, thirty-five vessels sunk by enemy action were raised in the port, and help was given to another forty-six. As regards barges, tugs and other small craft, nearly six hundred were raised from the river and docks.

The principal salvage craft owned by the Port of London Authority before the war were the self-propelled salvage vessel *Yantlet*, four salvage lighters and two camels. The *Yantlet*, with a gross tonnage of 379, had a bow davit with a lifting capacity of 120 tons. Under the terms of an agreement with the Admiralty, the self-propelled salvage vessel *King Lear*, owned in peacetime by the Ocean Salvage and Towage Company, served with the P.L.A. fleet. She had a speed of eleven knots, so was particularly useful in reaching a wreck and rendering "first-aid" as quickly as possible.

The Dover Harbour Board's self-propelled salvage vessel *Dapper* also did excellent work in the Port of London between October, 1940, and May, 1942, and two Admiralty vessels, the *Forde* and *Freya*, joined the salvage fleet during the main period of heavy enemy air attack. The Admiralty also placed a "Port Salvage Clearance Unit" at the disposal of the Port of London Authority, the unit's equipment including steam and electric pumps of varying capacity, compressors, generators, impact wrenches and other items invaluable in wreck-raising operations.

One vessel not salvaged remains to the present day. The masts and

derricks of the wrecked American liberty ship *Richard Montgomery** can still be seen off the Kent coast. She left the Delaware river in August, 1944, with a cargo of bombs and detonators bound for the Thames, where she was to await a convoy to the liberated port of Cherbourg. On 20th August, she went aground on Sheerness Middle Sand in the estuary at the top of a spring tide, which meant that she had to be lightened if she were to float on the next spring tide. Discharge began three days after her stranding, by which time some of her welded plates had buckled, over 3,000 tons of cargo being removed. However, the hull cracked open, the holds flooded and hopes of salvaging the ship vanished when she finally broke her back, leaving some 3,700 tons of submerged bombs and detonators still in the wreck. The hull is now sunk deep in sand and mud, and it has not been thought prudent to attempt recovery of the remaining munitions.

Of equal importance to the war effort was the repair and re-equipment of any vessel raised, patched and brought in by the Salvage Service; it may not be generally realised that during the war London was the largest ship-repairing port in Great Britain. The River Thames Dry Dock Proprietors and Ship Repairers Association comprised the principal companies engaged in the industry whose work in normal times covered ship maintenance and ship servicing. To a lesser degree, ship repairing as understood in many of the ports in the North—that is, repair to damaged hulls and machinery—was also carried out.

The lease of one important London ship repair depot, the Blackwall Yard, was negotiated in 1587, a year before the coming of the Spanish Armada, and in those early times this yard was probably closely associated with the first East India Company, building and repairing ships for the Far East trade.

In common with most industries in this country, the threat to world peace caused Thamesside ship-repairing firms to draw up passive defence schemes as early as 1937, and these were well on the way to completion by September, 1939. At the same time the general character of the work of member firms of the association changed, not only in volume, but in kind, for during 1938 and 1939 they became increasingly engaged in the rearmament programme, both in preparing defensive equipment for merchant vessels and in supplying warlike stores. With the outbreak of war, they came under Admiralty control and all their activities became gradually absorbed by the system of "priorities", the installation of defensive equipment in merchant vessels being speeded up, conversion of vessels for special service being put in hand, and

*Her name commemorated that of an eighteenth century American patriot of Irish extraction who fought against Britain in Canada

158

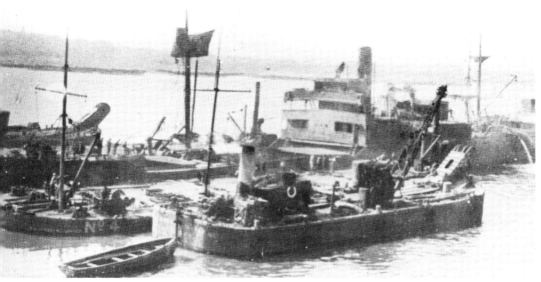

Salvage craft raising a vessel, believed to be the s.s. *Halo*, a vessel of 2,365 gross tons mined off Beckton on 21st March, 1941. *P.L.A.*

organisation and methods being devised for dealing with ships and vessels of many specialised types. The system functioned throughout the war with surprising smoothness and redounded to the credit of the industry and the controlling Government department.

The first enemy bombs that fell on the London area on 18th June, 1940, were a prelude to the Battle of Britain which developed gradually into the intensive attacks of early August. The docks and riverside areas were not greatly affected during the early period, although on 1st September, 1940, one of the works of a member firm at Tilbury received a direct hit from a bomb which demolished many of its stores and workshops; alternative accommodation was immediately obtained in the district and work continued.

In assessing the strain on men and women engaged in this industry, it is important to note that the call for Local Defence Volunteers (which later became the Home Guard) was met with immense enthusiasm by employees of the various firms, some of which had complete L.D.V. companies in their own works. A Local Defence Volunteer military guard, first mounted at an important works on 25th May, 1940, (like others in many establishments) functioned every night without a break

until the Home Guard "stood down" in November, 1944. Other employees in the industry joined the Women's Voluntary Service or—like millions of citizens—undertook Civil Defence duties in their home districts, including those of street fire parties on fire patrols.

Who among those who were in the Thames ship repairing industry on 7th September, 1940, will ever forget the rain of destruction that fell on that brilliant Saturday afternoon? In the dockside and riverside boroughs hundreds of people were killed and injured, thousands of houses were destroyed or damaged, transport was disorganised; but Sunday morning saw workers and staffs of the ship repairing industry at their jobs getting plants running again.

That Sunday night the procession of bombers started again and for nine-and-a-half hours some two hundred of them again dropped their tonnage of destruction on London's dockland; but the industry was learning how quickly injury could be made good and how soon vital plant could be restarted. Although the continuity and persistence of attack lessened in intensity, the strain on the people continued and the difficulties of transport varied from day to day. Some firms had evacuated sections of their staffs; others kept staff in the dock area throughout the war.

For long periods individuals had to spend their nights in street

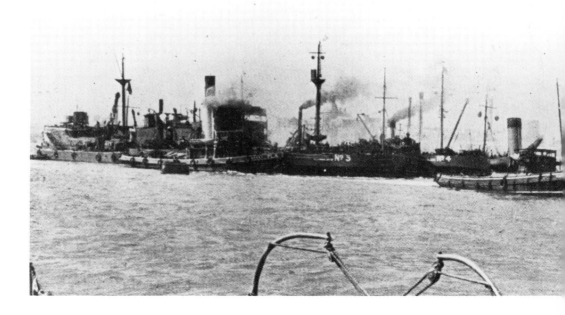

shelters and still be on the job at starting time each morning. There were people who had to find other accommodation, travelling as much as twenty or thirty miles each way every day; a hardship for people who normally lived near their work. There was also the problem of getting food, accentuated by the obliteration of or damage to many of the taverns and eating places in the riverside boroughs, a problem which was gradually met by the provision of mobile canteens serving the dock areas, and ultimately by permanent canteens provided by certain firms and the Port of London Authority itself. The ship repairing industry has recorded its intense appreciation of the service given by those hard-working women who operated the mobile canteens and organised the distribution of food.

In addition to the strain and anxiety of not knowing what might be found on returning home, there was, too, the strain on men working in dry dock bottoms; they knew what would follow the blowing-in of a dry dock caisson which held back the forty feet or more depth of water outside the dry dock.

Because of pride in its accomplishments, and perhaps because of its necessary passion for calculations and costings, the industry kept a detailed account of what it had suffered. According to its records, the active raids on London numbered 1,386 with a total duration of 2,383

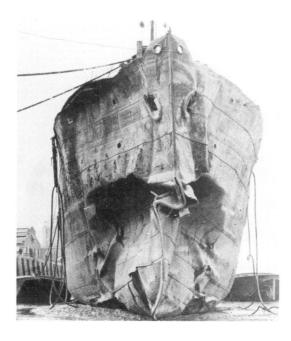

Opposite: Tugs taking the Gas Light and Coke Company's collier *Halo* upriver to a dry dock where she was refitted in time to take part in the D-Day operations. She was sunk for a second time when torpedoed by an E-boat off the French coast on 22nd January, 1945.

P.L.A.

Right: The *Halo* beached at Woolwich before being taken into dry dock, showing the damage caused by a mine laid in the river at Beckton. *P.L.A.*

hours 53 minutes. In addition, raid warnings which did not presage active attack numbered 594. Upon the riverside boroughs which housed the industry fell approximately 15,000 high-explosive bombs, uncounted thousands of incendiary bombs, approximately 350 parachute mines and bombs, 550 flying bombs and 240 V.2 rockets.

Of the eight individual firms comprising the industry in the port, one with six establishments suffered 128 separate cases of damage; another with six installations had 41 cases, and yet another with three had 18 incidents. Of the remaining five, each with one establishment, they had respectively twenty, twelve, seven, six and six cases. The period of approximately six months when the long-range rocket attacks were directed mainly at London was perhaps the greatest strain on employees' nerves. Certainly no other British port suffered to the same extent.

The bare figures of what was accomplished in this industry during the war years are in themselves impressive, but when coupled with the conditions under which the work was done they represent a magnificent contribution to the war effort. Altogether 23,315 vessels and craft of all kinds were handled, involving either conversion, repair or maintenance. Of these 4,402 required dry docking, and this while the eastern riverside boroughs were for quite a time under almost continuous bombardment.

The changing fortunes and necessities of war had a marked effect on the class of work dealt with, and also affected the number of ship casualties which increased or diminished according to the intensity of attacks against Allied shipping. Generally throughout the war the work consisted of the fitting out and equipping of armed merchant cruisers, damage repairs and refits to H.M. cruisers, destroyers, submarines, corvettes, sloops and auxiliary vessels, the conversion and repair of minesweepers, aircraft carriers, transports, ammunition ships, oil carriers and supply ships of all kinds, together with hundreds of Thames barges which were turned into landing craft for men and vehicles. Special service craft such as torpedo boats, minelayers, salvage vessels, rescue tugs, cable ships and landing craft of many kinds were also handled.

Amidst all this volume of diverse work there are certain outstanding cases. London ship repairers took pride in the fact that they fitted out and equipped the armed merchant cruisers *Jervis Bay* and *Rawalpindi*, both of which earned undying fame in the North Atlantic. Also dealt with in London for extensive war damage and refit was the famous destroyer *Kelly*, forever associated with the late Earl Mountbatten of Burma, and H.M.S. *Suffolk* was refitted in London before proceeding to the Far East. The coming of this last ship was regarded as a happy coincidence, since the first vessel to bear the name had been laid down at the same yard in 1679.

The *Bulolo*, which served as headquarters ship, Combined Operations, in the North Africa landing, was another equipped in London for her particular job. The four vessels used in the laying of "Pluto"—the pipe line under the ocean—were converted and fitted out in London, while many vessels large and small steamed or were towed into the port having suffered mine, torpedo or bomb damage. Many did not reach harbour, though several were salvaged and ultimately repaired.

One outstanding success was the cutting away from a salvaged vessel of the damaged midship section, the construction in dry dock of a new section one hundred feet long, and the rejoining of the three sections and

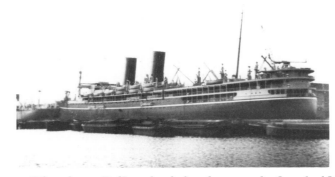

A Peninsula and Oriental Steam Navigation Company "R" class liner in dock. One of this class, the *Rawalpindi*, earned undying fame after being converted into an armed merchant cruiser by London ship repairers.

equipping the ship for sea. The sloop *Pelican* had the damaged after-half of her hull cut away and a new half was built and joined up to what remained (Perhaps the ghost of Sir Francis Drake, who circumnavigated the world in his ship *Pelican*, renamed *Golden Hind* at Deptford, looked on approvingly at this repair work). The destroyer *Vanessa* had a third of her total length amidships completely renewed, and the supply ship *Fort Dearborn*, badly twisted as a result of mine explosions, was cut in half, straightened, rejoined and refitted.

The fluctuations of war became apparent to those in the ship repairing industry by the varying nature of their work. With the approach of D-Day, they took further pride in the procession of transports, ammunition ships, supply ships, oil carriers and water carriers (many of them having passed through their hands) which sailed into the docks ready for the great adventure.

The approaching assault on Europe also made new calls on the industry which included the building of special types of vessels and craft. Essentially ship repairing firms, the Thamesside yards had to adjust their organisations and augment their output to the extent of building and delivering sixty-six tank landing craft, two rocket ships and eleven floating cranes and pontoons.

Once launched, the invasion called for a constant schedule of sailings to maintain landings, and during this period all demands for repair and maintenance were fully met.

A member firm of the association, in addition to its major function of ship repairing, also dealt with other classes of work, including 61,971 separate orders for the repair and maintenance of dock plant for the Port of London Authority. It constructed and erected aeroplane factories, hangars and other structures in various parts of the country—20,300 tons in all—built and erected hundreds of wireless towers from the Orkneys and the Western Isles of Scotland round to the Scillies, and supplied thousands of items of equipment and appliances for the Services, other Government departments and borough councils, including 16,200 tons of castings from its foundry. The industry also dealt with much of the war damage to members' own works and plant. Most firms had internal organisations for this purpose, and the success of their work was such that, in spite of the destruction, travelling difficulties and blackout, production was practically uninterrupted. The main offices of one member firm were completely burnt out, but temporary quarters were arranged and the staff continued to function. As fast as roofs and windows were blown in, temporary coverings were found and fitted. One office received a direct hit in the autumn of 1940; within ten minutes the debris was being cleared and accommodation rearranged for the staff.

One morning in 1945, a V.2 rocket dropped beside the main offices of a member firm which housed a staff of over 150, leaving the interior a shambles. One hundred casualties were dealt with; forty-five of these requiring hospital treatment were dressed and sent off by the firm's own Civil Defence and first-aid personnel within thirty-two minutes of the fall of the rocket. This "incident" happened at approximately eleven o'clock on a Saturday morning and the office block was cleared of debris, the gaps in the building, windows, doors, etc., were temporarily closed in, and normal office routine was resumed on the following Monday.

A high-explosive bomb blew in the dry dock wall of one company and at the same time completely destroyed the managerial offices. The dry dock was only out of use for a few hours, as the gap was bridged with deep steel girders and the wall filled with concrete, shuttered from the dock side. These incidents show not only how the organisation worked, but the spirit of those involved.

At the end of the war, it was hoped that the co-operation, courage and effort would continue and once again make London the greatest peacetime ship-repairing port in Great Britain.*

*Although the Thames has superb dry docks and other ship-repair plant, that hope has not been fulfilled.

CHAPTER SIXTEEN

On the Riverside

THE ONLY disservice rendered by the Thames to the Port of London at war was to provide a broad and unmistakable flight path for raiding aircraft. Other routes to the Metropolis were also taken by the enemy, but in the main the greatest aerial activity was over the Thames, and this factor, coupled with the heavily industrialised tideway banks, resulted in the riverside areas becoming badly battle-scarred.

The many miles of public and private wharves and warehouses fringing the tideway were complementary to the Port of London Authority's five dock systems and they accounted for the handling of a substantial part of London's overseas trade. During the war two bodies, the London Association of Public Wharfingers Limited and the Federation of London Public Wharfingers Limited, representing a large number of individual privately-owned businesses, gave wholehearted support to the Port Emergency Committee and were an important part of the port's defensive and operational organisation.

One story regarding the first A.R.P. lecture given in the boardroom of the London Wharfingers' Association is worth telling. Enthusiasm ran so high, questions after the lecture were so many and the hour was getting so late that the lecturer was at his wit's end to know how to close the meeting; he solved the problem by igniting a stink bomb.

The evacuation of foodstuffs and vital commodities involved the public wharfingers in many arduous and complicated operations. Some of the staff for the "Buffer Depots" were supplied by the wharves. The wharfingers were able to provide specialised knowledge and services which were gladly used by the Government departments concerned in the packing and forwarding of Red Cross supplies, prisoner-of-war parcels and special ration packets.

In common with most port undertakings, the riverside wharves carried on under the 1940-41 bombardment; like the docks, the very nature of their highly skilled and vital services to the continued resistance of the port precluded any thought of evacuation by the businesses and personnel to safer areas. At the end of the war, there were many broad gaps in the river frontage where was formerly a continuous line of busy wharves and warehouses.

Some of these wharves, bearing the ancient description "Legal Quays", were part of London's history. The rapid expansion of overseas

trade in the reign of Elizabeth I had been aided by an Act of 1558 which gave certain quays in the Upper Pool a monopoly of cargo handling; a later Act increased their number. In the eighteenth century other quays known as "Sufferance Wharves", with more limited privileges, were nominated. The failure of these landing places to keep pace with the growing trade was one of the reasons for the building of enclosed docks. But tradition was of no avail against modern high explosives.

Early during the main aerial attack, Brewer, Chester and Galley Quays* near the Tower of London, at which in the sixteenth century wine galleys from Genoa had discharged their cargo, were completely razed. Sufferance wharves in the City area near Southwark Bridge also ceased to exist. Here and there blackened ruins appeared along every reach of the tideway.

The difficulties of work in the port under blitz conditions applied with particular force to the wharves; their staffs were comparatively small in number and the restricted area of their premises allowed little mobility in defence measures. Only too often was a riverside warehouse consumed by fire in spite of frantic efforts by overstrained and exhausted employees.

A wharfinger arrived at his premises one morning to find them a mere shell, even barges alongside awaiting discharge having suffered in the night's bombardment. When he was able to open his safe he found only a charred mass of paper representing many hundreds of pounds in Treasury notes, but luckily for him he was able to prove his case and received prompt replacements from the Bank of England.

An example of the sense of duty prevailing among the personnel of London wharves and cold stores is worthy of record. A delayed-action bomb which fell within fifty feet of a riverside cold store, causing the premises to be evacuated, was the cause of three workmen being warned away by A.R.P. officials when they reported for work at 8 a.m. The inborn feeling that, whatever happened, the work must go on overcame their good sense and caution and, contrary to orders, they decided to remove the missile, but it exploded on their approach, one man being killed and the other two seriously injured.

A lighter story of the wharves at war concerns a wharf manager who was returning to his office after a visit to a poultry-keeping friend when the wharf was completely wrecked by a flying bomb. The blast knocked him down, but his chagrin at the state of his office may have been somewhat lightened by the fact that the eggs which he was carrying remained intact.

*The post-war office block on this site has been appropriately named 'Three Quays'.

The Thamesside wharves seen above a duty launch of the Metropolitan Police Thames Division.

Another "escape" story centres on Peter, for some years the resident cat at a wharf near Cannon Street railway station. During the last great raid of May, 1941, the wharf caught fire and was completely gutted, and it was several days before the building could be entered owing to the terrific heat. When eventually the first floor was visited, two points of light in a corner revealed the presence of Peter, who had survived with only a burned back and a singed coat. Under the care of staff in new premises, Peter was soon himself again.*

A detailed war story of the private wharves and riverside factories, the overseas, coasting and Continental wharves which served Thamesside industry and commerce is impossible within the scope of this survey, for the number and diversity of the heavy and light industries established on the banks of the tideway were probably unrivalled. Out of some nine hundred riverside premises within the County and City of London, nearly three hundred recorded war damage ranging from "minor" to

*During the Great Fire of London, Pepys recorded in his diary: 'I also did see a poor cat taken out of a hole in a chimney, joyning the wall of the Exchange, with the hair all burned off the body, and yet alive.'

complete demolition. Many of them played a major part in the manufacture and testing of the strange new weapons produced in the Port of London, and most of them contributed in varying degrees to the general war effort.

Special mention must be made of the firm of Tough Brothers at Teddington, on the back doorstep, so to speak, of the Port of London. All through the war this company built various types of light warships, an outstanding undertaking being the construction of midget submarines for the Pacific campaign, classified as "Most Secret" for many years after the war. These craft were designed to carry Commandos, inevitably in cramped and primitive conditions, to an enemy-held island where the vessel could be sunk and so concealed while the crew carried out operations ashore. An automatic device would blow the ballast tanks and refloat the submarine in time for the Commandos' return so that they could board it and return to the mother ship, perhaps as much as a hundred miles away. One of the problems, eventually overcome, was ensuring that the craft did not surface upside down. Two such craft were

Reconstruction work under way at Teddington Weir after a bomb had destroyed part of the weir, causing a rush of water which imperilled vessels moored in the river below.
Thames Water

taken over by the Navy for trials but the Japanese surrender came before they could be used operationally.

This firm was also one of the main collecting points for the little ships that went to Dunkirk. Craft were commandeered, sometimes without the owner's knowledge, prepared for the crossing and sent downriver. One of Tough's earlier-built launches, the *Tigris*, rescued some nine hundred men from the beaches, but she then had to be abandoned, the crew first putting her engine out of action. Two days later she arrived off the Goodwins with ninety Frenchmen aboard, one of them having managed to get the engine going again.

The enemy obviously knew of the work being done by this firm for, considering their semi-rural site, Tough Brothers had more than their share of the blitz and the later flying bombs. A high-explosive bomb on neighbouring Teddington Weir caused a great rush of water past Tough's wharf, imperilling ships moored there.

At the end of the war, all the way downstream from Teddington, many waterside premises, formerly regarded as landmarks, had either vanished or presented unrecognisable silhouettes. At Twickenham, near the end of the tideway, the most noticeable loss was Radnor House, hit by a high-explosive bomb. With it had gone the beautiful eighteenth century painted glass and its memories of the Earl of Radnor and Horace Walpole. Only a short time before the war, Queen Mary had headed a fund for the preservation of Radnor House, then used as a museum.

The principal war scar at Isleworth was the badly damaged Royal Naval School, built nearly a hundred years ago by the Earl of Kilmorey. Something about it—history does not record what—must have offended him, for he never occupied it, preferring to live in nearby Gordon House. At Chiswick, high explosive and fire had crenellated the top of the surviving walls of the Griffin Brewery so that they resembled that bogus "anciente" atmosphere acquired by certain nineteenth century castles.

A large gap was torn in the Battersea river frontage by the disappearance of the Candle Factory. On the night that it was snuffed out, the Harbour Master had the problem of recovering hundreds of barrels of paraffin wax floating in the river, each with a surface so slippery that it rejected the embraces of a running bowline. The complete demolition of St Luke's, Chelsea's old parish church, was one of the saddest losses of the tideway. Although founded in the twelfth century, most of the building dated from the fourteenth century, but dates were ever cold and unsatisfying food for the imagination, and it is preferable to think of it as already old and venerable when the Armada sailed. The ghosts of Sir Thomas More and Charles Kingsley found nothing left of the building.

At Pimlico, the gaunt and unloved Royal Army Clothing Factory had disappeared; with it had gone Watson House, which formerly stood in the premises of the gasworks at Nine Elms on the opposite bank. Watson House, which began its career as a jam factory and later became offices and stores, was a mundane building with no historic or antiquarian interest, yet it was proof of the tortuous ways in which effect is sometimes reflected from cause; it was built soon after the catastrophic fire resulting from the San Francisco earthquake of 1906, and this persuaded the architect who designed Watson House to incorporate excessively thick fire-resisting walls. They were of little avail against the German attack.

Above Westminster Bridge and on the south bank, St Thomas's Hospital was badly damaged in the eastern wing and appeared to be much in need of an architectural surgeon not afraid to amputate. One shudders to think of helpless patients lying there under the hail of hate; yet such are the traditions of our medical and nursing services that one knows without details that their comfort and safety were the first consideration of the doctors and nurses on duty at the time. Mercifully, there was no view from the river of the damage done to the Houses of Parliament on the north bank.

Upstream and downstream of Cannon Street railway station, looking vacant under its glassless roof, was one of the worst blitzed areas along the Thames. By comparison, the Upper Pool looked reasonably trim, for the considerable damage suffered by wharves and other undertakings on both banks was either quickly cleared or was largely hidden from the river. Only two major losses were noticeable, the historic old Brewer, Chester and Galley Quays and the eastern wing of the Custom House, struck by a high-explosive bomb in 1941.

Another great loss to the Port of London was the partial destruction on Tower Hill of Berkyngechirche, All Hallows by the Tower. This Saxon church, one of the oldest, perhaps the oldest, in London, had survived the Great Fire of 1666 but succumbed to the greater fires of 1940 and 1941. Roof, arch, chapel and chancel, buttress and pillar, all were destroyed, and the old church stood open to the sky, with bare walls on three sides; the east wall shattered and only the Cromwellian tower remaining comparatively undamaged. Here the heart of *Coeur de Lion* had rested in the Royal Chapel; here was established the Guild Chapel of Toc H.

In the vicinity was a desolation of rubble where formerly existed the quaintest of waterside lanes; St Dunstan's Hill, Harp Lane, Water Lane and Great Tower Street. Here was the very birthplace of ancient London; the first settlement of riverside Cockneys. Little did they dream, those first Cockneys, as they paddled their primitive craft in the nearby river,

of the fate that would one day overtake the site of their rude hutments.

Below Tower Bridge heavy damage was suffered by wharves and Thamesside industries all the way down to Woolwich. On the north bank the riverside "screens" were down and there were many new and surprising views of the ships and warehouses of the London and St Katharine Docks. On the south side of Limehouse Reach there was immense desolation left by the timber wharves which burned with the Surrey Commercial Docks during the first weekend of the main attack.

Bomb damage to the Custom House, caused during an air raid in 1941.

H.M. Customs and Excise

Just downstream of the Greenland Entrance to the Surrey Commercial Docks in Limehouse Reach was the site of a famous waterside hostelry, the *Dog and Duck*, completely destroyed by enemy action. Below the Greenland Entrance, prefabricated store huts dotted the site of the famous old Deptford Victualling Yard, destroyed early in the attack. The loss to Thamesside was exemplified by this sight of prefabricated huts standing where King Harry had walked, where Sir Francis Drake, Queen Elizabeth, Pepys and almost countless seamen and adventurers had added their quota to the traditions of British sea power.

At Greenwich the old *Ship Hotel* with its memories of Ministerial whitebait dinners had gone. Parts of the Naval College were severely damaged, but luckily from the river's angle there seemed little perceptible change to one of the finest waterside vistas on the Thames. In the lower reaches below Woolwich the enemy had much more space in which to miss and, although most of the industries and wharves along this section of the river had their fair (or unfair) share of bombs, there were no noticeable losses.

At Gravesend, beached on her beam ends and about to be broken up, was the training ship *Cornwall*, which had narrowly escaped foundering at her moorings when she suffered near-misses from enemy bombs.

Thames bridges were, of course, vital links in the national lines of communication and supply and the enemy made them special targets, exerting every effort to smash them. All the bridges across the Thames had narrow escapes, the four City bridges alone being concerned in twenty-one "incidents". Blackfriars Bridge suffered from two high-explosive bombs and was partly closed for two days. Southwark Bridge had six "incidents" and in May, 1941, a high-explosive bomb destroyed the north arches and closed the bridge for eight weeks. London Bridge suffered from blast in 1940 and again in 1944 but never received a direct hit; nor was it ever closed. In 1940 the high-level span of Tower Bridge was struck by a high-explosive bomb and the bridge ceased to function for a short time owing to severing of the hydraulic mains. This bridge was concerned in all with nine "incidents", the worst apart from the direct hit being damage to a bascule, the towers and engine room caused by a parachute mine exploding on the river foreshore nearby in April, 1941. The upstream bridges were also affected in one way or another, Waterloo Bridge, for instance, being concerned with no fewer than twenty-three "incidents". The Hungerford foot bridge was completely cut in 1944 by a flying bomb, which also severely damaged Charing Cross railway bridge.

The most serious tunnel "incident" occurred on 7th September, 1940, when a high-explosive bomb caused part of the lining of the Greenwich pedestrian tunnel to collapse, resulting in the tunnel being flooded.

Readers familiar with the wealth of ancient and cultural associations of "England's lifeline" may well realise the war's cost to Thamesside in the loss of its historical and architectural monuments.

CHAPTER SEVENTEEN

The Army, Royal Air Force and Home Guard

RESPONSIBILITY for defending the Port of London against the raiders who used the Thames as an approach fell to the Army's anti-aircraft gunners and to the fighter pilots of the Royal Air Force. When the first great air attack on the port began on 7th September, 1940, most of the anti-aircraft weapons in the South-eastern area were concentrated along the lower river, but that first attack pointed out the urgent need for a more powerful barrage in the dockland area itself. Next day reinforcements were on their way to the Metropolis from all over Britain.

At the beginning of the war A.A. Command was badly equipped; guns and searchlights were scarce and the men were inexperienced. Radar, or radio location as it was known in the early days, had yet to be applied to the direction of anti-aircraft guns, and sound locators were in general use to range on enemy planes. The installation of these aids, the levelling of gun sites, the provision of telephone cables and the co-ordination of the warning systems all made for delay before the newly-collected guns could go into action. Nevertheless, all was ready by 11th September, 1940, and that night the incoming enemy bombers were met by a barrage astonishing for those days in its volume. The bombers immediately climbed to 20,000 feet, many turned back and at least nine were shot down by the ground defences. All over London the populace gave thanks; there is no doubt that the nightly roar of London's guns fighting back did much to encourage the spirit of resistance in the citizens. Starting from that night, soldiers, scientists and engineers developed and moulded the London barrage into an efficient weapon which, within a few months, assisted the other forms of defence in making mass night raids too costly for the enemy.

In addition to the orthodox land sites for high-angle guns in and around London's dockland and the Maunsell forts manned by Navy and Army gunners in the waters of the estuary, a notable improvisation was the mounting of anti-aircraft guns in two hopper barges permanently moored in the tideway off Holehaven. These two vessels, *Tatem I* and *Tatem II*, were connected by telephone to land-based headquarters and made most useful additions to the outer ring of London's defences.

Sector officers of the Port of London Home Guard photographed outside the P.L.A. head offices in 1944. P.L.A.

Little has been recorded of the detailed work of London's guns during the war, but in *Roof over Britain*, published by H.M. Stationery Office, some of the dangers and difficulties experienced by the Royal Corps of Signals and by heavy gun batteries installed in the Isle of Dogs were told. Not the least valuable contribution came from members of the A.T.S. who volunteered and successfully manned heavy A.A. units with the sole exception of the guns themselves. Something of the help given to batteries by the searchlights and the Royal Observer Corps was told in that excellent but, alas, now-forgotten publication.

At the outbreak of war the Royal Air Force was nearly as poorly equipped as the Army. Only a leisurely trickle of fighter planes was coming out of the factories and the number of squadrons was quite inadequate for a proper defence. Soon after Munich, when war seemed inevitable, the Government asked the P.L.A. to take a party of high-ranking Service officers, politicians and civil servants round the port to study defence problems. The party embarked in the inspection yacht *St Katharine* and went downriver and through the Royal Docks. On the return passage the visitors assembled on the foredeck and P.L.A.

officials on the ship's bridge heard a confused murmur of comment and opinion. Then a loud and angry voice rose above the rest saying, or rather bellowing, "You say you have built another seventy planes. That's no damned good. Neither would seven hundred. When you have built another seven thousand you can start being satisfied."

Only the barrage balloons were ready; London had already seen a practice run—or rather rise—in 1938 and, on the declaration of war, some three hundred soared into the sunshine.

When the first air attack on the port was made with magnetic mines the Army and the R.A.F. played their part in the drama. The first mine that provided scientists with the information which enabled them to devise an antidote was reported by a coastal battery overlooking Shoebury Sands, where the mine was recovered, and before effective measures could be taken to combat these menaces the R.A.F. made aerial sweeps for them. Wellington bombers were fitted with metal hoops, each some fifty feet in diameter, encircling the nose, wingtips and tail of the aircraft, a magnetic coil in the hoop being energised to create a magnetic field which, it was hoped, would detonate the mines when the aircraft flew over them. It was not a success.

The greatest contribution made by the R.A.F. to the defence of the port was during the brief period of intensive daylight attacks which reached a climax on Sunday, 15th September, 1940, when it was reported that a record number of 185 German aircraft had been destroyed.* Although post-war access to German files shows that only fifty-six had in fact been shot down, it was a defeat from which the Luftwaffe never fully recovered. If some of the writers who now downgrade the effect of Britain's fighting qualities on the outcome of the war could have seen the reaction of the populace to the writhing vapour trails and the sight of an enemy aircraft plunging into the tideway, they would realise that British determination and the later victory on the Continent were profoundly affected by this battle over London's dockland.

The salient features of the part played by the R.A.F. in the port's war story were told by John Hockin in 1945 in a series of articles, *The Air Defence of the Port of London* in the P.L.A. magazine *The PLA Monthly* (now the quarterly *Port of London*). Some of the following is condensed from his work.

It was the successes of the R.A.F. and the anti-aircraft guns which forced the Luftwaffe to abandon daylight raiding and turn to bombing in darkness, when it was much more difficult to pinpoint individual targets such as dock quays and warehouses, leading the enemy to turn to indiscriminate attacks on urban areas. In the meantime the country,

*Winson S. Churchill, *The Second World War*, Vol. II. Cassell

under the urgings of Winston Churchill, was combining experience, science and imagination to help defeat the attackers. The guns and searchlights had already been greatly improved and multi-muzzled rocket projectors were invented and installed. Churchill records that by May, 1941, there were 1,687 heavy guns and 790 light, with about forty rocket batteries, as compared with the previous December when there

Barrage balloons did not always seem to be an effective defence against raiding aircraft, but their presence did force German bombers to fly higher than the bomb-aimers would have liked. *Gordon Kinsey*

had only been 1,400 heavy guns and 650 light.

The main problem of night defence was interception—almost literally a matter of luck, for that alone decided whether defending planes would see the glare from enemy bombers' exhausts. Twin-engined Beaufighters and later Mosquitoes were stationed at special night-fighter airfields. Equipped with radar and heavy cannon, these aircraft had longer air endurance than Spitfires and Hurricanes. On the ground they were aided by a superb organisation which planned and directed the air battles. Londoners and, indeed, all those in other areas of the country under attack were enormously impressed when pictures were released showing the underground operations room, like a huge theatre, with its

large-scale map-table surrounded by quietly efficient W.A.A.F.s, and the huge blackboard with its flashing lights representing individual fighter squadrons. After the war we learned how the enemy's directional beams by which his aircraft were guided to their targets had been "bent" by our scientists; Churchill records that the very few who were in the secret "exchanged celestial grins" when during one raid more than a hundred bombs exploded on grassland well outside the built-up areas of London.

The barrage balloons were deployed to give the greatest protection to the port. One German pilot has been recorded as saying that he dared not go below seven thousand feet because of this barrage and that he let his bombs go at about ten thousand feet, which at night was literally a shot in the dark. The balloons required constant replenishment with hydrogen; a complete goods train arrived daily with supplies of the highly inflammable gas. Early in the war balloons tethered to anchored lighters guarding the convoy anchorages in the estuary sometimes became charged with static electricity and one by one burst into flames and fell, each a mass of blazing gas; one ship narrowly escaped being engulfed.

Thanks to our intelligence services and pre-emptive attacks by the R.A.F., the flying bomb assaults which began in 1944 amounted to only about one-tenth of what the enemy had planned. Here again the balloons played an important part; a barrage of some six hundred, rapidly increased to nearly two thousand, was installed between Gravesend and Guildford. Of course, the pilotless flying bomb was not able to alter altitude to avoid the balloon barrage and collision with a balloon wire inevitably placed the ground crews in mortal danger. Some of these missiles were able to get through and there were casualties, damage and many near misses. It was left to Field-Marshal Montgomery's armies to bring deliverance in September, 1944, when they overran the whole area of the launching sites in one irresistible surge.

"For years," wrote John Hockin, "the Port of London had been under bombardment; for 1,500 days and nights the danger of air attack had been ever present and the defences had never been able to relax. At last it seemed that the danger was past. But Hitler still had something left, and the V.2 rockets added the final chapter to a war story of intrepid bravery, dogged perseverance and high achievement. The German General Staff believed they could close the Port of London; the defenders were determined to keep it open. It is upon the results of such decisive clashes that wars are won and lost."

The last story in these port war annals is that of the Port Home Guard, dockland's citizen army, the men who were both war workers and soldiers, the men of a defensive arm which undoubtedly did a great deal

to discourage the enemy from an attempt at invasion. That their service was necessary and worthwhile was revealed in the autumn of 1945 when the enemy's plans for the invasion of Britain, captured in the fall of Germany, showed that Tilbury was one of the key points in the subjection of Britain.

Immediately after the announcement that brought into being the Local Defence Volunteer Force it was decided by the P.L.A. to form a "house" group to defend the docks and port plant and equipment. An invitation to P.L.A. employees and other workers at the docks met with an immediate positive response. Besides the urge to serve their country in a crisis, the volunteers were conscious of their responsibilities to protect so vital a buttress to the nation's fortunes. Many of those who came forward were ex-officers and N.C.O.s (complete with drill sergeants' vocabulary) of the First World War, and with their assistance training began at once with such weapons as were available; these included sporting guns loaned by their public-spirited owners. Guards were maintained nightly at vulnerable points. Among the volunteers guarding the docks were employees of shipping companies, ship repair firms, contractors and tenants. Along the banks of the river, the staffs of public wharves and Thamesside industries formed similar groups. If invasion came, L.D.V. groups in the Port of London confidently expected to be among the first to go into action. Apart from the attraction for the enemy of the great prize of the port, large expanses of lonely marshland providing ideal landing grounds for parachute troops and gliders flanked many river and dock areas.

When the L.D.V. Force was designated the Home Guard, two battalions—the 14th and 15th City of London, Royal Fusiliers—at first comprised the P.L.A. Sector. These battalions, under the command of an experienced officer in the service of the P.L.A., were responsible for the river banks from the Pool to Bow Creek and all docks with the exception of Tilbury. The latter docks were covered by the Essex Home Guard, while other river areas were the responsibility of various riparian Home Guard battalions.

Most people in this country over the age of fifty are familiar with the early obstacles to be overcome by the Home Guard. Instruction was given from almost forgotten drill books, weapons were heterogeneous and, in many cases, extremely unorthodox. On one occasion members of a Port of London battalion collected two old but highly prized machine guns; the guns were wrapped in newspapers and transported in a London taxi. On another occasion, mountings for guns were improvised and made with a complete absence of official forms and sanction at a Thamesside works. In the early days, some training took place in the moat of the

Mrs Winston Churchill inspecting a guard of honour provided by the Port of London Sector of the City of London Home Guard. *P.L.A.*

Tower of London and one squad, in civilian clothes, was much abashed to find itself mixed up with the famous Ceremony of the Keys. Gradually, however, the picture changed. Despite the increasing volume of work, men spent the maximum time available in acquiring training in all types of weaponry, camouflage and modern methods of combat. It must be remembered that these men were not parading and training in their home towns and so lost that local encouragement and pride as home defenders which was almost the only compensation for their arduous duties. Gradually the Home Guard built up the complex organisation by which modern armies move and fight until it blossomed into a well-trained and well-equipped arm on which the country relied so heavily.

At a later stage, another battalion—the 24th City of London, Royal Fusiliers—was recruited from the watermen, lightermen and river workers of the Thames to defend and man floating craft and equipment. Proud of its shoulder flash of the Naval fouled anchor, this amphibious body was trained primarily to function in conjunction with the London Naval Command.

179

South African Premier Field-Marshal Jan Smuts was among a group of distinguished visitors to the Port of London in 1944.
P.L.A.

In addition to the weekend camps, battle drill instruction, and special courses of training sponsored by regular Army battalions, the areas surrounding the docks devastated by the blitz were the scene of most realistic practice battles in which live grenades and ammunition of all types were used. By this means all the lessons of tank stalking, street fighting and battle craft in a built-up area were learnt under conditions nearly approaching the realities of actual warfare.

Company headquarters were established on various waterside sites, and the ingenuity shown in matters of camouflage and defence measures were both artistic and effective. One tugmaster protested at the excellent camouflage of a particular post; he had difficulty himself, he maintained, in finding it and there was in his opinion a serious danger that the enemy would pass it by without making an attack! At the West India Docks, the Guard House built about the year 1800 by the West India Dock Company to accommodate its own armed guard again served the original purpose for members of the Home Guard, whose battalions were, in fact, the twentieth-century descendants of volunteers recruited during the recurring national crises from Thamesside workers of the period. In 1796, for

example, the East India Company raised two regiments under the threat of French invasion, while river fencibles, volunteers, militia and territorials have always received much support from workers of the port.

Exigencies imposed by urgent war work severely restricted ceremonial occasions. Perhaps the most stimulating of the few events that were held was the parade and march past of the Sector on Home Guard Sunday, 1943, in the moat of the Tower of London. Of the Guards of Honour for distinguished visitors, those provided for Mrs Churchill and Field-Marshal Smuts are most easily recalled.

Enough of the history of the Port of London Home Guard has been outlined to justify the tribute on the occasion of its stand down from the Flag-Officer-in-charge, London, that all ranks "have played an important part in keeping the Port of London open during a critical period of its history."

The Port of London Sector, City of London Home Guard march past the Flag Officer in Charge, Port of London, Admiral Sir Martin Dunbar-Nasmith, V.C., on Home Guard Sunday, 16th March, 1943. *P.L.A.*

CHAPTER EIGHTEEN

Aftermath

THE PORT of London has faced many challenges during its two thousand years of recorded history, but the Second World War was the greatest of all its crises. And the crisis did not end when the guns fell silent. The physical state of the Thames as a haven was lower than at any time since the beginning of the century. Damage to premises and equipment belonging to the P.L.A. was assessed at £13½ million on a pre-war valuation, while damage to private Thamesside installations was probably as great.

A particularly serious loss to a port on which the world's entrepot trade was then centred was the destruction of some fifty per cent of the total storage accommodation. Plant and cargo-handling equipment was similarly in a parlous state. Some had been taken by the Government to help West Coast ports; some had gone to the Services; and some to the Continent for liberated ports. The remainder in London needed much more than a lick of paint. Maintenance dredging in the river, too, had perforce been neglected, and although the ship channels had been kept open many wrecks in the estuary were still potential hazards to navigation.

There was no lack of determination both afloat and ashore when the port began the task of restoration, but it soon encountered two formidable obstacles—the government's refusal to grant priority over other national recovery projects for scarce labour and even scarcer material or to permit the necessary capital expenditure. In the meantime ships were rapidly shedding guns and grey paint and returning to normal trading, while manufacturers and shipowners were being exhorted by the same government to concentrate on exports. Both loudly demanded a quicker turnround of ships, a demand which our ports were in no position to meet.

On the Continent certain ports, traditional trade rivals of London, were contemplating with satisfaction their totally devastated sites. In the normal course of events it is difficult for massive port installations to keep pace with the changing needs of ships and cargo, and rarely before had port planners been afforded such an opportunity (aided by American capital) for a completely new start on the most modern lines.

It has been claimed that the fearfully destructive powers of modern warfare are to some extent matched by enhanced methods of recovery.

Certainly this was the case in these near Continental ports, but along the Thames a grim time of patching and making-do began; not until the 1950s was the P.L.A. able to start proper reconstruction. Although the port has never fully recovered from that setback, the tidal Thames has enjoyed many post-war triumphs and suffered many vicissitudes.

It now bears little relationship to the port which emerged from the war in 1945, but, however much diminished in stature, it is still the nation's largest port; the river is still our island line of fate. Its traditions are our country's traditions and this story of the tideway at war should provide a basis for all Thamesmen to aim at restoring its former glories.

After the war the two men who were successively Flag Officer in Charge, Port of London, Admiral Sir Martin Dunbar-Nasmith, V.C., on extreme left, and Rear-Admiral E.C. Boyle, V.C., second left, presented a commemorative plaque to the Port of London Authority. Reading the inscription is Sir John Anderson, later Lord Waverley, who was chairman of the P.L.A. after the war. *P.L.A.*

Selected Bibliography

Bomber's Moon, Negley Farson. Gollancz, 1941.
The Epic of Dunkirk, E. Keble Chatterton. Hurst & Blackett, 1941.
The Merchant Service, L.M. Bates. Muller, 1945.
Dunkirk, A.D. Divine. Faber, 1946.
The Siege of London, Robert Henry. Dent, 1946.
Trinity House, Hilary P. Mead. Sampson Low, Marston, 1947.
London Bridge & The Pool, A.G. Thompson. Allman, 1949.
The Londoner's River, L.M. Bates. Muller, 1949.
The Port of London, R.Douglas Brown. Terence Dalton, 1978.
Independent Member, A.P. Herbert. Methuen, 1950.
Fire Service Memories, Sir Aylmer Firebrace. Melrose, 1948.
Tide Time, A.S. Bennett. Allen & Unwin, 1949.
The War Story of Southend Pier, A.P. Herbert. County Borough of Southend-on-Sea, 1945.
The Spirit of London's River, L.M. Bates. Gresham Books, 1980.
Trinity House, J. Grosvenor. Staples Press, 1959.

Newspapers and Magazines
The P.L.A. Monthly,
The Port of London,
The Port,
Polanews,
Lloyd's List and Shipping Gazette.

One of the barges which was handed over to the Royal Navy, fitted with a stern ramp and powered by a petrol motor, seen in the Thames. In the background is a tier of sailing barges which continued to trade throughout the war. *P.L.A.*

Index

Illustrations in bold type

A

Aberdeen & Commonwealth Line, 53, 55
Agriculture, Ministry of, 46
Alexander, Charles, ix
Alexander, W. H. J., ix
Anti-sabotage warning, **114**
Army, 173, 174, 175, 179, 180
Aspinall, Robert, ix

B

Balaclava helmets, **145**
Barrage balloons, **176,** 177
Barrow lightvessel, 136, 148, 149
Bazzone, Alan, ix
Bibby Line, 53
Blackwall, 44, 125, 126, 127, 158
Bomb damage, 38
Bow Creek, 125, 178
Boyle, Rear-Admiral E. C., V.C., 101, **183**
Braithwaite, Charles, ix, 98
Braithwaite & Dean, ix, 98
Brewer, Chester & Galley Quays, 166
British India Line, 53
Buffer depots, 4, 69, 165

C

Canadian Pacific Line, 52
Cant Sand, 149, 153, 156
Canvey Point, 104, 108
Chamberlain, Neville, 3
Churchill, Junior Cmdr. Mary, **85**
Churchill, Mrs Winston, **54, 179,** 181
Churchill, Winston, 67, 175, 177
City Corporation, 14
City Line, 53
Clan Line, 53
Cliffe, 101, 102, 111
Clyde Anchorages, 19, 137, 139
Coast Lines, 53
Coffer dam, **108**
Colliers, 130
Commemorative plaque, **183**
Company of Watermen & Lightermen, 91
Control Room, 40, 41, 44, 145

Conundrums, 23, **23**
Cory, William & Sons, 136
Cunard White Star Line, 53
Custom House, **171**
Customs & Excise, H.M., ix, 123

D

D-Day, 35, **36,** 37, 139-140
Deal porters, **69**
Defensively armed merchant ships, 109
Deptford, 171
Dockmasters, 51, 52, 55, 56, 58, 61, 63, 64, 81
Dover, 94, 139, 145
Dunbar-Nasmith, Admiral Sir Martin, V.C., 101, **183**
Dundee, Perth & Ldn. Shipping Co, 149
Dungeness, 138, 140
Dunkirk, 6, 8, 9, 55, 86, 93, 121, 134, 138, 144, 145, 146, 169

E

Ennels, G. E., ix
Evans, Bram, ix
Exchange Sidings, R. Victoria Dock, **79,** 82

F

Fane, Lieut. Gordon, **109**
Federal Line, 53
Ferro-concrete barges, 76, 77, 99
Firefighting, **x,** 13, 43, 48, 55-58, 59, 63, 65, 88, 95-96, 117, 121-122, 129
Fire floats, 13, 64, **120,** 121, **122**
Fire Patrol, River Tug, 14, 88, 95-96
Fire services, 29, 56, 117, 121
Food, Ministry of, 69
France, Fenwick, Wm, 136
Fulham, 14, 135

G

Gadfly, Exercise, 112
Gas Light & Coke Co, 131, 132
Gas precautions, 64-65, **115,** 116, **116**
General Steam Navigation Co, 53

Girl Pat (drifter), 85
Gravesend, 5, 15, 103, 104, 123, 137, 139,
 140, 143, 146, 172, 177
Greenhithe, 101, 102, 111
Greenwich, 44, 172

H
Harbour Service, 14, 43, 44, 45, 84, 86,
 87, 88, 89, 101, 102, 103, 169
Harrisons (Ldn) Ltd, 137
Havengore (launch), 85
Health, Ministry of, 117
Herbert, Sir Alan, **102,** 103, 106, **106,** 107
Hockin, John, ix, 175
Hodge, Major W. J., ix, 28
Holehaven, 101, 102
Home Guard, 8, 14, 34, 80, 112, 159, 160,
 174, 177-181, **181**
Hoylake (lighter), 87
Human minesweepers, 78

I
India & Millwall Docks, vii, 17, 29, 32, 35,
 41, 42, 43, 44, 45, 52, 58, 60, 67, 69,
 70, 72, 75, 76, 78, **80,** 81, 96, 99, 180
Isle of Dogs, 10, **11,** 174

J
Jenkinson, J. C., ix
Jones, Freddie, ix

K
King George VI, **53**

L
Leigh, H.M.S., 110, 143
Lend-Lease, 26, **33,** 70
Lewis, Lt. Cmdr. R. C., 103
Liberty Ships, 26, **71**
Lighterage Executive, 5, 13, 14, 17, 18,
 37, 90, 92, 93, 96, 98, 99
Lightermen, 90, 91, **91,** 94
Limehouse, 44, 171
London County Council, 14, 129, 130
London Mammoth (crane), 83
London Passenger Transport Board, 13
London Power Co, 134
London & St Katharine Docks, vii, 18, 39,
 43, 53, 56, 57, 70, 78, 111, 171
London Tug & Barge Control, 97, 99,
 100

Long Sand, 148, 149
Lower Hope, 10, 109, 130

M
Mackie, T. L., viii, 64
Massey Shaw (firefloat), 117, 121, **122**
Master Lightermen & Barge Owners,
 Ascn. of, 92, 93, 99
Maunsell forts, 15, **15, 16,** 139, 150, 152,
 173
Merchant aircraft carrier, **69**
Mines, 4, 5, 13, 86, 103, 104, 107, 149,
 175
Mobile canteen, **66,** 67, 161
Montgomery, General, 34, **75**
Mountbatten, Lord Louis, 22, **72**
Mouse lightvessel, 10, 128
Mucking, 127, 130
Mulberry Harbour, 27, **27, 30,** 100, 139,
 150

N
National Dock Labour Corporation, 20,
 75, 77, 82
New Zealand Shipping Co, 53
Nore lightvessel, 16, 103, 111, 127, 136,
 144

O
Orient Line, 53
Ouvry, Lt. Cmdr. J. D. G., 103

P
P & O Line, 53, 54
Passive defence, 113-121
Petroleum, 18, 22
Phoenix units, 27, **27,** 28, **30,** 100
Pilotless planes, 37
Pilots, 137, 138, **138,** 139, 140, 141
Pluto, 22, 24
Police, PLA, 50, 51, **51,** 52, 56, 57, **60,** 61,
 67, 82
Police, Thames Division, ix, **115, 116,**
 123-125, **125, 167**
Port Emergency Committee, 2, 3, 5, 6, 9,
 13, 17, 18, 20, 32, 33, 37, 40, 45, 74,
 77, 78, 93, 96, 98, 100, 121, 137, 150,
 165
Port of London Authority, ix, 1, 4, 5, 8, 9,
 22, 23, 33, 37, 40, 101, 113, 114, 115,
 116, 117, 118, 161, 164, 165, 174,
 178, 182

PLA head office, **42,** 46, 47, **47,** 48, **48,** **49,** 101, 103, 104, 110, 111
Port of London Health Authority, 64, 116
Prince Line, 53
Public Wharfingers, Federation of London, 165
Public Wharfingers, Ldn. Ascn. of, 165
Purfleet Oil Wharf, 43

R
Railways, dock, 56, 78, **79,** 82
Rainie, Robert, ix
Ramsgate, 94, 148
Richmond, 19, 111, 124
Ritchie, Sir Douglas, **2**
River Emergency Service, 84, **88,** 101, 117
Rocket bombs, 37, 164
Rotherhithe, 10, 44, 124
Royal Air Force, 86, 93, 96, 174, 175, 176, 177
Royal Docks, vii, 15, 22, 32, 34, 38, 41, 42, 43, 44, 45, 53, 54, 61, 72, 73, 75, 78, 81, 83, 117, 119, 123, 129, 133
Royal Mail Lines, 53
Royal Navy, 3, 8, 31, 33, 37, 46, 84, 101, 102, 103, 105, 107, 108, 109, 110, 111, 123, 130, 143

S
Sailing barges, **9, 142**
Aidie, 7
Barbara Jean, 7
Beatrice Maud, 7
Doris, 7
Duchess, 7
Ena, 7
Ethel Everard, 7
Glenway, 7
H.A.C., 7
Lady Rosebery, 7
Lark, 7
Pudge, 7
Royalty, 7
Spurgeon, 7
Thyra, 7
Tollesbury, 7
Will Everard, **9**
Salvage services, 31, 45, 46, 151, 152, 153, 156, **156,** 157, 158, **159**

Seamen's Hospital, 61
Shaw, Savill Line, 53
Sheerness, 5, 93, 94, 111, 154
Shellhaven, 156
Ship repair, 157-164
Ships
Abbekirk, 61
Alert, **126,** 127-128
Alexander Kennedy, 135
Ambrose Fleming, 135
Argus, 128, **129**
Ashley, 133
Athenia, 3
Bennevis, 43, 44, 58
Betty Hindley, 133
Borde, 133
Brixton, 132
Broadhurst, 133
Brockley, 149
Bululo, 163
Camerata, 149
Catford, 132
Charles Parsons, 135
Chemong, 137
City of Brisbane, 148
City of Christchurch, 146
City of Dundee, 148
Colonel Crompton, 135, 148, 149, 153
Corduff, 136
Cornwall, 172
Crested Eagle, 131
Dagenham, 153
Dapper, 157
Dicky, 149
Dixcove, 149
Dundee, 149
Effra, 132
Empire MacAlpine, **83**
Empire Seaman, 149
Ewell, 133
Exmouth, 121
Ferranti, 135
Firelight, 132
Flashlight, 131
Flathouse, 134
Florence Martus, 149
Forde, 157
Fort Dearborn, 163
Fort Frontenac, 149
Fort Kootenay, 149
Freya, 157

INDEX

Fulham, 135
Fulham II and *III*, 135
Fulham, IV, V, VI and *VII*, 136
Gasfire, 131
Gaslight, 131
George Balfour, 135
Glenstrae, 43
Goodwood, 136
Gothland, 44
Granton, 136
G. W. Humphreys, 130
Halizones, 148
Halo, 132, **159, 160, 161**
Haytor, 133
Helvellyn, H.M.S., 66, 155
Henry Woodall, 133
Horseferry, 132
Horsted, 133
Icemaid, 131
Ilse, 131
Ingineer N. Vlassopol, 148
Inkosi, 44
Isaac Shelby, 149
J. B. Paddon, 134
Jersey City, 149
Jervis Bay, 55, 162
Josefina Thorden, 149, 156
Joseph Swan, 134
Katowice, 146
Kelly, H.M.S., 162
Keynes, 133
King Lear, 140, 157
Kolga, 135
Lady Olga, 132
Leonard Pearce, 134
Lieisten, 148
Llandilo, 149, 153, 154
London, 22
Lossibank, 149
Lowestoft, H.M.S., 148
Lunula, 14, 88, 104
Maurice Rose, 149
Middlesbro, **134**
Mount Othrys, 149
Mr Therm, 132
Nephrite, 134, 149
Old Charlton, 132
Otaio, 61
Paris, 146
Pelican, H.M.S., 148, 163

Philip M, 132
Pioneer, 140
Pitwines, 133, 134
Pomona, 52
Portslade, 133
President, H.M.S., 87, 109
Pulborough, 133
Rawalpindi, 54, 162, **163**
Reculver, 127, 128
Richard Montgomery, 158
Rogate, 134
Royal Daffodil, 7
Royal Eagle, 128
Royal Sovereign, 7
Samos, 149
Scottish Musician, 149
Sir Russell, 133
St Katharine, 5, **5**, 85, 143, 174
Sted Aldmark, 133
Strathearn, 127, 128
Suffolk, H.M.S., 162
Tatem I and *II*, 173
Tolworth, 133
Turpin, 149
U 776, 39
Valborg, 149
Vanessa, 163
Vigilant (police launch), **125**
Wandle, 133
Wandsworth, 130
William Cash, 44, 133
Williamstown, 146
Wimbledon, 133
Winkfield, 149
Worcester, 102, 111, 121
Yantlet, 153, 157
Shoebury, 103, 108, 175
Silvertown, 44, 124, 129
Smuts, General, **180**
South Met. Gas Co, 132, 149
Southend, ix, 35, 36, 93, 94, 110, **110,**
111, **112,** 143, 153
Steer, Capt. P. B., 28
Stenhouse, Commander J. R., **144**
Stephenson, Clarke Ltd, 133, 134
Sunk lightvessel, 141, 144
Supply, Ministry of, 28, 69
Surrey Commercial Docks, vii, 10, **12,** 29,
43, 44, 45, 52, **62,** 63, 64, 66, **69,** 72,
76, 78, 82, 98, 99, 120, 121, 155, 171

188

T

Teddington, 5, 19, 24, 105, 168, **168,** 169
Thames Estuary, 4, 17, 126, 127, 128, 134, 136, 139, 141, 143, 173
Thames Water Authority, ix
Thameshaven, 9, 88, 108
Tilbury Docks, vii, 22, 23, 24, 32, 34, 35, 36, 39, 41, 43, 44, 45, 53, 61, 62, 63, 72, 78, 80, 81, 87, 94, 101, 102, 108, 109, 154, 159, 178
Tilbury Hotel, 81
Tough Bros., viii, 168, 169
Tower, H.M.S., 101
Tower Bridge, 41, 104, 123, 171, 172
Tower Pier, 43, 89, 101, 102
Transport, Ministry of, 2, 74
Transport Liaison Committee, 74
Trinity House, ix, 34, 125, 126, 127, **128,** 137, 138, 139
Tugs, 4, 8, 14, 90, **92,** 94, 95, **97,** 100, 111, 143, 145, **152**
Tugs
 Arcadia, 149, 150
 Badia, 149, 153
 Betty, 148
 Beverley, 61
 Bruno, **152**
 Canada, 64
 Cervia, 146, 148
 Challenge, **147,** 148
 Charlight, 96
 Contest, 148
 Crested Cock, 148
 Danube III, V and *VI,* 143
 Deanbrook, 62
 Denton, 93
 Ditto, **152**
 Doria, 148
 Fabia, 148
 Fairplay I, 148
 Foremost, 87, 146, 148
 Fossa, 94, 148
 Gondia, 148
 Hibernia, 148
 Hurricane, 93
 Java, 148
 Jean, 64
 Kenya, 148
 Keverne, 43
 Kite, 43
 Lea, 62
 Lion, 93, 96
 Naja, 100
 Ocean Cock, 148
 Persia, 88, 148
 Racia, 148
 Simla, 148
 St Clears, 148
 Sun, 148
 Sun II, 149
 Sun III, 140, 148
 Sun IV, V, VII, X, XI, XII, XV, 148
 Sun VIII, 148, 149
 Tanga, 148
 Vincia, 148
 Walbrook, 61
Turco, 37

U

Union Castle Line, 52
United States, 26

V

Volta (power station), 120

W

Walton Committee, 18, 19
Walton-on-Thames, 18
Wandsworth & District Gas Co, 132, 133
Wapping police station, 123, 124
War Office, 28, 37, 98
War Transport, Ministry of, 37, 41, 46, 74, 93, 99, 156
Water Gipsy, H.M.S., 105, 106, 107
Watermen, 4, 5, 8, 13, 15, 19, 21, 31, 91, 94, 98, 99, 143
Watkins, William, Ltd, 149
Westminster, 14, 39, 89, 106, 170
Women's Legion, 67
Women's Voluntary Service, 160
Woolton, Lord, **73**
Woolwich, 10, 44, 45, 124, 129, 153, 171, 172
Woolwich Ferry, 43, 124, 129
Wreck raising, 4, **156**

Y

Yeoman, H.M.S., 101

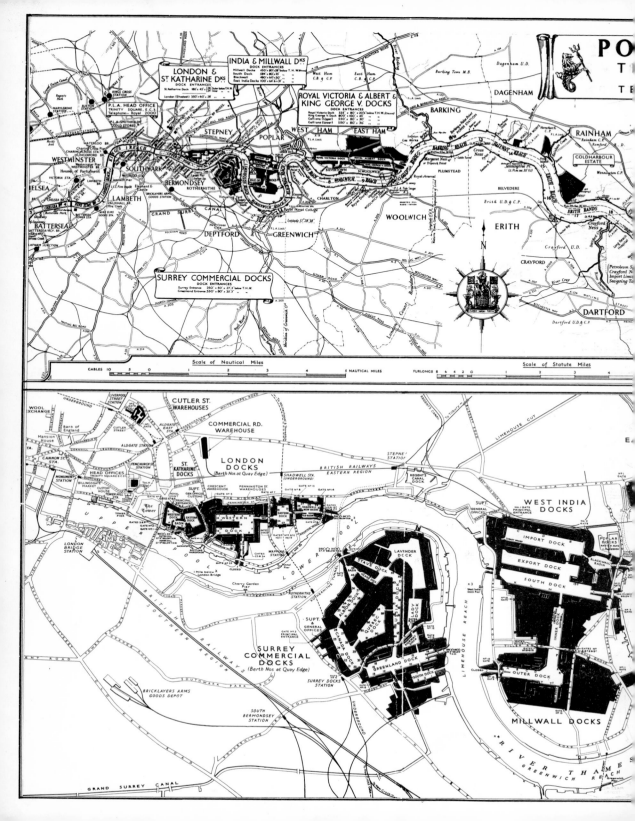